"Matthew Milliner's ca
circumstances draws ι
Chesterton, who made ____, ___ _____ ____ ___ ___ _____ _____, turns out to
have addressed themes that for Milliner illuminate Indigenous experience with
unusual force. Art, history, contemporary reflection, and theology combine to
make this a work of rare and sparkling insight."
Mark Noll, author of *A History of Christianity in the United States and Canada*

"Taking Chesterton's baton to recognize the 'Red Indian,' Milliner continues the
relay. His work of 'unexpected connections' looks at Native rock art, Christian-
ity, and massacre sites left in the wake of westward expansion. Native rock art
tells the story of a people who sought the same as the Christians—release from
darkness, hunger, sickness, death, and threats from a hostile world. Milliner is
a go-between between the worlds, following the greater relay, the cross of Jesus.
Milliner's work recognizes the supplication, contradiction, and contagion of Na-
tive rock art. *The Everlasting People* is a reminder of the stain on America's history.
For the Native Christian, however, behind the shroud of heavy sails was the light
of Christ."
Diane Glancy, author of *Island of the Innocent: A Consideration of the Book of Job*

"Matthew Milliner applies inspiration from the writings and musings of
G. K. Chesterton to look deeper into the cultures of the Indigenous peoples of
Turtle Island (North America). Milliner allows his own experiences in rela-
tionship with Native North Americans to challenge his preconceptions and his
understanding of where faith in Jesus begins on this continent. With unusual
transparency for a theologian, he shares much from his own relational and
cultural experiences as he gives readers thoughtful ways to approach Indigenous
theology. This book is filled with contemplative insights, soul-searching ques-
tions, and generous footnotes for further reading. It is my hope that books like
this will create cultural bridges that will foster further conciliatory opportunities."
Terry M. Wildman, lead translator, general editor, and project manager of
the First Nations Version New Testament

"In one of the most unexpected and original explorations of G. K. Chesterton's
rich ideas, Matthew Milliner has opened an entirely new territory of scholar-
ship and social studies. Chesterton's endless creativity has somehow gotten even
more creative!"
Dale Ahlquist, president of the Society of Gilbert Keith Chesterton

"I'm so grateful to read my friend Matthew's good words in this new book. They would not have come together without many long days and nights of researching and uncovering terrible truths about the atrocities of the colonization and attempted eradication of Indigenous people in North America. Those stories are not easy to tell, especially for settlers. Years ago, I remember Matthew speaking about these very atrocities and again I was grateful. He is a truth seeker and teller. His work is well researched and therefore may cause discomfort to those who are still living with a colonizer mindset. Decolonization simply means hearing a different story and changing your mind. In this book, Dr. Milliner does a beautiful job of telling that different story. Thank you, my friend."

Cheryl Bear, Nadleh Whut'en First Nation

"Somewhere under the larches of Paradise, G. K. Chesterton and Nicholas Black Elk are sharing a pipe to celebrate the publication of *The Everlasting People*. Down here we can do our part by spreading the word. Buy a copy for yourself and three more to give to friends."

John Wilson, founding editor of *Books & Culture*

HANSEN LECTURESHIP SERIES

MATTHEW J. MILLINER

THE
EVERLASTING
PEOPLE

G. K. CHESTERTON AND THE FIRST NATIONS

FOREWORD BY
CASEY CHURCH
POKAGON BAND OF POTAWATOMI

IVP
Academic

An imprint of InterVarsity Press
Downers Grove, Illinois

InterVarsity Press
P.O. Box 1400, Downers Grove, IL 60515-1426
ivpress.com
email@ivpress.com

©2021 by The Marion E. Wade Center

All rights reserved. No part of this book may be reproduced in any form without written
permission from InterVarsity Press.

InterVarsity Press® is the book-publishing division of InterVarsity Christian Fellowship/USA®, a
movement of students and faculty active on campus at hundreds of universities, colleges, and schools
of nursing in the United States of America, and a member movement of the International Fellowship
of Evangelical Students. For information about local and regional activities, visit intervarsity.org.

Scripture quotations, unless otherwise noted, are from the New Revised Standard Version Bible,
copyright © 1989 National Council of the Churches of Christ in the United States of America.
Used by permission. All rights reserved worldwide.

Cover design and image composite: David Fassett
Interior design: Daniel van Loon
Images: Mexican textile: © Gabriel Perez / Moment / Getty Images
 landscape: © Maksim Tarasov / EyeEm / Getty Images
 shoulder bag: © The Charles and Valerie Diker Collection of Native American Art,
 Gift of Charles and Valerie Diker, 2019
 brown leather background: © Yaorusheng / Moment / Getty Images
 speckled paper background: © Zakharova_Natalia / iStock / Getty Images

ISBN 978-1-5140-0032-8 (print)
ISBN 978-1-5140-0033-5 (digital)

Printed in the United States of America ∞

InterVarsity Press is committed to ecological stewardship and to the conservation of natural resources
in all our operations. This book was printed using sustainably sourced paper.

Library of Congress Cataloging-in-Publication Data
Names: Milliner, Matthew J., 1976- author. | Church, Casey, writer of
 foreword.
Title: The everlasting people : G.K. Chesterton and the First Nations /
 Matthew J. Milliner ; foreword by Casey Church.
Description: Downers Grove, IL : IVP Academic, [2021] | Series: Hansen
 lectureship series | Includes bibliographical references and index.
Identifiers: LCCN 2021034697 (print) | LCCN 2021034698 (ebook) | ISBN
 9781514000328 (paperback) | ISBN 9781514000335 (ebook)
Subjects: LCSH: Indian art—North America. | Art—Historiography. | Indians
 of North America. | Chesterton, G. K. (Gilbert Keith), 1874-1936.
Classification: LCC E59.A7 M52 2021 (print) | LCC E59.A7 (ebook) | DDC
 970.004/97—dc23
LC record available at https://lccn.loc.gov/2021034697
LC ebook record available at https://lccn.loc.gov/2021034698

P	25	24	23	22	21	20	19	18	17	16	15	14	13	12	11	10	9	8	7	6	5	4	3	2	1
Y	38	37	36	35	34	33	32	31	30	29	28	27	26	25	24	23	22	21							

TO THE ORIGINAL AND EVERLASTING PEOPLE
OF LANDS I HAVE CALLED HOME.

CONTENTS

FOREWORD
by Casey Church ix

PREFACE
by G. Walter Hansen xiii

ACKNOWLEDGMENTS xxi

INTRODUCTION
From the Holy Mountain to Spirit Island. . . 1

1 The Sign of Jonah 23
Response: Capt. David Iglesias

2 The Cost of Chicago 60
Response: David Hooker

3 Mother of the Midwest 102
Response: Amy Peeler

CONCLUSION
Returning a Pipe 127

CONTRIBUTORS 149

FIGURES CREDITS 151

NAME INDEX 153

SUBJECT INDEX 155

FOREWORD

CASEY CHURCH

WHEN ASKED TO WRITE A FOREWORD to Dr. Matthew Milliner's book, I accepted because I was intrigued by the title of the series of lectures that were the original basis for this publication: "Turtle Island Renaissance."[1] Turtle Island is the name for the land of my people, the Anishinaabe, the Indigenous inhabitants of the Great Lakes region. In each of the chapters of his book there are references to my Indigenous religious, spiritual, and cultural beliefs and the community ways of my family and relations. Having heard Milliner speak before at various events, I've come to enjoy his enthusiasm when he presents on topics dealing with Native Americans. This book has a special relevance to many aspects of my life as a Potawatomi person growing up in the southwest Michigan woodland area. Milliner takes a look at the mythology, religion, culture, and traditions of my Anishinaabe people in a unique way. Not having studied the writing of G. K. Chesterton in the manner Milliner has for the focus in this book, I had to do some investigation. Dr. Milliner's understanding of G. K. Chesterton's perspective and the parallels he draws between his many works and the Native American people are interesting, making this project a unique addition in learning more of Native American history, culture, and religion in a fresh, new way.

[1]For an article form of these early lectures, see Matthew J. Milliner, "Turtle Island Renaissance," *Journal of NAIITS: An Indigenous Learning Community, Une Communauté Autochtone D'apprentissage* 16 (2018): 120-41.

This book is more than a systematized introduction to American Indian thinking. In large part, *The Everlasting People* is a critical reflection on Western thought and culture and American Indian intellectual and religious beliefs through a Euro-American lens. As a result, the book's greatest contribution is that it seriously shakes things up in standard approaches to research. Dr. Milliner again demonstrates the inadequacy of various Western approaches of research. His methods offer what some might find to be a shocking or unique way of looking at the various evidence found in Native American studies, maybe not to the non-Indigenous researcher but mostly to professionals like myself, an Indigenous researcher and minister. Milliner has a deep sensitivity to the pain caused by years of trauma inflicted on the Natives of North America by White settlers and their Christianity. It is this depth of feeling that I sense in his look at the history of Indigenous people's faith. His understanding of the atrocities done to the North American Indigenous people through massacres, relocation, and being forced to make dramatic life-and-death changes to their way of life is reflected in his research.

Milliner's chapter "The Sign of Jonah" gives the reader a well-researched look at an aspect of Native American spirituality most people might overlook because of their limited view of the beliefs and artistic nature found in the culture and traditions of the Native American. His perspective on Native rock art draws deep insights for theologians and students to ponder. His unique look at the cave rock paintings throughout the Midwest takes us further down the road to seeking another way to view the artistry depicted on the rock walls as a living expression of the Indigenous peoples' beliefs in mythical creatures. I particularly enjoyed his look at the mythology of the Great Lakes peoples' belief in the Underwater Panther, also called the *Mishipeshu*, and other spiritual beings that have both malevolent and benevolent traits recognized and respected by the Natives.

Dr. Milliner's more philosophical/theological research is not limited in its effect only to Native American peoples but can be very instructive to those who function mostly in the Western intellectual tradition. I truly expect this and other works by Dr. Milliner will contribute to the ongoing study of Native Americans and will become increasingly important to not only secular studies but also to the religious and theological studies on Indigenous people.

As a Native American from the tribe called the Potawatomi, originally from the Michigan/Indiana region, I grew up with these beliefs of the underwater creatures that researchers call myths. My family and other families lived the stories that Matthew relates of moving through stages of faith toward a White man's version of Native Christianity. As a missiologist, I view many aspects of Native beliefs and culture as entry points to moving the Native toward Christian belief. I respect Matthew's desire to research Native art and mythology and interpret it for his particular audience, and it is my desire like Matthew's to find ways to share the life-changing message of Jesus Christ to the world. It is my hope as new approaches to research are ventured and new models are implemented that God will be known more fully among Indigenous and non-Indigenous peoples of the world.

In many traditional Native ways, it is protocol to introduce oneself and their connection to others in the community. The following is written for context to my life and community as it relates to the subject matter of the book. These are topics connected to the Anishinaabe people and specifically to my familial heritage and story: I am Casey Church, a member of the Pokagon Band of Potawatomi Indians of Southwest Michigan; I am of the Bear (Makwa) clan on my mother's side (the late Mary Church [Pokagon]), a member of the Pokagon Band of Potawatomi. Her father was the late Peter Pokagon, Great Uncle of Chief Simon Pokagon, and my Great, Great, Great Grandfather was Chief Leopold Pokagon. I am also of the Crane (Jijak) clan on my

father's side (the late Leonard H. Church), of the Huron Band of Pot-awatomi, the son of Sarah Church (Madewis) of the Huron Band of Potawatomi. My Indian name is Ankwawango "Hole in the Clouds." I am called an Ogitchida, meaning "warrior," for my service as a Sergeant in the United States Marine Corps. Religiously, I am a Banai, meaning "spiritual leader." I am further a Licensed Minister with the United Methodist Church. Culturally, I am a Northern Traditional Dancer–Eagle Whistle Carrier. I am married to Lora Church (Morgan), a Navajo Native of Albuquerque, New Mexico, and we raised five children together.

PREFACE

G. WALTER HANSEN

MATTHEW MILLINER AND G. K. CHESTERTON share a common interest in rock paintings created by people in caves. Chesterton imagines a boy digging deep into a cave and finding a place where a man had drawn the picture of a reindeer. That boy would feel an immediate sense of nearness, a bond of common humanity with the artist, because he would know intuitively that the art could not have been drawn by any other animal than a human being. However remote and strange they are, these artists are still close to us, because, unlike any other creatures, they are like us: they are creators as well as creatures. "Art is the signature of man," says G. K. Chesterton.[1]

Milliner is like Chesterton's boy digging deep into the cave. When you see the rock paintings of the First Nations of America (Native Americans) that Milliner found, you will feel that same sense of nearness; you will feel a common bond with their human hopes, fears, and beliefs depicted in their art. Whether or not the petroglyphs carved by the artists of the First Nations contain signs foreshadowing Christianity, there can be no debate that their paintings reveal an amazing depth of spirituality. Milliner asks us to look at the Underwater Panther representing the beneath-world spirit at Agawa Rock on Lake Superior and to notice the Thunderbird, an image of Christ for the followers of the Ojibwe painter Norval Morrisseau.

[1]G. K. Chesterton, *The Everlasting Man* (Oxford: Oxford City Press, 2011), 21-22.

Milliner shows us that Native rock art is replete with images bearing spiritual meaning. When you draw near to these images and sense the human creative impulse of these artists, you can almost feel their pulse. They are so much like us in the human family. We grow to admire them and love them as we follow Milliner on his tour of their rock art.

But Milliner also deeply disturbs us on his tour. After he makes us aware of our bond with these rock artists, he then confronts us with the painful truth. Even though many of the Potawatomi had converted to Christianity, White Christians rounded them up and marched them out of their land. The Trail of Death, only one of many such forced removals, cleared the land for places like Wheaton College, where the lectures published here were first delivered. As he made me aware of forced removals, broken treaties, ethnic cleansing, and mass murder, I was deeply distressed. But I'm grateful for Milliner's truthfulness about what he found while he was digging in caves to discover the meaning of the rock paintings of the First Nations because I know that the only hope for justice is truth.

In his chapter "Flag of the World" in *Orthodoxy*, Chesterton argues forcefully that the reformation of a place can only come from those who have a primary loyalty to that place: "primary devotion to a place or thing is a source of creative energy."[2] He adds, "Before any cosmic act of reform we must have a cosmic oath of allegiance."[3] The one who has a cosmic oath of allegiance does not turn a blind eye to the truth of injustice and evil in the place that one loves. "The devotee is entirely free to criticize; the fanatic can safely be a sceptic. Love is not blind; that is the last thing it is. Love is bound; and the more it is bound the less it is blind."[4]

[2]G. K. Chesterton, *Orthodoxy* (1908; repr., New York: Image, 1990), 68.
[3]Chesterton, *Orthodoxy*, 71.
[4]Chesterton, *Orthodoxy*, 71.

Milliner takes off our blinders so that we can see the truth about the country we love. We must not rewrite our history to delete all our blunders and sin. The only way forward is to see it all clearly and bravely. The reality of 1619 confronts us with the painful fact of the enslavement of African people and the subjugation of First Nations people at the founding of our country. The story of 1776 tells us of our ideal that all are created equal. I love my country. I am bound to my country. But I do not want to be blind to the evil realities of ethnic cleansing by Christians clearing the land by forcing First Nations people on death marches. Along those trails of tears, hymn singing accompanied death.

As you read this book by Matthew Milliner, remember the words of Chesterton: "Art is the signature of man." These First Nations artists are one with us in their artistic impulse. And also remember: "Love is not blind." It takes courage for us to face the painful truth of our history with the First Nations. We want to turn aside from so much suffering and pain. However, removing our blinders and facing this hard truth is the only way forward to show our love and to seek justice for the First Nations.

The Ken and Jean Hansen Lectureship

I was motivated to set up a lectureship in honor of my parents, Ken and Jean Hansen, at the Wade Center primarily because they loved Marion E. Wade. My father began working for Mr. Wade in 1946, the year I was born. He launched my father's career and mentored him in business. Often when I look at the picture of Marion Wade in the Wade Center, I give thanks to God for his beneficial influence in my family and in my life.

After Darlene and I were married in December 1967, the middle of my senior year at Wheaton College, we invited Marion and Lil Wade for dinner in our apartment. I wanted Darlene to get to know the best storyteller I've ever heard.

When Marion Wade passed through death into the Lord's presence on November 28, 1973, his last words to my father were, "Remember Joshua, Ken." As Joshua was the one who followed Moses to lead God's people, my father was the one who followed Marion Wade to lead the ServiceMaster Company.

After members of Marion Wade's family and friends at ServiceMaster set up a memorial fund in honor of Marion Wade at Wheaton College, my parents initiated the renaming of Clyde Kilby's collection of papers and books from the seven British authors—C. S. Lewis, J. R. R. Tolkien, Dorothy L. Sayers, George MacDonald, G. K. Chesterton, Charles Williams, and Owen Barfield—as the Marion E. Wade Collection.

I'm also motivated to name this lectureship after my parents because they loved the literature of these seven authors whose papers are now collected at the Wade Center.

While I was still in college, my father and mother took an evening course on Lewis and Tolkien with Dr. Kilby. The class was limited to nine students so that they could meet in Dr. Kilby's living room. Dr. Kilby's wife, Martha, served tea and cookies.

My parents were avid readers, collectors, and promoters of the books of the seven Wade authors, even hosting a book club in their living room led by Dr. Kilby. When they moved to Santa Barbara in 1977, they named their home Rivendell, after the beautiful house of the elf Lord Elrond, whose home served as a welcome haven to weary travelers as well as a cultural center for Middle-earth history and lore. Family and friends who stayed in their home know that their home fulfilled Tolkien's description of Rivendell:

> And so at last they all came to the Last Homely House, and found its doors flung wide. . . . [The] house was perfect whether you liked food, or sleep, or work, or story-telling, or singing, or just sitting and thinking best, or a pleasant mixture of them all. . . . Their clothes were mended

as well as their bruises, their tempers and their hopes. . . . Their plans were improved with the best advice.[5]

Our family treasures many memories of our times at Rivendell, highlighted by storytelling. Our conversations often drew from images of the stories of Lewis, Tolkien, and the other authors. We had our own code language: "That was a terrible Bridge of Khazad-dûm experience." "That meeting felt like the Council of Elrond."

One cold February, Clyde and Martha Kilby escaped the deep freeze of Wheaton to thaw out and recover for two weeks at my parents' Rivendell home in Santa Barbara. As a thank-you note, Clyde Kilby dedicated his book *Images of Salvation in the Fiction of C. S. Lewis* to my parents. When my parents set up our family foundation in 1985, they named the foundation Rivendell Stewards' Trust.

In many ways, they lived in and lived out the stories of the seven authors. It seems fitting and proper, therefore, to name this lectureship in honor of Ken and Jean Hansen.

Escape for Prisoners

The purpose of the Hansen Lectureship is to provide a way of escape for prisoners. J. R. R. Tolkien writes about the positive role of escape in literature:

> I have claimed that Escape is one of the main functions of fairy-stories, and since I do not disapprove of them, it is plain that I do not accept the tone of scorn or pity with which "Escape" is now so often used: a tone for which the uses of the word outside literary criticism give no warrant at all. In what the misusers of Escape are fond of calling Real Life, Escape is evidently as a rule very practical, and may even be heroic.[6]

[5] J. R. R. Tolkien, *The Hobbit* (London: Unwin Hyman, 1987), 50-51.
[6] J. R. R. Tolkien, "On Fairy-Stories," in *Tales from the Perilous Realm* (Boston: Houghton Mifflin, 2008), 375.

Note that Tolkien is not talking about escap*ism* or an avoidance of reality but rather the idea of escape as a means of providing a new view of reality, the true, transcendent reality that is often screened from our view in this fallen world. He adds:

> Evidently we are faced by a misuse of words, and also by a confusion of thought. Why should a man be scorned, if, finding himself in prison, he tries to get out and go home? Or if, when he cannot do so, he thinks and talks about other topics than jailers and prison-walls? The world outside has not become less real because the prisoner cannot see it. In using Escape in this [derogatory] way the [literary] critics have chosen the wrong word, and, what is more, they are confusing, not always by sincere error, the Escape of the Prisoner with the Flight of the Deserter.[7]

I am not proposing that these lectures give us a way to escape from our responsibilities or ignore the needs of the world around us but rather that we explore the stories of the seven authors to escape from a distorted view of reality, from a sense of hopelessness, and to awaken us to the true hope of what God desires for us and promises to do for us.

C. S. Lewis offers a similar vision for the possibility that such literature could open our eyes to a new reality:

> We want to escape the illusions of perspective. . . . We want to see with other eyes, to imagine with other imaginations, to feel with other hearts, as well as with our own. . . .
>
> The man who is contented to be only himself, and therefore less a self, is in prison. My own eyes are not enough for me, I will see through those of others. . . .
>
> In reading great literature I become a thousand men yet remain myself. . . . Here as in worship, in love, in moral action, and in knowing, I transcend myself; and am never more myself than when I do.[8]

[7]Tolkien, "On Fairy-Stories," 376.
[8]C. S. Lewis, *An Experiment in Criticism* (Cambridge: Cambridge University, 1965), 137, 140-41.

The purpose of the Hansen Lectureship is to explore the great literature of the seven Wade authors so that we can escape from the prison of our self-centeredness and narrow, parochial perspective in order to see with other eyes, feel with other hearts, and be equipped for practical deeds in real life.

As a result, we will learn new ways to experience and extend the fulfillment of our Lord's mission: "to proclaim freedom for the prisoners and recovery of sight for the blind, to set the oppressed free" (Lk 4:18 NIV).

ACKNOWLEDGMENTS

HALFWAY THROUGH THE RESEARCH FOR THIS PROJECT, I attended a lecture by the Potawatomi scholar John Low and explained to him afterward that I had every reason to believe I should stop. The story of Indigenous persons, after all, is not mine to tell. He looked at me patiently at said, "We are 1.5 percent of the population; we need all the help we can get." Professor Low instructed me to proceed in conversation with Indigenous communities, counsel I have attempted to follow. I thank these communities for their patience with my awkward surprise visits or embarrassing, gaffe-inflected expressions of my own ignorance as I learn to both listen and lament. Without the Indigenous learning community of NAIITS, especially Terry and Matt LeBlanc, Cheryl Bear, Jonathan Maracle, Julie Eby, Damian Costello, Naaman Wood, and Keith Starkenburg, this book would not be possible. Among the Potawatomi I thank Casey Church for his kind preface, Tom Boelter, Blaire Topashi, Mike Zimmerman Jr. for saving me many errors, and Sharon Hoogstraten, whose photographs remain the best portraits of these everlasting people I know of. Thank you to friends from the 2018 Trail of Death caravan, especially Shirley Willard, Katerina Friesen, Chelsea Risser, Rich Meyer, Peggy and Linda Anderson, and Stanley Perry.

When I was a graduate student at a large research university, I could afford not to care about Native Americans; specialization and funding protected my interests. However, when I came to teach at Wheaton College, that ignorance transformed into an urgency thanks to the heart

of Gene and Deb Green, without whom this project would never have begun. I also owe deep thanks to Wheaton's Global Programs and Services under the leadership of Laura Montgomery, who generously funded trips to Indigenous communities and historic sites as well as Wheaton's Sabbatical Committee, its Center for Faith and Innovation, and HoneyRock camp.

I thank Walter and Darlene Hansen, whose gift for scholarly patronage has made this project possible. Thanks goes of course to the Wade Center, especially Marj Mead, Crystal and David Downing, Laura Schmidt, and to David McNutt at InterVarsity Press for taking a risk on this unusual project. Without the generosity of Howard and Roberta Ahmanson and the Institute for Advanced Studies in Culture, this book would just not have gotten done. Thank you for the everlasting encouragement of John Wilson, Tim Larsen, Jerry Root, Martin Johnson, Jay Moses, Michaljohn Rezler, Tiffany Kriner, Daniel Master, Keith Johnson, Tim Taylor, Jason Long, Bob Goldsborough, Andy Tooley, and Adam Wood, and also to my gracious and insightful formal respondents (David Iglesias, David Hooker, and Amy Peeler). Thanks to Scott Moringiello of DePaul University, Michael McGreggor at the generous Collegeville Institute, Scott Johnson of the University of Oklahoma, and the Chesterton House at Cornell University for kindly hosting, in one way or another, different phases of this project.

Finally, I thank Tiffany Sosnowski for showing me an Indigenous painting she had purchased at a reduced price because its Christian content rendered it less desirable to secular art world consumers. My puzzlement at this "Jesus discount" is what launched this project so long ago. Thanks above all to my wife, Denise, who drove so much of this long journey with me (I stopped counting at ten thousand miles). We started it with no children and ended with two. Peter and Polly, we're glad to report, have attended more pow-wows before they turned four than we did before we turned forty.

INTRODUCTION

FROM THE HOLY MOUNTAIN
TO SPIRIT ISLAND

Jesus has a purpose for me. He wants me to paint.

NORVAL MORRISSEAU (OJIBWE)

Yea, we are very sick and sad
Who bring good news to all mankind.

G. K. CHESTERTON

I often think how the forest is like our Christ.
It is stronger than the evil that passes.

KATERI TEKAKWITHA
(IN DIANE GLANCY'S *THE REASON FOR CROWS*)

O**NE OF THE ADVANTAGES** of writing a book on G. K. Chesterton and the First Nations of North America is that there is not a lot of competition. Traffic at the intersection of these particular interests is light. Just as curious, perhaps, the person to bring these fields together is a specialist in neither realm of study. My academic training is in the art and architecture of the Eastern Christian world.[1] On first glance, the cavernous, candlelit sanctuaries of the monastic republic

[1] I should add that as much as I love Chesterton, on this subject at least he is singularly unilluminating. Late Byzantium was far more than an "Asiatic theocracy" that "flattened everything as it flattened the faces of the images into icons." G. K. Chesterton, *St. Thomas*

of Mount Athos, where prayers rise with incense, and the darkened womb of a North American sweat lodge, where prayers rise with pipe smoke and steam, seem unrelated. But the British journalist G. K. Chesterton, with his gift for making unexpected connections, taught me otherwise. Let me explain.

Throughout my education, I managed to hold on to my Christian faith with confidence thanks in part to the ministrations of Chesterton, "the Prince of Paradox." Chesterton's *Orthodoxy* was inoculation against newfangled versions of Christianity while I was a youth minister at a mainline Protestant church and a student at a mainline Protestant seminary. "I tried to be some ten minutes in advance of the truth," he tells us, "and I found that I was eighteen hundred years behind it. . . . I did try to found a heresy of my own, and when I had put the last touches to it, I discovered it was orthodoxy."[2] Written in the early 1900s, when Chesterton was in his thirties, *Orthodoxy*'s attacks on bare logic ("Poets do not go mad; but chess-players do"[3]) squared well with the fashion for deconstruction of the early 2000s. Chesterton melted the ice of mere reason with the fire of wonder. Fairy tales, he reminds us, "say that apples were golden only to refresh the forgotten moment when we found that they were green."[4] And what upholds this gratitude for existence is not fleeting sentiment but sound doctrine, "the heavenly chariot" that "flies thundering through the ages, the dull heresies sprawling and prostate, the wild truth reeling but erect."[5]

Later in graduate school at a research university where knowledge was fragmented into endless specializations, Chesterton's coherent

Aquinas (1933; repr., Mineola, NY: Dover, 2009), 47. A fuller response to such reductions will be on offer in chap. 3 below.

[2] G. K. Chesterton, *Orthodoxy* (1908; repr., New York: Image, 1959), 4-5.

[3] Chesterton, *Orthodoxy*, 10.

[4] Chesterton, *Orthodoxy*, 51.

[5] Chesterton, *Orthodoxy*, 103.

bravado on offer in *The Everlasting Man* provided an antidote. Because the book was published in 1925 when Chesterton was in his fifties, reading it was like enjoying extended conversation with a wise older brother. I learned from Chesterton that so-called pagan culture could be approached positively. "In so far as all this sort of paganism was innocent and in touch with nature, there is no reason why it should not be patronized by patron saints as much as by pagan gods."[6] And yet, Christ burst into uroboric time "swift and straight as a thunderbolt."[7] Chesterton showed me that when the rivers of mythology and philosophy flowed separately, they flowed sadly. Until, that is, they merged in the joyful cataract of Christian faith.[8] When the celebrity philosopher Slavoj Žižek visited my graduate school and cited Chesterton approvingly, I was delighted to learn that my reading choice had become suddenly fashionable. I expect Chesterton would have relished Žižek's challenge just as he enjoyed the company of all his atheist sparring partners. "In order to save its treasure, [Christianity] has to sacrifice itself—like Christ, who had to die so that Christianity could emerge," claimed Žižek.[9] "Why not?" I imagined Chesterton replying. For "Christianity has died many times and risen again; for it had a God who knew the way out of the grave."[10]

En route to Europe for a research trip, on a plane thirty thousand feet above Nova Scotia, land of the Mi'kmaq (a term I did not then know), I learned from Chesterton that the best thing I could do was leave North America as quickly as possible and make my way to the Mediterranean, for

[6]G. K. Chesterton, *The Everlasting Man* (1925; repr., San Francisco: Ignatius Press, 1993), 108.

[7]Chesterton, *Everlasting Man*, 207.

[8]Chesterton, *Everlasting Man*, 240.

[9]Slavoj Žižek, *The Puppet and the Dwarf: The Perverse Core of Christianity* (Cambridge, MA: MIT Press, 2003), 171.

[10]Chesterton, *Everlasting Man*, 250.

round that little sea like a lake were the things themselves, apart from all extensions and echoes and commentaries on the things; the Republic and the Church; the Bible and the heroic epics; Islam and Israel and the memories of the lost empires; Aristotle and the measure of all things.[11]

What a thrill then to finally land in reality itself, not just its British or North American imitations. Wandering the streets of Thessaloniki on my first trip to that city, I could see Mount Olympus in the distance, abode of the gods. But I could save myself the bus trip and grueling hike because the brown-brick medieval churches I was studying, autumn leaves of the Byzantine Empire's waning years, were themselves the abode of God.

Even Mount Olympus seemed to smile on these late Byzantine-decorated churches.[12] In their frescoes, mosaics, and icons I found the creative zest of Zeus without his escapades of rape; the light and clarity of Apollo without his petulant revenge; and the confidence of Ares absent the warmongering. Hermes's promise of meaning was realized at last; Orpheus's descent to the underworld was confirmed by Christ's harrowing of hell. In these churches—the living heirs of Hellenism—the mother goddesses Hera, Artemis, and Aphrodite, were transformed into something far less expected: Mary, the mortal Mother of God. Athena was present as Holy Wisdom herself. The power of Poseidon was contained in baptismal fonts, Hestia's sacred hearth fire in the votive candles, and Demeter's shafts of wheat in the

[11]Chesterton, *Everlasting Man*, 79.

[12]"Jupiter, Mars, Venus, Mercury, Diana, Apollo, etc. were not at all demons, but leading prototypes of the development of human personality who, in their turn, correspond to cosmic—planetary and zodiacal—principles. . . . It cannot be otherwise than that as the coming of Jesus Christ was an event of universal significance, it had its universal preparation. . . . The incarnated Logos was awaited everywhere wherever one suffered, died, believed, hoped and loved." Anonymous, *Meditations on the Tarot: A Journey into Christian Hermeticism*, trans. Robert Powell (New York: Tarcher /Putnam, 1985), 426-27.

consecrated bread.[13] Or, as Chesterton himself put it: "We have entered more deeply than they into the Eleusinian Mysteries and have passed a higher grade, where gate within gate guarded the wisdom of Orpheus. We know the meaning of all the myths."[14]

Three times I enjoyed the ferry to the rocky outcrop of Mount Athos for research in fresco-festooned monasteries. I came to love the massive singular peak of Athos, a monotheistic answer to jagged Mount Olympus. Once Alexander the Great was asked if he'd like his face carved into the mountain. Fortunately, Alexander demurred, saying that the peninsula had already been defaced by a canal carved by the Persian King Xerxes I. That my own government had carved the faces of its leaders into a different holy mountain in the Black Hills of South Dakota did not then occur to me; but it is the kind of connection I expect Chesterton, ever suspicious of imperialism, might have made.

※▸◂※▸◂※▸◂※

A good decade after my trips to the Mediterranean I found myself on a different ferry, heading for a different rocky outcrop, a freshwater Mount Athos of sorts. A short drive from my wife's childhood home in Ontario is a place known as Manitoulin Island,[15] the largest freshwater island in the world. Just as the Mount Athos ferry flashed with

[13]To suggest that monotheism fulfills pagan insights is, of course, a standard Christian maneuver on offer in thinkers from Clement of Alexandria to Thomas Aquinas, but it is shared by some depth psychologists as well: "The gods and the goddesses are often in opposition. As long as the archetypal powers themselves are divided, the ego is cast in a tragic role, being split by the conflict that exists in the divine realm. . . . It is only with the unification symbolized by monotheism and psychologically represented by the Self that there is a chance to overcome this essential tragedy." Edward F. Edinger, *The Eternal Drama: The Inner Meaning of Greek Mythology* (Boston: Shambhala, 1994), 46. Edinger's faithfulness to the classic Jungian approach, in contrast to more recent polytheistic Jungianism, is refreshing.

[14]Chesterton, *Everlasting Man*, 115.

[15]As *manitou* can be understood as spirit, a literal translation of Manitoulin Island is "Spirit Island."

icons that defied both the norms of Renaissance art and our contemporary digital screens, so the exterior of the Chi-Cheemaun ferry was emblazoned in the Woodland School style founded by the "Picasso of the North," Norval Morrisseau (1932–2007). I was on my way to Wikwemikong, the only unceded First Nation reserve in Canada.[16] Technically, therefore, Wiky (as its residents refer to it) is not *in* Canada at all. Like Athos or the Vatican City, it is an entity all its own.

And as with Athos or the Vatican, proper connections were required to make this trip. I met an Ojibwe friend, who was understandably cautious that I not be too conspicuous. That night we attended a sweat lodge, as intimate and as foreign an experience for me as the liturgies on the Holy Mountain. First we prayerfully anointed our foreheads with bear grease (an unexpected move, but I went with it). We arrived at the home of a man who was conducting the sweat, a charge his family has upheld for generations. His face was as serious as the face of the Athonite monks who presided over the Eucharist. As Christians, my companion and I were not New Age seekers looking for a spiritual high.[17] Still, I realized just how quickly I could ruin this.

[16]Theresa S. Smith, *The Island of the Anishnaabeg* (Lincoln: University of Nebraska Press, 1995), 10.

[17]George Tinker's caution on this front remains valuable: "These visitors see little or nothing at all of the reservation community, pay little attention to the poverty and suffering of the people there, and finally leave having achieved only a personal, individual spiritual high." George E. Tinker, *Missionary Conquest: The Gospel and Native American Cultural Genocide* (Minneapolis: Fortress, 1993), 122. Elsewhere, Tinker calls White participation in such ceremonies a "colonizing virus" and the "New Age invasion of Indian ceremonies." George Tinker, "American Indian Religious Traditions, Colonialism, Resistance, and Liberation," in *Native Voices: American Indian Identity & Resistance*, ed. Richard A. Grounds, George E. Tinker, and David E. Wilkins (Lawrence: University Press of Kansas, 2003), 229-30. He recommends that even a valid invitation be refused (233) as White participation in Indian ceremonies is "the ultimate act of postmodern colonialism" (237). Such participation can be everything Tinker suggests, especially under New Age auspices. The risks are real, but the answer to appropriation need not always be segregation. For Indigenous leaders who cautiously welcome non-Natives into ceremony, see Casey Church, *Holy Smoke: The Contextual Use of Native American Ritual and Ceremony* (Cleveland, TN: Cherohala Press), 51-74; Howard P. Bad Hand, *Native American*

I wondered if I already had. As on Mount Athos, nothing about the ceremony catered to my desire to see it, and if I was regarded, understandably, with caution, I was still welcomed.

After the heated stones were deposited in the lodge, ten of us entered, sat in a circle, and covered ourselves with blankets. Most in the group were Anishinaabe, which can be translated "original people." This is the Great Lakes umbrella term that includes (but is not limited to) the Council of Three Fires, the Potawatomi, the Ojibwe, and the Odawa.[18] The only other White attender was from the nearby drug rehabilitation clinic. One of the elder women looked at me, glanced at my friend, and, guessing why I was joining them, raised her eyebrows and said, "Manopause?" I laughed and braced myself for the first round of heat. As the steam intensified, the prayers began. A woman on the reservation was ill, and this particular sweat was dedicated to her. In other words, this was a prayer meeting. The prayers were extemporaneous, just as they were in the evangelical youth group that won my enthusiasm as a high school student. I internalized my amens, and I kept breathing, anchoring my breath to a word internally spoken, *Christ*. "It's not my job to make amends," I remember thinking to myself, "but I know the one who did." With each round, the heat intensified as did the prayers, and I made it through. We exited for a potluck feast, which was markedly unspiritual. We offered a cake we had purchased at the grocery store, and I enjoyed my first taste of Zizania, wild rice harvested on the Great Lakes.

Healing: A Lakota Ritual (Taos, NM: Dog Soldier Press, 2002). For the latter, "open [and inclusive] self-expression is an affirmation of the dignity, integrity, and strength of the well-being of our people" (xiv).

[18] *The Canadian Encyclopedia*, s.v. "Anishinaabe," by Karl S. Hele, and Gretchen Albers, last edited July 16, 2020, www.thecanadianencyclopedia.ca/en/article/anishinaabe. Though spellings for this term abound, "[I]n the 1990s, this Indigenous People generally agreed that the spelling Anishinaabe was a closer approximation of a phonetic English spelling." Gregory Younging, *Elements of Indigenous Style: A Guide for Writing by and About Indigenous Peoples* (Edmonton, AB: Brush Education, 2018), 70.

The next day I found myself face to face with the altarpiece by Ojibwe artist Blake Debassige at the Anishinabe Spiritual Centre, which depicts Christ as a cosmic tree.[19] I had learned of the cosmology of the Mississippian Indians (c. AD 900–1500), for whom the above and below worlds were conjoined by an axial tree, and with the throughways between those worlds marked by crosses.[20] In a 2004 exhibition at the Art Institute of Chicago that attempted to disseminate knowledge of Mississippian art, the director lamented, "Why has knowledge of this early form of [Native North American] civilization failed to make its way more decisively into our public system of education and our sense of cultural heritage?"[21] Thanks to Debassige's painting, however, it finally had. Here ancient Native cosmology was not an artifact of a bygone era or an instance of a superseded worldview, but part of a living faith. I asked the Centre staff if they had any resources that put Christianity into conversation with Indigenous spirituality. They promptly produced a responsible, community-generated fusion of the Ignatian Exercises and Ojibwe prayer that now informs a course I teach,[22] which includes a visit to "the Ojibwe Jerusalem," Madeline Island.[23] "The

[19]For a description of this masterpiece of Christian and Ojibwe visual theology, see Christopher Vecsey, *The Paths of Kateri's Kin* (Notre Dame, IN: University of Notre Dame Press, 1997). He writes that Debassige's *Tree of Life* "portrays a cedar tree upon which Jesus is crucified, only in the image Jesus is within the tree; He *is* the tree; His body is the tree's trunk and he shared in the tree's medicinal properties" (232). See also the extensive reading of Debassige's *Tree of Life* in Ron Tourangeau, *Visual Art as Metaphor: Understanding Anishinabe Spirituality and Christianity* (Graduate Theological Union dissertation, 1989).

[20]See the drawing of the MACC (Mississippian Art and Ceremonial Complex) Cosmological Map in F. Kent Reilly III, "People of Earth, People of Sky: Visualizing the Sacred in Native American Art of the Mississippian Period," Richard F. Townsend, Robert V. Sharp, eds., *Hero, Hawk, and Open Hand: American Indian Art of the Ancient Midwest and South* (New Haven, CT: Yale University Press, 2004), 127.

[21]Townsend and Sharp, *Hero, Hawk, and Open Hand*, 6.

[22]The Anishinabe Spiritual Centre, Dorothy Regan, CSJ, director, *The Quest for Spiritual Wisdom: Naandaawaam Daaming Gi Jemanitou Nibwaakaawin* (Espanola, ON: Anishinabe Spiritual Centre, 2000).

[23]Mary Annette Pember, "Welcome to the Jerusalem for Ojibwe People," *Indian Country Today*, March 7, 2014, updated September 13, 2018, accessed April 13, 2021, http://indiancountrytoday .com/archive/welcome-to-the-jerusalem-for-ojibwe-people.

Christian religion is like a huge bridge across a boundless sea, which alone connects us with the men who made the world," said Chesterton on a journey to the more famous Jerusalem.[24] Thankfully, the insight is not site-specific.

There have been many more trips and experiences like that one in the course of writing this book, along with a temptation to leave G. K. Chesterton behind. After all, he visited North America twice, in 1921 and 1930, including visits to lands rich with Indigenous presence, places such as Oklahoma and Ontario. I have traced Chesterton's journeys, and then some, in my own travels. Along the way, I have wondered why a thinker so effusive about pre-Christian myth did not make the same connections on his visits to this continent. But instead of cataloging Chesterton's deeds,[25] or his misdeeds,[26] why not simply supplement his vision instead? If Chesterton taught me to see European Indigenous culture fulfilled in the churches of Thessaloniki, the same lesson can be applied to sweat lodges and Sun Dances as well. Or as Steven Charleston (Choctaw) puts it:

> If, in fact, the Jewish rabbi, Jesus of the first century, is truly Christ of the twenty-first century, then he must be transcendent of time and culture. He must be as much a part of the Native story as he is of the

[24]G. K. Chesterton, *The New Jerusalem* (New York: George H. Doran Company, 1921), 218.

[25]It is difficult to imagine how Ian Ker's magisterial biography could be surpassed. Ian Ker, *G. K. Chesterton: A Biography* (Oxford: Oxford University Press, 2011). Chapters 11 and 14 offer detailed accounts of Chesterton's North American journeys.

[26]For an extended critique of Chesterton's attitude toward Jews, see Simon Mayers, *Chesterton's Jews: Stereotypes and Caricatures in the Literature and Journalism of G. K. Chesterton* (self-pub., CreateSpace, 2013). For a defense, see Ann Farmer, *Chesterton and the Jews: Friend, Critic, Defender* (Brooklyn, NY: Angelico Press, 2015). Ian Ker (*G. K. Chesterton*, 420-24) concludes that Chesterton resisted racial anti-Semitism while not being innocent of his culture's anti-Jewishness.

story of any tribe or people. Consequently, we should be able to see his vision through lenses of Native American tradition as clearly as through European thought.[27]

After Chesterton's extensive travels in America, it was *he* who perceived a profound lack in his analysis. "I wish I had more space here to do justice to the Red Indians," he tells us.[28] That is what I aim to work toward here. This adaptation (as opposed to adulation) of Chesterton strikes me as necessary, lest North American fascination with figures like Chesterton, J. R. R. Tolkien, C. S. Lewis, Charles Williams, and Dorothy Sayers devolve into a self-serving Christian intellectual subscription to BritBox.[29] Instead of bewailing the limits of Chesterton's richly Christian vision of history, I aim therefore to extend it.

Chesterton's desire for a "homogeneous England" is evident.[30] "One can imagine," a sympathetic biographer suggests, "what [Chesterton's] reaction would have been to a multicultural England."[31] This book is one attempt to so imagine, and to suggest otherwise, but without leaving Christianity behind.[32] Such a project is possible only thanks to the wealth of scholarly material that has recently emerged, complicating the relationship of Indigenous culture and Christianity,

[27]Steven Charleston, *The Four Vision Questions of Jesus* (New York: Morehouse Publishing, 2015), 74.

[28]G. K. Chesterton, *What I Saw in America*, Collected Works 21 (San Francisco: Ignatius Press, 1990), 154. Blaming Chesterton for not using our more sensitive terminology to describe the First Nations is like complaining that a horse and carriage are unequipped with airbags. Obviously I will be updating his terms. Richard Twiss has a helpful terminology guide titled "What Should We Call You?" in *Rescuing the Gospel from the Cowboys: A Native American Expression of the Jesus Way* (Downers Grove, IL: InterVarsity Press, 2015), 239-41. Also, see Younging, *Elements of Indigenous Style*.

[29]As Alan Jacobs once quipped, "We don't need another C. S. Lewis as much as we need ten people doing the kinds of things that he did" (personal communication).

[30]Ker, *G. K. Chesterton*, 424.

[31]Ker, *G. K. Chesterton*, 424.

[32]Ralph C. Wood's *Chesterton: The Nightmare Goodness of God* (Waco, TX: Baylor University Press, 2011) is another, and more extensive, foray in this direction.

questioning popular stereotypes of evil missionaries and Indigenous victims.[33] Scholarly prejudice against Christian Indigenous material, sometimes deemed insufficiently "exotic" to White imagination, has led to major losses, making it important to highlight material that survives.[34] In lieu of a summary of this literature, which is woven throughout this study, material culture makes the point with particular force, whether the funeral remains of an eleven-year-old Pequot girl, buried around 1700 with a medicine bundle containing the skeletal remains of a bear paw and a fragment of Psalm 98,[35] or the illustrated vision of a Kiowa man named Fíqí (Eater), received

[33]"[Missionary] encounters could transform missionaries even as their missionary projects could transform the cultures of Native communities. Missionary encounters have led to the tragic loss of many Native languages; missionary encounters have also led, through the mechanisms and practices of literacy, to the retention of Native languages. Missionary encounters could eradicate tradition; they could also provide material for new articulations of those traditions. The encounters could introduce or exacerbate divisions in Native communities and families, fomenting disastrous results, if not violence; through those encounters could also emerge novel social networks and institutions around which fragmented Native peoples could restore their communities." Michael D. McNally, "Naming the Legacy of Native Christian Missionary Encounters," in *Native Americans, Christianity, and the Reshaping of the American Religious Landscape*, ed. Joel W. Martin and Mark A. Nicholas (Chapel Hill: University of North Carolina Press, 2010), 289. A Canadian extension of this scholarly project is on offer in Tolly Bradford and Chelsea Horton, eds., *Mixed Blessings: Indigenous Encounters with Christianity in Canada* (Vancouver: UBC Press, 2016). "In place of ... dichotomous depictions, scholars of Indigenous-Christian interaction ... have increasingly stressed Indigenous agency and explored how Christianity had, and continues to have, real meaning for many Indigenous people" (5).

[34]"By and large, to most twentieth-century scholars, Native Christianity remained relegated to eddies off the mainstream of scholarly production. As a consequence, important histories of exchange were ignored, compelling stories of individual and communal transformation went unnarrated, archival collections of incalculable value were untapped, and important primary texts written by Native Americans themselves remain unpublished." Martin and Nicholas, *Native Americans, Christianity, and the Reshaping of the American Religious Landscape*, 14.

[35]The discovery was made in 1990 in Massachusetts. The girl would have been buried sometime between 1683 and 1720. The verse reads, "The LORD hath made known his salvation: his righteousness hath he openly shewed in the sight of the heathen" (Ps 98:2 KJV). Linford D. Fisher, *The Indian Great Awakening: Religion and the Shaping of Native Cultures in Early America* (Oxford: Oxford University Press, 2012), 5-6.

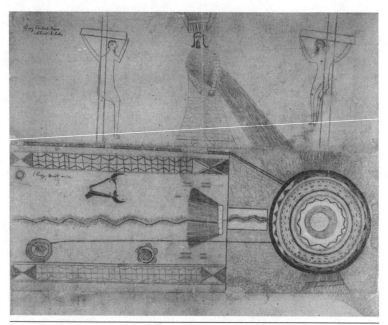

Figure I.1. Fíqí (Kiowa), Vision of Jesus between crosses blessing the Feather (Ghost) Dance collected by Smithsonian ethnologist James Mooney, c. 1890

during the revived Ghost Dance, of Christ blessing the ceremony himself (see fig. I.1).[36]

Over the last 150 years, White views of Native spirituality have shifted "from a shocked contempt for primitive superstition that verges on devil worship, to an envious awe for a holistic spirituality

[36]Jennifer Graber explains that this revival of the Ghost Dance, known in this case as the Feather Dance, emerged in Kiowa territory shortly after the suppression of the Ghost Dance at Wounded Knee. Jennifer Graber, *The Gods of Indian Country: Religion and the Struggle for the American West* (Oxford: Oxford University Press, 2018), 187-91. It was looked at with trepidation by Christian missionaries, and by some Native Christians themselves, and yet in the Ghost Dance Christ was repeatedly encountered, a fact also emphasized in Louis S. Warren's *God's Red Son: The Ghost Dance Religion and the Making of Modern America* (New York: Basic Books, 2017). The drawings were created because anthropologist James Mooney asked Eater and other leaders to "draw about his experience with sacred power" (Graber, *Gods of Indian Country*, 173).

that might be the last best hope for the human race."[37] Christianity has colored every point of this dizzying spectrum. Yet it is too often forgotten that secular admiration of Indians can be as patronizingly violent in "editing" Indigenous Christianity as Christian missionaries had once been in attacking Indigenous ceremonies.[38] The embarrassments of early Christian missionaries are real; but so is the appropriation and commercialization of Indigenous culture by the New Age movement at present.[39] While the fusion of Indigenous and New Age thought is a recent invention,[40] the fusion of Christianity and Indigenous North American culture is nearly five centuries old, and is vastly preferable to more recent uses of Indigenous culture to buttress "claims about lost continents and UFOs. . . ."[41] Tutored by Chesterton's humor, his taste for paradox, his love of legend and mythology, and his distrust of imperialism,[42] this book continues the age-old conversation between Christianity and Indigenous North American life.

Some readers might wonder how a Protestant Christian, which I happen to be, manages the ultramontane swagger of Chesterton's Catholicism. W. H. Auden's remarks on this score are hard to improve upon: "If [Chesterton's] criticisms of Protestantism are not very interesting, this was not his fault. It was a period when Protestant theology (and, perhaps Catholic too), was at a low ebb, Kierkegaard had not been

[37]Philip Jenkins, *Dream Catchers: How Mainstream America Discovered Native Spirituality* (Oxford: Oxford University Press, 2004), 2-3.

[38]John Collier's (1884–1968) blood and soil romanticization of Native Americans, including "the mystical ideas of *Volk* . . . translate painfully well into German." Jenkins, *Dream Catchers*, 89.

[39]Jenkins, *Dream Catchers*, chaps. 8, 9, and 10.

[40]Jenkins, *Dream Catchers*, 143. "Though presented as a record of traditional teaching, [Frank] Waters's (1902–1995) commentary transforms the *Book of the Hopi* into a survey and an overview of occult and esoteric teaching as it has flourished in the United States since the late nineteenth century" (163).

[41]Jenkins, *Dream Catchers*, 218.

[42]See "Chesterton the Postcolonial Theorist," in Luke Seaber, *G. K. Chesterton's Literary Influence on George Orwell: A Surprising Irony* (Lewiston, NY: Mellen, 2012), 340.

re-discovered and Karl Barth had not yet been translated."[43] Indeed, it may be that the Prince of Paradox underestimated Luther's Pauline paradox that so effectively describes the redeemed human condition, that of *simul iustus et peccator* (at the same time just and sinful).[44] But speaking of sin, few have considered how much Indigenous Americans suffered from competition among Protestants and Catholics on North American shores. In 1565, decades before Plymouth Rock, Jean Ribault visited the New World, establishing Fort Caroline near what is now Jacksonville, Florida. The first European artist to visit what is now America was on that mission, Jacques Le Moyne de Morgues (c. 1533–1588). He encountered the Timucuan people, producing valuable engravings of their lifeways, which he carefully observed.[45] And they, in turn, carefully observed European practices, soon witnessing 143 French Huguenots executed by Pedro Menéndez de Avilés, a pious Catholic. The inscription above the gallows read, "I do this not as to Frenchmen, but as to Lutherans."[46] When the Indians protested, "You killed fellow Christians, the French," the Spanish reply was simply, "They were bad Christians."[47]

Whatever is to be said about reports of cannibalism among Indigenous Americans, the French explorer Jean de Léry, who produced

[43]W. H. Auden, foreword, *G. K. Chesterton: A Selection from His Non-fictional Prose* (London: Faber & Faber, 1970), 17.

[44]For an attempt to charitably discern this "Protestant" theme in traditional Catholic and Orthodox art, see Matthew J. Milliner, "Visual Ecumenism: The Coy Communion of Art," in George Kalantzis and Marc Cortez, eds., *Come, Let Us Eat Together: Sacraments and Christian Unity* (Downers Grove, IL: InterVarsity Press, 2018), 124-49.

[45]Miles Harvey, *Painter in a Savage Land: The Strange Saga of the First European Artist in North America* (New York: Random House, 2008).

[46]Charles E. Bennett, *Fort Caroline and Its Leader* (Gainesville: University Press of Florida, 1976), 38. This killing was later avenged by a surprise French attack on the Spanish, and a sign above the gallows read, "Not as to Spaniards, but as to Traitors, Robbers, and Murderers" (49). For an account of the St. Augustine mission following such violence, see Robert L. Kapitzke, *Religion, Power, and Politics in Colonial St. Augustine* (Gainesville: University Press of Florida, 2001).

[47]Nicholas P. Cushner, *Why Have You Come Here? The Jesuits and the First Evangelization of Native America* (Oxford: Oxford University Press, 2006), 37.

similar reports on South American Indians, asserts that Europeans were worse. Hatred between Protestants and Catholics in France was so severe in the wake of the 1572 Saint Bartholomew's Day Massacre that one victim "was cut to pieces and displayed for sale to those who hated him, who wanted to grill it over coals to eat it, glutting their rage like mastiffs."[48] Such was the atmosphere in which competing Christian missions in the New World began, and in which they continued. "Many of the reasons why Native religions offended and irritated American Protestants—ritualism, fanaticism, clericalism, a veneration for sacred objects and places—have to be understood in the context of contemporary anti-Catholicism."[49] An unsavory, but perfectly typical, illustration of such polemics in full flair is on offer in competing cat-echetical ladder illustrations used by Catholic, and then Protestant, missionaries to Native Americans, each ridiculing their denomina-tional competitors with perfected visual spite.[50]

Sobered by these facts, I will not perpetuate internecine squabbles here. "We do not want churches because they will teach us to quarrel with God, as the Catholic and Protestants do," complained the Nez Perce chief Joseph (1840–1904). "We do not want to learn that."[51] And some of us now want to unlearn it.[52] I remain grateful for Chesterton's

[48]Jean de Léry, *History of a Voyage to the Land of Brazil*, trans. Janet Whatley (Berkeley: University of California Press, 1990), 132. The account was originally published in 1578. For an instructive caution not to imagine Native societies as any less war-torn, see Jen-kins, *Dream Catchers*, 220-22.

[49]Jenkins, *Dream Catchers*, 33. Also see "Protestant Rivalry" in Christopher Vecsey, *Where the Two Roads Meet* (Notre Dame, IN: University of Notre Dame Press, 1999), 20.

[50]Graber, *Gods of Indian Country*, 55-58.

[51]Daniel J. Sharfstein, *Thunder in the Mountains: Chief Joseph, Oliver Otis Howard, and the Nez Perce War* (New York: Norton, 2018), 165.

[52]Laurence Freeman offers just such a lesson centered in the Christian contemplative tradi-tion in *Jesus the Teacher Within* (New York: Continuum, 2000), 146-50. Moreover, his entire argument is surprisingly "Indigenous," based in land and animal life. "The resur-rection of Christian contemplative practices, *theoria physike* (natural contemplation), might open the modern Christian's 'inner eye' to the light shining through Native Ameri-can spirituality and the natural world." Donald P. St. John, "Paying His Debts to Native

reclamation of Christianity's essential contours in the face of a Protestant establishment that neglected them.[53] But "Christianity shattered on the shores of this continent," reminds Vine Deloria Jr.[54] Boasting, as Chesterton does, that the largest piece of a fractured vessel is intact is no argument that the vessel is unbroken.[55] That Indigenous persons drank from the Christian vessel still, and thereby transformed it, remains a marvel—even one of Christianity's grimmer "proofs."[56]

SUMMARY AND RATIONALE

My first chapter takes its cues from *The Everlasting Man* to examine not the cave paintings of Europe, as Chesterton did, but the Indigenous rock art of North America that is only recently coming to light. The Indigenous belief of the Underwater Panther (Mishipeshu) and Thunderbird (Animiki), so often depicted in rock art and mounds, emerges as the book's guiding motif; the former I connect to the process of settlement, the latter to Christ. Of course, when using Indigenous symbols, the thorny question of appropriation emerges. If anyone has come to this book wishing for an Indigenous description of these complex beings who inhabit the upper and lower realms, they have come to the wrong place. To understand these creatures and their symbolic contours on Native terms, I refer readers to Native

Americana Peoples: Thomas Merton on the 'Spiritual Richness of the Indian Religious Genius,'" in *Merton and Indigenous Wisdom* (Louisville: Fons Vitae, 2019), 140.

[53]For a coherent account of what it means to be a principled ecumenical Protestant today, see Phillip Cary, *The Meaning of Protestant Theology: Luther, Augustine, and the Gospel That Gives Us Christ* (Grand Rapids, MI: Baker Academic, 2019), esp. 12.

[54]Vine Deloria Jr., *God Is Red: A Native View of Religion*, 30th anniv. ed. (Golden, CO: Fulcrum, 2003), 143.

[55]I commend Ephraim Radner's *A Brutal Unity: The Spiritual Politics of the Christian Church* (Waco, TX: Baylor University Press, 2012) for an account of Christian division that takes the consequences of discord fully into account.

[56]When asked, after a talk at Wheaton College, why Black slaves embraced the religion of their oppressors, Willie Jennings responded, "Despised Black flesh was drawn to the despised Jewish flesh of Jesus." A similar dynamic may have been at work among Indigenous Americans.

persons themselves.[57] My Potawatomi contacts in particular were only comfortable with my proceeding with my interpretation insofar as that was made abundantly clear. I am borrowing these motifs not to define, reduce, or explain them,[58] but in order to drive home the realities of settlement and the presence of Christ among the First Nations, and even to illuminate my own psychology.[59] To be sure, this method has its risks, but the invitation to employ these symbols beyond the Native world has been extended.[60] My approach is certainly preferable, I hope, to the current options of popularizing these symbols in tourist attractions (the Hodag), automobiles (the Pontiac Thunderbird), or TV shows.[61]

It is also preferable, I hope, to the considerable risk taken by most North Americans by default: ignoring these symbols altogether. Put another way, I refuse to pass by depictions of Thunderbirds and Underwater Panthers that surround me without letting them deeply inform my life as a Christian. What Hugo Rahner said of classical culture applies to Native American culture as well: "All that is good

[57]The sensitive work of Theresa Smith is exemplary in its attentiveness to Indigenous descriptions of these beings. She is careful to avoid the suggestion that the two beings function as a Manichean view of the world where good and evil are paired off in equal combat. Smith, *Island of the Anishnaabeg*, 132. But Smith points out that they can also—supplemented by Ojibwe tripartite psychology—stimulate wider reflection on psychological wholeness, which anticipates the present book's conclusion as well.

[58]For an example of just that, and how such a reduction played into the process of settlement, see James Joseph Buss, *Winning the West with Words: Language and Conquest in the Lower Great Lakes* (Norman: University of Oklahoma Press, 2011), 110-17.

[59]For the dangers of using Indigenous culture as a "vehicle for [one's] own personal mythology," see Jenkins, *Dream Catchers*, 140. Still, when Selwyn Dewdney wondered what we should call Underwater Panthers, he was right to ask, "How does one name one's deepest, unspoken fears?" Smith, *Island of the Anishnaabeg*, 99.

[60]Kitty Bell, for example, sees "Ojibwe tradition not as a culturally bound belief system but as a potential contributor to a new world philosophy." Smith, *Island of the Anishnaabeg*, 194.

[61]In one episode of the television series *Grimm*, the Underwater Panther possesses Native American and African American men and women, and stalks White men. As will be seen, I am suggesting quite the opposite.

and true has proceeded from the Logos and has its homing-point in the incarnate God, even though this be hidden from us, even though human thought and human good-will may not have perceived it."[62] Or as an Ojibwe elder says in Ignatia Broker's novel *Night Flying Woman*: "Only time will tell if [Christianity] is the right thing for our people. If it is, then the people who wish us to be baptized will some day come to know the goodness that has been our life."[63] That overdue day has come. The Christian Thunderbird, long muffled and suppressed by European entitlement, is once more taking to flight.[64]

In the second chapter, I intend to contribute to the burgeoning regionalist literature of the Midwest[65] with what I am calling *penitent* regionalism. If Chesterton's localism adored the Notting Hill neighborhood of London, we can love our own homes wherever they are, but without forgetting the Indigenous cultures that came first. I hope in this exploration to have avoided the risk of romanticization that can emerge, sometimes unintentionally, when approaching Indigenous societies.[66] In *Guns, Germs, and Steel*, Jared Diamond famously explained how the accidents of geography and climate are what gave Europeans "more cargo."[67] "If [Indigenous] people had enjoyed the same geographic advantages as my people," he cheerfully explains, "[they] would have been the ones to invent

[62]Hugo Rahner, *Greek Myths and Christian Mystery* (New York: Biblo & Tannen, 1971), xiv.

[63]Ignatia Broker, *Night Flying Woman: An Ojibway Narrative* (St. Paul: Borealis Books, Minnesota Historical Society, 1983), 93.

[64]On the currents provided by Indigenous theologies such as Randy Woodley's *Shalom and the Community of Creation: An Indigenous Vision* (Grand Rapids, MI: Eerdmans, 2012). It is particularly exciting to see an Indigenous Bible translation: Terry M. Wildman, ed., *First Nations Version: An Indigenous Translation of the New Testament* (Downers Grove, IL: InterVarsity Press, 2021).

[65]Jon K. Lauck, *The Lost Region: Toward a Revival of Midwestern History* (Iowa City: University of Iowa Press, 2013).

[66]Jenkins, *Dream Catchers*, esp. chap. 7.

[67]Jared Diamond, *Guns, Germs, and Steel: The Fates of Human Societies*, 20th anniv. ed. (New York: Norton, 1999), 14.

helicopters."[68] Diamond neglects, at least in this upbeat documentary encapsulation of a complex thesis, to mention they might have been helicopters of war.[69] A Chestertonian perspective, ever cognizant of original sin ("the stone that the builder of Utopia rejected . . ."[70]), avoids that risk. In this respect, the American Indian Movement activist and convert to Christianity Richard Twiss offers a corrective: "If Natives had canoed across the Atlantic and discovered Europe, . . . we would have been no less ethnocentric and brutal than the Whites who came here from France, Holland, England, Spain, etc."[71] Still, it was the guns-, germs-, and steel-bearing settlers who, in any event, gained the upper hand and who now, in retrospect, bear responsibility to make amends. It may not have been the job of nineteenth-century frontier settlers, struggling for survival, to engage in the kind of investigation offered in this book; but it can be the job of settler descendants today. Twiss is right to add, "We must continually ask the Holy Spirit to anoint our hands with oil so we won't be able to hold on too tightly to the wrongs of the past."[72] But some of us, especially in the Midwest, have not even gripped the wrongs in the first place.

In the third chapter, I turn to one of Chesterton's neglected poems and evoke the Virgin Mary in a way that offsets some of the younger Chesterton's triumphalism, offering a Virgin that speaks to both settler and settled alike with the mystery of suffering love. Chesterton's bellicosity, his nostalgia for Christendom, and his satires of

[68]*Guns, Germs, and Steel*, based on the book by Jared Diamond, National Geographic documentary, July 11, 2005.

[69]For Diamond's extended exploration of non-Western societies, see *The World Until Yesterday: What Can We Learn from Traditional Societies?* (New York: Penguin, 2013).

[70]G. K. Chesterton, "On Original Sin," in *In Defense of Sanity* (San Francisco: Ignatius Press, 2011), 19.

[71]Richard Twiss, *One Church, Many Tribes* (Ventura, CA: Regal, 2000), 165. For an account of Twiss's conversion, see Twiss, *Rescuing the Gospel from the Cowboys*, 97-105.

[72]Twiss, *One Church, Many Tribes*, 165.

multiculturalism can be vicious. In *The Resurrection of Rome*, Chesterton runs into a person who suggests that "we may yet have a black Pope." Chesterton's reply was this: "In a spirit of disgraceful compromise I suggested meekly that (if not quite ready for that) I should be delighted to see a black Cardinal."[73] His ill attempt at humor on this occasion is off-putting to the extreme. If we remove these lines from their original context, impute ill motives, broadcast them to people unfamiliar with his work, we need not bother reading Chesterton at all. But it would be a mistake to say that Chesterton himself was not already overcoming his own prejudices, and, moreover, he knows it. "Then I remembered," the passage continues, "the great King who came to Bethlehem, heavy with purple and crimson and with a face like night; and I was ashamed."[74] There will be no apologies for Chesterton's obvious faults in this book. I will however be using the best in the later Chesterton to correct the worst. As one critic put it, he is too important a writer to be left to his mere admirers.[75]

Finally, Chesterton was confident enough in his own Englishness that he trashed his own family records, showing little interest in his ancestry.[76] But more than a few White explorers of Indigenous issues eventually realize, as I have, that examining the resources of one's own ancestry is preferable to siphoning someone else's.[77] This is why pursuing Indigenous matters with Chesterton, whose English heritage I share, is particularly important. As the beneficiary of a pattern of settlement with which I, and many North Americans, have yet to take

[73]G. K. Chesterton, *The Resurrection of Rome* (New York: Dodd, Mead, 1930), 320.
[74]Chesterton, *Resurrection of Rome*, 320.
[75]Tom Villis, "G. K. Chesterton and Islam," *Modern Intellectual History* 4 (2019): 1.
[76]Ker, *G. K. Chesterton*, 2.
[77]As one Indigenous person said to a White researcher like myself: "Dig into your own culture. Find what you need there and recover what has been lost. Don't consume our culture for what you need." Keith Starkenburg, "Falling and Standing: Learning a White Theology of Land in North America," *Journal of NAIITS: An Indigenous Learning Community, Une Communauté Autochtone D'Apprenstissage* 17 (2019): 129-30.

into full account, I have been prompted (by Chesterton!) to reconstruct my own unglamorous ancestry, including an unexpected connection to a central conflict on the American frontier. Hating my own Whiteness, however, remains a dead end. "His sickness was only part of something larger," says Leslie Marmon Silko of Tayo, the Indigenous protagonist in her novel *Ceremony*, "and his cure would be found only in something great and inclusive of everything."[78]

Thanks to such exploration, I have discovered that my wife and I are just as much guests on Turtle Island, a widespread Indigenous name for this continent, as we are respectively "Canadian" or "American." Acknowledging this hospitality, which comes with considerable humiliation, is a first step toward calling this land home. Chesterton protested that myth "cannot be properly judged by science; still less properly judged as science."[79] Moreover, "there are too many keys to mythology. . . . Everything is phallic; everything is totemistic; everything is seed-time and harvest . . . everything is everything."[80] He pleaded that we take such stories as the imaginative incantations that they are, and "imaginative does not mean imaginary."[81] Looking at the Turtle Island creation, or in some cases re-creation, story in that spirit, it is the humble muskrat who collects earth from the watery depths to establish this continent on the turtle's back.[82] The story might be

[78]Leslie Marmon Silko, *Ceremony* (1977; New York: Penguin Books, 2006), 116. Compare the great patristic Christian maxim of Gregory Nazianzus, "The unassumed is unhealed." As shall be seen in this book's conclusion, this involves going beyond "Whiteness" to much finer gradations of identity, just as it is necessary to go beyond pan-Indian approaches.

[79]Chesterton, *Everlasting Man*, 102.

[80]Chesterton, *Everlasting Man*, 103.

[81]Chesterton, *Everlasting Man*, 105.

[82]*The Canadian Encyclopedia*, s.v. "Turtle Island," by Amanda Robinson, last edited November 6, 2018, www.thecanadianencyclopedia.ca/en/article/turtle-island. For wider "Earth Diver" legends, see Robert A. Birmingham and Amy L. Rosebrough, *Indian Mounds of Wisconsin*, 2nd ed. (Madison: University of Wisconsin Press, 2017), 90. Some Indigenous thinkers argue that their myths be respected "as conveyors of a historical reality experienced or perceived by people of ancient times." Vine Deloria Jr., "Myth and

considered a fitting take on Christ's words that "the meek . . . will in-
herit the earth" (Mt 5:5); and it might also be considered a parable of
the settler's journey. It is a difficult plunge to touch the earth at last, to
hear the silenced stories this continent conspires to tell us. And in the
process, it cannot be forgotten, the muskrat dies, as perhaps part of us
must as well.

the Origin of Religion," in *Spirit and Reason: The Vine Deloria, Jr., Reader*, ed. Barbara
Deloria, Kristen Foehner, and Sam Scinta (Golden, CO: Fulcrum, 1999), 352. Chester-
ton's view is in line with the more common Indigenous perspective that respects myth
in a different way, "as symbolic and nonhistorical, just as nonfundamentalist Christians
commonly understand the chronology of the book of Genesis." Jenkins, *Dream Catchers*,
212. Chesterton's chief target was those who did not respect myth at all.

1

THE SIGN OF JONAH

The majority of these people, the Native American survivors of ethnic cleansing, were Christian.

STEVEN CHARLESTON (CHOCTAW)

Metaphor is largely in use among these Peoples; unless you accustom yourself to it, you will understand nothing.

REVEREND FATHER PAUL LE JEUNE,
NEW FRANCE, 1636

All men live by tales.

G. K. CHESTERTON

CONTINENTAL POWERS

Toward the end of the 1900s, in a town called Haddonfield in southern New Jersey, a group of mostly White high school students heard the good news of the Christian gospel. God, we discovered in a top-floor recreation room filled with secondhand couches, was *for* us, not against us. I wasn't sure the friends I had managed to string together were for me, nor was I necessarily for them. I'm not even sure I was for myself. But Christ, we learned through this youth group attached to a mainline Methodist church, was for us. The cosmos we inhabited, hitherto puzzling and possibly hostile, suddenly became hospitable and radiant. Thanks to intensive Bible study, the considerable gaps in my nominal understanding of Christianity were rectified in a matter of months.

The older adults in the church to which our youth group was appended may have looked at the fervor of our youth group with some concern. We knew this but did not care. We feasted on the books and cassette tapes on offer at the Good News Bible bookstore, we handed out tracts of the Four Spiritual Laws on the Jersey Shore boardwalk, and we canvassed door to door for the 1992 Billy Graham Crusade in Philadelphia. Seeking a deeper spirituality, we were introduced to Quaker books like Thomas Kelly's *Testament of Devotion*.[1] Seeking a name for what happened to us, we learned somewhere along the way it was called evangelicalism, but the name was not that important.

Over two centuries before that youth group, in the same land, there was a similar series of conversions. These converts would have known the land not as New Jersey but as Turtle Island,[2] and they called themselves the Lenni Lenape.[3] It is a term of humility that simply means "common people."[4] They were also called the Delaware, after an English politician, the third Baron De La Warr. The Lenape, or Delaware, also learned that God was for them. They were not sure the neighboring Haudenosaunee (a.k.a. Iroquois) were for them, still less the colonists. But Christ, they learned through the Quakers, and later through missionaries like David and John Brainerd and the Moravian David Zeisberger, was *for* them.[5] These missionaries became primary recorders of their lifeways.[6] Some historians have a word for the successful tactics

[1]Thomas R. Kelly, *A Testament of Devotion* (New York: Harper & Brothers, 1941).

[2]Lenape seemed to have been among the first to use the term. Jay Miller, "Why the World Is on the Back of a Turtle," *Man*, n.s., 9, no. 2 (1974): 306-8.

[3]Carl Waldman, s.v. "Lenni Lenape," *Encyclopedia of Native American Tribes*, 3rd ed. (New York: Checkmark Books, 2006).

[4]William A. Young, *Quest for Harmony: Native American Spiritual Traditions* (Indianapolis: Hackett, 2002), 62. Young's book offers a helpful overview of the Lenape spiritual traditions and those of many other nations as well.

[5]George D. Flemming, *Brotherton: New Jersey's First and Only Indian Reservation and the Communities of Shamong and Tabernacle That Followed* (Medford, NJ: Plexus, 2005).

[6]David Zeisberger "was fluent in German, Dutch, English, Mohawk, and Delaware, and understood Onondaga and Shawnee." Hermann Wellenreuther and Carola Wessel, eds.,

employed by these ministers, and it is the same word used to describe my youth group: evangelicalism.[7] The catechetical efforts of some previous missionaries, insufficiently connected to Lenape lifeways and thought, were rectified in a matter of months.[8] Establishment Presbyterians looked at these missionaries and their new converts with suspicion.[9] The Lenape knew this but did not care. The cosmos they inhabited, presided over by the one they called "The Master of Life" but by malevolent forces as well, became more hospitable and radiant. These Lenape did not need to become English in receiving Christianity any more than I, when choosing Christ for myself, needed to become Lenape.[10] The missionaries defended the Lenape from settler hostilities,[11]

The Moravian Mission Diaries of David Zeisberger, 1772–1781, trans. Julie Weber (University Park: Pennsylvania State University Press, 2005), 73. Zeisberger's *History of the Northern American Indians* was finally published in 1910.

[7]"Moravians . . . were key players in the rise of international evangelicalism." Katherine Carté Engel, *Religion and Profit: Moravians in Early America* (Philadelphia: University of Pennsylvania Press, 2009), 1. An examination of David Zeisberger's "extraordinarily Christ-centered" method shows it to be squarely in line with accepted historical definitions of evangelicalism (Wellenreuther and Wessel, *Moravian Mission Diaries*, 55). For a well-considered definition of *evangelical*, see Timothy Larsen, "Defining and Locating Evangelicalism," in *The Cambridge Companion to Evangelical Theology*, ed. Timothy Larsen and Daniel J. Treier (Cambridge: Cambridge University Press, 2007), 1.

[8]John Howard Smith points in particular to the Moravian emphasis on blood, dreams, and wounds to account for their success. J. H. Smith, *The First Great Awakening: Redefining Religion in British American, 1725–1775* (Madison, NJ: Fairleigh Dickinson University Press, 2015), 257. New Siders like Gilbert Tennent and Jonathan Dickinson eventually criticized the Moravian theology (Smith, *First Great Awakening*, 166). The Quakers, of course, enjoyed considerable success as well, criticizing Brainerd's emotional methods (Flemming, *Brotherton*, 33). As ever, evangelicals did not get along.

[9]In 1741 the Old Lights, of Scotch and Irish heritage and inclining to a more settled orthodoxy, ejected the New Lights who employed these emotional methods, resulting in the Old Side and New Side Presbyteries, respectively. This event is known as the "New Light Schism." W. A. Hoffecker, "New Light Schism," in *Evangelical Dictionary of Theology*, ed. Daniel J. Treier and Walter A. Elwell, 3rd ed. (Grand Rapids, MI: Baker Academic, 2017), 590. For more accounts of New Light success among Indigenous persons, see Linford D. Fisher, *The Indian Great Awakening: Religion and the Shaping of Native Cultures in Early America* (Oxford: Oxford University Press, 2012), 69.

[10]"Statutes and Rules" of the missions "did not mandate that converted Indians had to give up their former way of life." Wellenreuther and Wessel, *Moravian Mission Diaries*, 67.

[11]Flemming, *Brotherton*, 37-40.

until at last "the relentless forces of colonialism undermined [their] village world and Christian Indian community."[12] In high school and graduate school in New Jersey I was educated right next to the successful Brotherton (1746) and Bethel (1758) Lenape missions established by David and John Brainerd, respectively. Though I learned all about Christian missions in Europe, nary a word was breathed about the efforts that took place just miles away.

Christianity for me meant considerable success. My new faith took me halfway across the United States, through Pennsylvania, Ohio, and Indiana (where I was born), to a place called Wheaton College in Illinois. While at Wheaton, I went north to Wheaton's campus in the Wisconsin wilderness, where I sought God in solitary prayer. The beauty of this land hosted my newfound faith without hindrance or obstacle. I married a woman from Ontario and learned a new branch of the Great Lakes landscape. After a stint at ministry in Pennsylvania and more graduate school in New Jersey, I ended up back at Wheaton College, where I am today. Christianity has been good for me.

But Christianity was not as good for the Delaware converts. Lenape conversion to evangelical Christianity offered no protection from the tide of settlement. The Lenape had already learned that the sons of William Penn were not as kind as their father. Though they had made a covenant of friendship with Penn, sealed with crosses no less (see fig. 1.1), in 1737 the Lenape were deceived out of more land than they could have imagined in the Walking Purchase.[13] The Lenape leader and Moravian convert Teedyuscung (c. 1700–1763) remarked, "This very ground that is under me was my land and

[12]Julius H. Rubin, *Tears of Repentance: Christian Indian Identity and Community in Colonial Southern New England* (Lincoln: University of Nebraska Press, 2013), 194.
[13]Suzan Shown Harjo, ed., *Nation to Nation: Treaties Between the United States and American Indian Nations* (Washington, DC: Smithsonian Books, 2014), 63.

Figure 1.1. Lenape (Delaware) "Penn" wampum belt (c. 1682) presented by Lenape leaders to William Penn as part of a land agreement and treaty of friendship

inheritance, and is taken from me by fraud."[14] I enjoyed the same land as a playground for Christian ski weekends. In Easton, Pennsylvania, the same area where David Brainerd first preached to the Lenape, I attended a 1992 retreat to build up my newfound faith. Also in Easton, the Delaware made a 1758 agreement with the English to cede more land, but the promises made there were broken as well.[15] I drove happily and obliviously through Ohio on my way to college. The Moravian Lenape were pushed there, where they were caught between British and American military forces. In 1782 the Pennsylvania militia met them at their settlement known as Gnadenhutten, "tents of grace." American militiamen, falsely believing these Christian Indians had taken part in raids, voted to execute them.[16] This was not the fever pitch of battle. The Americans thought it over. The Christian Lenape, mostly women, children, and elderly men, requested the night for prayer, which was granted. And in the morning ninety-six of them "were beaten to death with mallets and hatchets, and scalped" as they sang Christian hymns.[17] What was left of them was buried in a mound reminiscent of the great Ohio Native mounds from centuries before (see fig. 1.2).

[14]Young, *Quest for Harmony*, 73. For Teedyuscung's conversion, see Smith, *First Great Awakening*, 257.

[15]If the Lenape and Haudenosaunee agreed not to join the French, they were promised the land of Ohio. *The Canadian Encyclopedia*, s.v. "Easton Treaty," by Anthony J. Hall and Gretchen Albers, last edited November 6, 2020, www.thecanadianencyclopedia.ca/en /article/easton-treaty.

[16]Chris Flook, *Native Americans of East-Central Indiana* (Charleston, SC: History Press, 2016), 99.

[17]Flook, *Native Americans*, 100-101.

Figure 1.2. Site of the 1782 Gnadenhutten Massacre, Gnadenhutten, Ohio

As settlers moved in, the Christian Delaware were pushed farther out. At the Treaty of Greeneville in 1795 they were deprived of their place in southern Ohio and moved to the White River in Indiana.[18] Understandably, Christianity was growing less popular among the Lenape in these distressed times, yet one Mohican convert among them named Joshua managed to hold onto his faith—even though two of his teenage daughters had been killed at the Gnadenhutten massacre. But whereas the White man had gone after his fellow Christian believers at Gnadenhutten, it was the Lenape themselves who came after Joshua. A series of Indian prophets arose that preached a gospel of racial separation. Demanding a return to Native lifeways, they sought to purge Delaware culture of Christian influence. But Joshua was not deterred. After professing his faith in Christ, the sixty-four-year-old Joshua, along with several other Christian Indians, was killed and burned.[19] Even then,

[18]Mary Stockwell, *The Other Trail of Tears: The Removal of the Ohio Indians* (Yardley, PA: Westholme, 2014), 133.

[19]Rachel Wheeler reports that his murderers considered it miraculous that his body "was scarcely singed after two hours, prompting the gathered Indians to stoke the fire even

many Christian Delaware held onto their faith. The descendants of these Moravian "praying Indians," the Stockbridge-Munsee Mohicans, many of them still proudly Christian, have taken up residence along the road that I had happily traveled on my way to camp in Wisconsin. They were granted American citizenship in 1843.[20] Not surprisingly, the prize object on display in their heritage center is an eighteenth-century Bible, finally returned to them by a Massachusetts museum in 1991. "While they held the big Book in one hand, in the other they held murderous weapons," complained one Delaware chief, referring to the Bible and to the tactics of colonization.[21] And yet others among the same Delaware embraced this book "to oppose forces of destruction, to defend Native American communities, and to strengthen Native American sovereignty, in spite of the odds."[22]

Also on my way to camp I drove past the headquarters of the Brothertown Indian Nation (sometimes spelled Brotherton), whose members were granted US citizenship in 1839. They also descend from the evangelical "praying Indians."[23] Another settlement of the Christian Lenape diaspora barely survives in Ontario: the Delaware Nation at Moraviantown near Thamesville. My wife and I unknowingly passed

hotter: Not until the following morning was Joshua's body reduced to ashes." Rachel Wheeler, *To Live upon Hope: Mohicans and Missionaries in the Eighteenth-Century Northeast* (Ithaca, NY: Cornell University Press, 2008), 239.

[20]Some almost immediately attempted to revoke their newfound citizenship as it led to unforeseen disadvantages. David J. Silverman, "To Become a Chosen People: The Missionary Work and Missionary Spirit of the Brotherton and Stockbridge Indians, 1775–1835," in *Native Americans, Christianity, and the Reshaping of the American Religious Landscape*, ed. Joel W. Martin and Mark A. Nicholas (Chapel Hill: University of North Carolina Press), 266-67.

[21]Young, *Quest for Harmony*, 78.

[22]Martin and Nicholas, *Native Americans, Christianity, and the Reshaping of the American Religious Landscape*, 3.

[23]Jarvis argues that the Brothertown story is not a story of assimilation but a story of creation and preservation. Brad D. E. Jarvis, *The Brothertown Nation of Indians: Land Ownership and Nationalism in Early America, 1740–1840* (Lincoln: University of Nebraska Press, 2010), 11.

it many times as we drove from Wheaton to visit her family home. I say it barely survives because in 1813, after the Battle of the Thames, William Henry Harrison and his troops burned this Moravian Indian village (Fairfield) to the ground, almost as if to suggest that America's beef with evangelical Indians was personal.[24] Still, these Indians remain.

I hope it is clear by now that my autobiographical comments are not an excuse for self-indulgence but a means of self-examination. The landscape from New Jersey through Pennsylvania, Ohio, Indiana, Wisconsin, and Ontario—as well as Oklahoma and Kansas, where I have traveled to write this book—is the dumping ground for any re-maining Lenape Christians who managed to survive my country's at-tempts to destroy them. On my one visit to the Delaware north of Anadarko, Oklahoma, I attempted to contact the nation. They showed me their sacred drum, which was as close as I could get to the heartbeat that White settlement has attempted to stop.[25] G. K. Chesterton spoke often about appreciating our own homes, showing gratitude for the places where we live. But when I try to do this, the truth does little to amplify the comfort of my Wheaton home on Harrison Avenue—in all likelihood named after the general.[26]

[24]John P. Bowes, *Land Too Good for Indians: Northern Indian Removal* (Norman: Univer-sity of Oklahoma Press, 2016), 102. This accords with the Delaware Nation's own ac-count: After the death of Tecumseh, "a group of American soldiers burned Fairfield to the ground that same day, accusing the Lunaapeew [Lenape] of sheltering British soldiers and holding Americans prisoner." "About Us," Eelünaapéewi Lahkéewiit: Dela-ware Nation, delawarenation.on.ca/about, accessed March 9, 2021. Sandy Antal sug-gests the burning "may have partly been motivated by revenge." *A Wampum Denied: Procter's War of 1812* (Ottawa: Carleton University Press, 1997), 355. Harrison "refused the Moravians' restitution for material losses, declaring Moraviantown 'an English garrison town'" (356).

[25]Until, that is, the experience I relate in this book at the end of chapter three.

[26]"More than any one man," concludes David Curtis Skaggs, Harrison ("Old Tip") "em-bodied the United States' effort to wrest control of the territory between the Ohio River and the Great Lakes from both the Indians and the British." Even so, in retirement, "the ghosts of things done and undone continued to haunt him." *William Henry Har-rison and the Conquest of the Ohio Country: Frontier Fighting in the War of 1812* (Balti-more: Johns Hopkins University Press, 2014), 245. Skaggs's study reproduces the gold

What are we to make of this strange contrast between two recep-
tions of the same Christian gospel: my own that led to success and
that of the Lenape, which led to martyrdom? At least one thing
seems clear to me: that there are more spirits at work on this con-
tinent than the Holy Spirit. If Christianity alone were at work in this
landscape, then the Lenape and I would have received similar
treatment, and our reception of the gospel in this land would have
mirrored the vision of the New Testament where all tongues, tribes,
and nations are welcomed into the kingdom. As it happens, the con-
version of these original people registered no change in their
treatment at all.[27] Why? Because other malevolent forces were at
work.[28] The Lenape and many other Indigenous peoples intuited
those dangerous powers, even painting them on caves, rock faces,
and birch-bark scrolls.[29] This chapter is simply an attempt to suggest
they were right.

"RED AUTHORITY"

When ancient cave paintings were first discovered in Europe,
G. K. Chesterton was baffled that this did nothing to uproot stubborn
ideas about the primitive "cave-man." These paintings alone could
have broken the European addiction to facile notions of progress if
only they could honestly be seen. Chesterton's approach was to connect

medal Congress produced to commemorate Harrison's victory at Fort Meigs and the
Battle of the Thames, which was followed by the burning of the Moravian Delaware
town of Fairfield (239).

[27]David J. Silverman, *Red Brethren: The Brothertown and Stockbridge Indians and the Prob-
lem of Race in Early America* (Ithaca, NY: Cornell University Press, 2015), 77.

[28]As Silverman explains in regard to Christian Indians of Brotherton and Stockbridge, "a
people's race, not their Christianity, civility, or political loyalties, determined whether
they would enjoy a place in the burgeoning white man's republic." Silverman, "To Be-
come a Chosen People," 264.

[29]On Lenape understanding of the underwater spirit that is the focus of this essay, see
Selwyn H. Dewdney, *The Sacred Scrolls of the Southern Ojibway* (Toronto: University of
Toronto Press, 1975), 128.

the art of the past with the present: "The brotherhood of men is even nobler when it bridges the abyss of ages than when it bridges only the chasm of class."[30] Chesterton was savage with the stereotype of the savage:

> We do know for a fact that the cave-man did these mild and innocent things; and we have not the most minute speck of evidence that he did any of the violent and ferocious things. In other words the cave-man as commonly presented to us is simply a myth or rather a muddle; for a myth has at least an imaginative outline of truth.[31]

These paintings offered an equivalent to the Big Bang theory in terms of human consciousness—an inexplicable explosion of awareness confirmed by more recent research,[32] and applicable to reductive theories in Chesterton's time or our own:

> What would be . . . the simplest lesson of that strange stone picture-book? . . . That he had dug very deep and found the place where a man had drawn the picture of a reindeer. But he would dig a good deal deeper before he found a place where a reindeer had drawn a picture of a man. . . . This creature was truly different from all other creatures; because he was a creator as well as a creature.[33]

If rock art is evidence for human uniqueness, then recently published Midwestern rock art should be at least as exciting as the discoveries to which Chesterton responded. As we try to make sense of the ambitious paintings and carvings in Missouri, Wisconsin, Minnesota, and Ontario, Chesterton, who revels in the mystery of

[30]G. K. Chesterton, *The Everlasting Man* (1925; repr., San Francisco: Ignatius Press, 1993), 32.

[31]Chesterton, *Everlasting Man*, 30.

[32]"Art came with a bang as far as the archeological record is concerned. There is nothing to foreshadow its emergence, no sign of crude beginnings." John E. Pfeiffer, *The Creative Explosion: An Inquiry into the Origins of Art and Religion* (Ithaca, NY: Cornell University Press, 1982), 11.

[33]Chesterton, *Everlasting Man*, 33.

human creativity without too quickly attempting to decipher a meaning, continues to be relevant. "The historian must take [such art] . . . for granted," he tells us. "It is not his business as a historian to explain it."[34] Interestingly, Lakota folklorists say the same things about North American Indigenous imagery. "Unexplainable things belong only to Taku Waken [Holy Mystery]," they tell us regarding these images.[35] Black Elk, rebuking the White man's curiosity, simply says, "It is a mystery."[36] But it is one we can still reverently explore. There are even passages where Chesterton expressly tells us that, when it comes to Native myths and legends, to go to Native peoples first. "When [the Professor] is assured . . . on the best Red Indian authority, that a primitive hero carried the sun and moon and stars in a box, unless he clasps his hands and almost kicks his legs as a child would at such a charming fancy, he knows nothing about the matter."[37] Yes, I wish Chesterton did not use the term "Red Indian" in that sentence, and I quite realize that Native myths are not child's play, but in comparison to reductive readings,[38] Chesterton's fundamental insight is correct. When newer scholarship leaps toward

[34]Chesterton, *Everlasting Man*, 38.

[35]Linea Sundstrom, *Storied Stone: Indian Rock Art in the Black Hills Country* (Norman: University of Oklahoma Press, 2005), 40.

[36]Sundstrom, *Storied Stone*, 42.

[37]Chesterton, *Everlasting Man*, 101.

[38]David Lewis-Williams's contributions to rock art research are essential, but by his own admission he "can think of no other way to explain [the parallels between contemporary shamanic reports and ancient rock art than] that they are the product of the universal human nervous system in altered states of consciousness, culturally processed but nonetheless still recognizably deriving from the structure and electro-chemical functioning of the nervous system." *The Mind in the Cave: Consciousness and the Origins of Art* (London: Thames & Hudson, 2002), 170. A more expansive perspective concedes the obvious function of the nervous system in any shamanic experience, but goes beyond that as well. For a delightful exposure of the limits of neuroscientific reductionism, see David Bentley Hart, *The Experience of God: Being, Consciousness, Bliss* (New Haven: Yale University Press, 2013), 152-237. For a neuroscientist's approach to artmaking that avoids reductionism, see Anjan Chatterjee, *The Aesthetic Brain: How We Evolved to Desire Beauty and Enjoy Art* (Oxford: Oxford University Press, 2015).

reductive meanings, Chesterton's hand clasping and leg kicking are to be preferred.

HODAGS ARE REAL

As it happens, I think Native rock art gives us an image that will help us hold the uncomfortable truth of what happened to the Lenape, and to so many Indigenous peoples, in our minds. Preeminent in rock-art motifs is the Underwater Panther, the Great Lynx, Piasa, or Mishipeshu (*Mishibizhiw* in Ojibwe), described less felicitously by some researchers as the BWS (Beneath World Spirit).[39] These images can be found at Agawa Rock in Canada on Lake Superior; in Picture Cave, Missouri; or throughout Wisconsin.[40] They are interpreted in a variety of ways, but rarely are these beings good. Most Indigenous traditions say they cause harm,[41] and most scholars insist they be interpreted dynamically, allegorically, symbolically—which I aim to do here.[42] Mishipeshu is not a generic category of beast that we could find in a zoo.[43] According to Ojibwe elder Fred Pine, they were "not created by the Holy Spirit."[44] Often they represent death.[45] Other Indigenous persons

[39] F. Kent Reilly III, "The Cave and the Beneath World Spirit: Mythic Dragons from the North American Past," in *Picture Cave: Unraveling the Mysteries of the Mississippian Cosmos*, ed. Carol Diaz-Granados, James R. Duncan, and F. Kent Reilly III (Austin: University of Texas Press, 2015), 134.

[40] Geri Schrab and Robert F. Boszhardt, *Hidden Thunder: Rock Art of the Upper Midwest* (Madison: Wisconsin Historical Society Press, 2016).

[41] Schrab and Boszhardt, *Hidden Thunder*, 19.

[42] "A literal approach was incapable of understanding the native style of thinking, subtle, indirect and highly allegorical, the more so when the concept was focus of fear at more than one level." Dewdney, *Sacred Scrolls*, 124.

[43] Alan Corbiere and Mikinaak (Crystal) Migwans, "Animikii miinwaa Mishibizhiw: Narrative Images of the Thunderbird and the Underwater Panther," in *Before and After the Horizon: Anishinaabe Artists of the Great Lakes*, ed. David W. Penney and Gerald McMaster (Washington, DC: Smithsonian Books, 2013), 47.

[44] Thor Conway, *Discovering Rock Art: A Personal Journey with Tribal Elders* (self-pub., Thor Conway, 2016), 184.

[45] Gerald McMaster, "The Anishinaabe Artistic Consciousness," in Penney and McMaster, *Before and After the Horizon*, 86.

I have spoken with would dispute these characterizations. And yet, one recent scholar describes White dismissals of these lake monsters as a tactic both to flaunt superior scientific knowledge and to "dislodge Native connections to lands they sought to conquer."[46] And now, the relegation of these monsters to the quirky annals of "Weird U.S.," charming as such regional pride might be, may perpetuate that condescension.

Chesterton understood this. "If we have called the first sort of [benign] mythology the day-dream," he tells us, "we might very well call the second sort of mythology the nightmare."[47] But I don't just want to connect that nightmare with aspects of Indigenous culture, but also with my own culture, because for the original inhabitants of this land, the nightmare was us. Indeed, there are reports that Native Americans considered settlers to be underwater beings upon first contact.[48] In Canada, the British in particular, with the lions in their heraldry, were regarded by the Ojibwe as "malignant manitou" (i.e., Underwater Panthers), and for Indigenous persons faced with ethnocide, those reports were not wide of the mark.[49] Morrisseau tells us that the Mishipeshu "lived away from the eyes of the white man," and that they stole Indigenous babies.[50] We might be tempted to ask, Do

[46]James Joseph Buss, *Winning the West with Words: Language and Conquest in the Lower Great Lakes* (Norman: University of Oklahoma Press, 2011), 115.

[47]Chesterton, *Everlasting Man*, 116.

[48]George R. Hamell, "Trading in Metaphors: The Magic of Beads," in *Proceedings of the 1982 Glass Trade Bead Conference* (Rochester, NY: Rochester Museum and Science Center, 1983), 5-28, cited in Janet Catherine Berlo and Ruth B. Phillips, *Native North American Art*, 2nd ed. (Oxford: Oxford University Press, 2015), 105.

[49]Theresa S. Smith, *The Island of the Anishnaabeg: Thunderers and Water Monsters in the Traditional Ojibwe Life-World* (Lincoln: University of Nebraska Press, 1995), 99. Compare these words: "If the white people never looked beyond the lie, to see that theirs was a nation built on stolen land, then they would never be able to understand how they had been used by the witchery. . . . The lies devoured white hearts." Leslie Marmon Silko, *Ceremony* (1977; New York: Penguin Books, 2006), 177-78.

[50]Norval Morriseau [*sic*], *Legends of My People: The Great Ojibway*, ed. Selwyn Dewdney (Toronto: Ryerson Press, 1965), 25, 32.

underwater panthers really steal babies? If we see the removal of Native children from their families by the American and Canadian governments as the Mishipeshu in action, the answer is a definite yes.[51] Chesterton viewed horned serpents triumphantly as an image for indestructible Catholicism: "Its horns and tiaras were like the horns or crests of antediluvian creatures."[52] But I choose to interpret this monster as something much less benign, applying another of Chesterton's insights: "Human Christianity in its recurrent weakness was sometimes too much wedded to the powers of the world."[53]

When the Jesuit missionary Father Jacques Marquette canoed the Mississippi River in 1673, near what is now Alton, Illinois, he saw a Mishipeshu—or at least a depiction of one.[54] The original is lost, but a recent copy of what it might have looked like, made by local residents, can be seen on the site today (see fig. 1.3). Marquette described the image in his journal. "Good painters in [F]rance would find it difficult to paint so well," he tells us.[55] We would be right to read

[51] Another monster from Native mythology (separate from the Mishipeshu) is the Wiindigo, "often used to refer to colonialism and its capitalist manifestations, particularly around natural resources." Leanne Betasamosake Simpson, *Dancing on Our Turtle's Back: Stories of Nishnaabeg Re-creation, Resurgence, and a New Emergence* (Winnipeg, MB: Arp Books, 2011), 70.

[52] Chesterton, *Everlasting Man*, 257.

[53] He adds, "But if it was wedded it has very often been widowed. It is a strangely immortal sort of widow." Chesterton, *Everlasting Man*, 257. Christianity, needless to say, will outlive its marriage to what is often called "Whiteness."

[54] An earlier draft of the following section was published in Matthew J. Milliner, "Turtle Island Renaissance," *Journal of NAIITS: An Indigenous Learning Community* 16 (2018): 129-31.

[55] Jacques Marquette, *Voyages of Marquette*, in *Jesuit Relations* 59 (Ann Arbor, MI: University Microfilms, 1966), 141. This approach to Indigenous art made an impact in Europe beyond Marquette's journals. The Jesuit Father Louis Nicholas provided a catalog of Great Lakes Native art in *Codex canadensis*, composed around 1700. Speaking of porcupine embroidery, he writes, "a thousand fine designs are seen on these objects. The natives esteem these works highly, and to tell the truth they are considered very fine in France." These should be seen not as isolated survivals but as representations of an impossibly vast canvas of the continent. Ruth B. Phillips, "Things Anishinaabe: Art, Agency, and Exchange Across Time," in Penney and McMaster, *Before and After the Horizon*, 55.

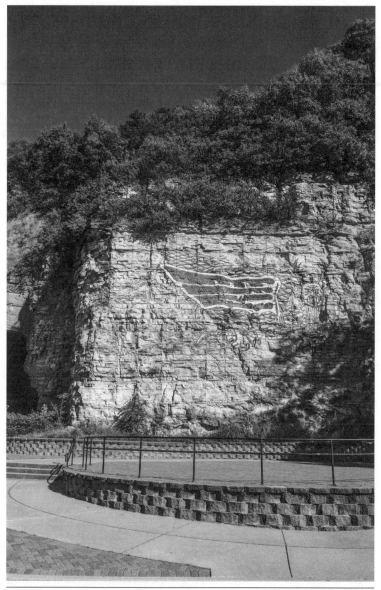

Figure 1.3. Modern evocation of the original Piasa pictograph seen by Jacques Marquette, Alton, Illinois

admiration in this European description. As one recent scholar suggests, Marquette "spent the majority of his narrative describing not how he took possession of the Illinois, but rather how the Illinois ceremoniously took possession *of him*."[56] These were the Jesuits who are on record weeping in relief, not when Native persons became French but when they worshiped Christ in their own way, namely, by sprinkling powdered tobacco over a crucifix.[57] But the Mishipeshu was hovering, and when Marquette witnessed it, he saw an image of what was to be.[58]

A few decades later, not far from the site of the painted Mississippi bluffs, things looked much different. In 1699 at what remained of the great pre-Columbian civilization of Cahokia, two ways of being Christian clashed.[59] Marc Bergier, a priest of the Seminary of Foreign Missions, attempted to steal the Illini language dictionary from the possession of the Jesuit priest Julien Binnetau. The incident escalated into an international controversy—it was even discussed at the court of Versailles. The new strategy of *Frenchifying* (literally, *francization*) was quickly eclipsing efforts to create a Christianity "*on the Illinois' own terms*."[60] Which is to say that France—through the person of Bergier—had finally caught up with this potentially Indigenous

[56]Robert Michael Morrissey, "The Terms of Encounter: Language and Contested Visions of French Colonization in the Illinois Country, 1673–1702," in *French and Indians in the Heart of North America: 1630–1815*, ed. Robert Englebert and Guillaume Teasdale (East Lansing: Michigan State University Press, 2013), 50.

[57]Christopher M. Parsons, "Natives, Newcomers, and *Nicotiana*: Tobacco in the History of the Great Lakes Region," in Englebert and Teasdale, *French and Indians*, 32.

[58]The embroilment of French Jesuit missions in the agenda of New France is explored at book length in Bronwen McShea, *Apostles of Empire: The Jesuits and New France* (Lincoln: University of Nebraska Press, 2019). It is interesting that Marquette is only briefly mentioned in this study, perhaps indicating that he was less illustrative of the mixed motivation of mainstream Jesuit missions.

[59]Morrissey, "Terms of Encounter," 43. This sad event was not a singular episode but the culmination of a series of confrontations in which these two priests tried to sabotage each other's ministries.

[60]Morrissey, "Terms of Encounter," 44; see also 63.

church. Eventually even the Jesuits would abandon their earlier strategy.[61]

Over a century later in 1819, in what is now the United States, a massive swath of what was previously French territory was under the supervision of a single French Catholic bishop: Benedict Joseph Flaget.[62] A refugee from the French Revolution, Flaget oversaw an impossibly large diocese based in Bardsville, Kentucky, that comprised what is now ten American states. Flaget had read stories of Jesuit encounters with Native people, accounts that—in light of the reality of life on the frontier—were now described by some as "sugar coated traps."[63] The possibility of realizing Indigenous forms of Christian faith was replaced by tending a disparate flock and defending the legitimacy of Catholicism to Protestants. Flaget's encounters with any remaining Native Americans who had survived the military campaigns directed against them were sparse and frequently negative.[64] Flaget would even make a nostalgic trip to the

[61]Robert Michael Morrissey, "'I Speak It Well': Language, Cultural Understanding, and the End of a Missionary Middle Ground in Illinois Country, 1673–1712," *Early American Studies* 9, no. 3 (2011): 617-48. Willie Jennings's account of José de Acosta gives evidence that other Jesuit missions began within an aggressive imposition of Whiteness. It seems, however, that the situation in some North American environs (but certainly not all) was considerably different. Willie James Jennings, *The Christian Imagination: Theology and the Origins of Race* (New Haven, CT: Yale University Press, 2010), 65. To suggest that early North American Jesuit missions among Native peoples were positive in their approach to Native culture is not to deny that the way such missions were *remembered* often validated Whiteness. See Emma Anderson, *The Death and Afterlife of the North American Martyrs* (Cambridge, MA: Harvard University Press, 2014).

[62]Michael Pasquier, "French Missionary Priests and Borderlands Catholicism in the Diocese of Bardstown During the Early Nineteenth Century," in *Borderland Narratives: Negotiation and Accommodation in North America's Contested Spaces, 1500–1850*, ed. Andrew K. Frank and A. Glenn Crothers (Gainesville: University Press of Florida, 2017), 143-67.

[63]Pasquier, "French Missionary Priests," 149.

[64]The original French biography contains fleeting and mostly negative accounts of interactions with Native peoples. In 1793 thirteen out of twenty-six baptized that year were Indian. But "what is surprising . . . is that Flaget doesn't mention any baptism of Indians after 1793, and only two burials in the course of the two following years. The fact is probably due to the dispersion of the savages [sic] against whom three successive military

grave of Father Marquette overlooking Lake Michigan. He was despondent, faced with the "discrepancy between the image of a missionary past, with its cradle in the Great Lakes region and Mississippi Valley and its interest in the salvation of the Indians, and the development of a national church."[65] Two years later in 1821, well over a thousand Lenape that remained in the White River of Indiana were removed in what has been called "the first trail of tears."[66]

As nation after nation was pushed westward, crossing the Mississippi, the concealed essence of the Mishipeshu witnessed by Marquette was revealed. When resistance to President Andrew Jackson—much of it from uncompromising Christians like Jeremiah Evarts[67]—failed, the Indian Removal Act was passed in 1830. Jackson's life was once saved in battle by a Cherokee, but that was immaterial.[68] The Seneca, Shawnee, Ottawa, and even more Delaware were forced out in 1831 and 1832.[69] These trails were mobile iterations of Gnadenhutten, extended over miles and months and also mingled with hymn singing and death. These parties crossed the Mississippi not terribly far from where Marquette saw the painting of the Mishipeshu. Painter George Winter's sketches of one band of these deported Indians leave no ambiguity about the nature of their faith (see fig. 1.4).[70] Still, these Indians also remain.

operations were conducted at this time." Charles Lemarié, *A Biography of Msgr. Benedict Joseph Flaget, b. 1763–d. 1850, First Bishop of the Dioceses of Bardstown and Louisville, Kentucky, 1811–1850*, trans. Mary Wedding with Rachel Willet (Bardstown, KY: Flaget-Lemarie Group in conjunction with St. Joseph Proto-Cathedral Archives, 1992), 75.

[65] Pasquier, "French Missionary Priests," 150.

[66] Stockwell, *Other Trail of Tears*, 134; and Flook, *Native Americans*, 145.

[67] John A. Andrew III, *From Revivals to Removal: Jeremiah Evarts, the Cherokee Nation, and the Search for the Soul of America* (Athens: University of Georgia Press, 2007).

[68] Jill Ahlberg Yohe and Teri Greeves, *Hearts of Our People: Native Women Artists* (Minneapolis: Minneapolis Institute of Art, 2019), 281.

[69] Stockwell, *Other Trail of Tears*, 209, 239.

[70] Sarah E. Cooke and Rachel B. Ramadhyani, comp.; essays by Christian F. Feest and R. David Edmunds, *Indians and a Changing Frontier: The Art of George Winter* (Indianapolis: Indiana Historical Society, 1993).

Many facilely blame aggressive Christianity as the single expla-
nation for Indigenous suffering.[71] But if the chief villain in this sce-
nario were Christianity, then the Lenape, the Mohican, the Ottawa,
and the Potawatomi—so many of them Christian—would have re-
ceived similar treatment to White Christians. As it happens, their con-
version registered little change at
all.[72] These Indians preached
moving sermons before and
during their expulsions, but it did
not matter, because there were
more forces on this continent at
work than the Christian gospel.[73]
"Two powerful and mighty spirits
or gods are standing and opening
wide their jaws toward each other
to swallow." The Wyandot
headman Half King spoke these
words to the Moravian Christians
at Gnadenhutten before the Indig-
enous people were killed.[74] The
metaphor is not pagan super-
stition but a prophetic and poetic
description of what would become
brute fact with competing powers

Figure 1.4. George Winter, Portrait of Miss
en nah go gwah (Potawatomi), c. 1837

[71]Peter Jenkins compiles these popular critiques in *Dream Catchers: How Main-
stream America Discovered Native Spirituality* (Oxford: Oxford University Press,
2004), 220-21.

[72]As we've seen, specifically Christian Indigenous settlements "would merely serve as an-
other way station for the Delawares to learn, yet again, that they would never enjoy
brotherhood with the whites." Silverman, *Red Brethren*, 77.

[73]Stockwell, *Other Trail of Tears*, 326.

[74]Eugene F. Bliss, ed., *Diary of David Zeisberger, a Moravian Missionary Among the Indians
of Ohio* (Cincinnati: Clarke, 1885), 4.

of settlement—a power that was visualized in the Mishipeshu, which could swallow nations whole.

This is not an easy lesson for most North Americans to absorb. As one Anishinaabe adage puts it with such images in mind, "Everyone must bear within them something unbearable."[75] Or as the Jewish psychologist Erich Neumann puts it, "Love and acceptance of the shadow is the essential basis for the actual achievement of an ethical attitude towards the 'Thou' who is outside me."[76] A refusal to acknowledge such tendencies may be what enabled settlers to project them somewhere else, or what enables settler descendants to make light of such symbols today. The point is made with unexpected force by another modern appearance of the Mishipeshu called the Hodag, the city mascot of Rhinelander, Wisconsin—another peculiar chapter in the Midwestern regionalism currently undergoing another revival. This creature was invented by the prankster Gene Shepard to draw people to his town, which has taken up this monster as its mascot (see fig. 1.5).[77] When my family visited the museum of Hodag paraphernalia, the tour guide showed full awareness that the Hodag could be traced back to Native American legends, even if it was now just a fun ghost story. The guide concluded with a friendly word to my children, "Hodags are real. Tell your friends." I'm not sure this is how he intended it, but with the unsettling history of American settlement in mind, we can affirm that these creatures exist. "Moloch is not a myth; or at any rate his meal was not a myth," Chesterton tells us.[78] And neither was America's systematic killing of Indians.

[75]Corbiere and Migwans, "Animikii miinwaa Mishibizhiw," in Penney and McMaster, *Before and After the Horizon*, 44. Compare Robert A. Johnson, *Owning Your Own Shadow: Understanding the Dark Side of the Psyche* (San Francisco: HarperCollins, 1991).

[76]Erich Neumann, *Depth Psychology and a New Ethic* (Boston: Shambhala, 1990), 95.

[77]The story is well told in B. J. Hollars, *Midwestern Strange: Hunting Monsters, Martians, and the Weird in Flyover Country* (Lincoln: University of Nebraska Press, 2019), 133-52.

[78]Chesterton, *Everlasting Man*, 145.

Figure 1.5. Hodag statue in present-day Rhinelander, Wisconsin

THUNDERBIRD

There are at least two errors about racism currently circulating in North American culture. One is that it has been permanently defeated, and the other is that it is omnipotent. By using the symbol of the Mishipeshu I have tried to counter the first error, but to conclude I want to counter the second. In Indigenous North American mythology, the Mishipeshu of the lower realm was complemented by a creature that inhabited the upper realm, namely, the Thunderbird, images of which are also found all over the Great Lakes region as well. This creature can also be interpreted in a variety of ways, often in fierce opposition to the Mishipeshu. It should not go without notice that the Thunderbird is a theme that Indigenous Christians have especially taken up as their own.[79]

[79]Similar dueling motifs might also be said to form the background to Chesterton's childhood. Speaking of the church and the waterworks outside his home, he remarks: "For the 'notion of a town of water' was to suggest to his imagination some 'colossal water-snake that might be the Great Sea Serpent, and had something of the nightmare nearness of a dragon in a dream'; while 'over against it, the small church rose in a spire like a spear; and

When the Ojibwe minister Sacred Feathers (Kahkewaquonaby), a.k.a. Peter Jones (1802–1856), converted to Christianity, he aligned himself with the Thunderbird, which can be seen on the bag he is holding in the oldest surviving photograph of any Indigenous North American (see fig. 1.6).[80] That same sacred bag, lovingly made by an anonymous Anishinaabe woman out of tanned leather, porcupine quills, dye, glass beads, metal cones, and deer hair, is still on view at the Metropolitan Museum of Art in New York. "Perhaps there is not much difference between them and the wild Indian," Jones says of his well-meaning White interlocutors. He is referring in particular to those who tell him he cannot be Christian. He calls out the racism of those who suggest that Native people are not capable of Christianity.[81] Admittedly, Jones's account is less embracing of his own Ojibwe heritage than many Ojibwe Christians would be today.[82] But the Thunderbird evidences the part of his culture that he, as a Christian, refused to discard. Which is to say, in a time when Native Christians sometimes felt required to abandon their culture as a survival strategy, the Thunderbird was an exception. Similarly, among the sacred artifacts that enhanced Protestant liturgical celebrations is an altar cloth that displays the word *wakan* (holy) and a head vestment for Dakota convert Andrew "Good Thunder."[83] The display is unfortunately now

I have always been pleased to remember that it was dedicated to St. George.'" G. K. Chesterton, *The Autobiography*, Collected Works 16 (San Francisco: Ignatius Press, 1988), 38.

[80] Ira Jacknis, "Preface," *American Indian Culture and Research Journal*, UCLA American Indian Studies Center, 20, no. 3 (1996): 1.

[81] Peter Jones, *History of the Ojebway Indians: With Especial Reference to Their Conversion to Christianity; with a Brief Memoir of the Writer* (London: A. W. Bennett, 1861), 92.

[82] For a more positive Christian embrace of Ojibwe culture, see Christopher Vecsey, *The Paths of Kateri's Kin* (South Bend, IN: University of Notre Dame Press, 1997), 229-33.

[83] Although Andrew had put himself at risk to help White families in the midst of hostilities, he was still exiled, like the Potawatomi, to Nebraska and South Dakota. Louis B. Casagrande and Melissa M. Ringheim, *Straight Tongue: Minnesota Indian Art from the Bishop Whipple Collections* (St. Paul: Science Museum of Minnesota, 1980), 20. The berries on his hat evoke a Dakota ritual food that feed the dead on their way to the underworld, which is where Andrew was relegated by the dominant American culture.

relegated to a back room of the Science Museum of Minnesota in Saint Paul; but as if to emphasize the continuity of Indigenous life before and after Christianity, the beadwork is displayed adjacent to a ceramic vessel from AD 1200–1300 that displays the Thunderbird and Mishipeshu.

The theme of the Christian Thunderbird has continued well into the present. Considering the modern Canadian "discovery" that birch-bark scroll imagery was entwined with Christianity from the start,[84] no one should have been surprised when the star of this movement, Copper Thun-

Figure 1.6. Ojibwe Methodist minister Peter Jones (Kahkewaquonaby, "Sacred Waving Eagle's Plume") in Scotland, oldest surviving photograph of a First Nations person, 1845

derbird (Norval Morrisseau), exclaimed, "Jesus has a purpose for me. He wants me to paint."[85] Even so, Morrisseau was soon drawn to the New Age amalgam known as Eckankar, giving him "leave of Christianity."[86] This new faith, invented in Minnesota in 1965 and emphasizing past lives and astral travel, was shared with Morrisseau by his art dealer's administrative assistant, Eva Quan. Lakota art historian Carmen Robertson suggests that Eckankar enabled Morrisseau to give "the press something it wanted—a brand of shamanism that

[84]Selwyn Dewdney, surprised by the Christian faith of his Ojibwe informant, asked at the start of his famous study: "How could he be a Midé shaman [and] . . . accept—let alone be nominated for—an eldership in the Presbyterian church?" Dewdney, *Sacred Scrolls of the Southern Ojibway*, 1.

[85]Armand Garnet Ruffo, *Norval Morrisseau: Man Changing into Thunderbird* (Madeira Park, BC: Douglas & McIntyre, 2018), 180.

[86]Ruffo, *Norval Morrisseau*, 196.

was in alignment with an established set of stereotypical tropes that reference the Imaginary Indian."[87] In other words, perhaps Eckankar greased the colonialist art machine that Morrisseau's Christianity threatened to stall.[88] Avoiding a facile branding of Morrisseau's work with Eckankar, Armand Ruffo skillfully weaves Morrisseau's famous series *Man Changing into Thunderbird* (1977) with Ojibwe mythology.[89] But to evoke such mythology is, like it or not, also to evoke the conversation between Christianity and Ojibwe thought that has been underway in North America for hundreds of years. That Eckankar would have immediately expunged all memory of this conversation from Morrisseau's vexed psychology is doubtful. Can we therefore consider his *Man Changing into Thunderbird* an account indebted not just to the New Age but to the hope of complete Christian transformation as well? Might the transformed man that culminates the series testify to that point where "there are no levels. . . . Praise praises. Thanksgiving gives thanks. Jesus prays"?[90] Whether or not that interpretation is possible, the Thunderbird theme continued for many Native artists in Morrisseau's Woodland School. *Thunderbird* (1982), a painting by Randy Trudeau, depicts the three crosses of Calvary within the Thunderbird's body.[91] A Thunderbird appears to guard the tomb in James Simon Mishibinijima's *Waiting by the Sepulchre* as well.[92] Beyond the Woodland

[87]Carmen L. Robertson, *Mythologizing Norval Morrisseau: Art and the Colonial Narrative in the Canadian Media* (Winnipeg: University of Manitoba Press, 2016), 101.

[88]James Elkins points out the NRMs (new religious movements) like Eckankar are far more acceptable to the art world than traditional religions like Christianity. Perhaps this is simply because NRMs sell. James Elkins, *On the Strange Place of Religion in Contemporary Art* (New York: Routledge, 2004), 51.

[89]Ruffo, *Norval Morrisseau*, 200-208.

[90]Thomas Merton, cited in David Steindl-Rast, "Recollections of Thomas Merton's Last Days in the West," *Monastic Studies* 7 (1969): 10.

[91]Ron Tourangeau, *Visual Art as Metaphor: Understanding Anishinabe Spirituality and Christianity* (Graduate Theological Union dissertation, 1989), vol. 2, plate 106.

[92]Tourangeau, *Visual Art as Metaphor*, plate 110. Christian themes pervade Mishibinijima's work, most famously in his image of Pope John Paul II.

School, the Tlingit carver Stanley Peters produced his *Totem Cross* in 1975, which also depicted Christ as a Thunderbird. "To most of the Indian peoples of North America," the artist explains, "the Thunderbird is a powerfully awesome messenger of the great God. [In my work] the Thunderbird is the sacred sign of God's force-filled entry into the world."[93]

This tradition continues into the present as well. Canada's *Report of the Truth and Reconciliation Commission* cataloged the horrific things done to the First Nations, often under Christian auspices. But when one actually takes up the challenge to read it, one finds this from a Presbyterian minister: "Can the Rev. Margaret Mullin/ Thundering Eagle [W]oman from the Bear Clan be a strong Anishinaabe woman and a Christian simultaneously? Yes I can."[94] As evidenced by the beaded stole she wears in her online profiles, she has taken up the Thunderbird in the name of Christian ministry as well. In addition, at the Indigenous Christian Fellowship of Regina, the self-taught Cree artist Ovide Bighetty's *The Creator's Sacrifice* (2002) series shows Christ fused with the Thunderbird on the cross (see fig. 1.7), with power lines extended even to his enemies. The Thunderbird is interwoven, in a variety of manifestations, throughout this entire Indigenous Stations of the Cross.[95] The Immaculate

[93]Stanley Peters, "Indigenous Art Collection: Totem Cross," Canadian Conference of Catholic Bishops, www.cccb.ca/indigenous-peoples/resources/cccb-art-collection /totem-cross. A red cedar panel of the baptism of Christ in the same collection by Kwakiutl artist Tony Hunt (Broken Copper) depicts the Holy Spirit as the Thunderbird instead. Tony Hunt, "Indigenous Art Collection: The Baptism of Christ by John the Baptist," Canadian Conference of Catholic Bishops, www.cccb.ca/indigenous -peoples/resources/cccb-art-collection/baptism-christ-john-baptist. Both sites accessed April 15, 2021.

[94]*Final Report of the Truth and Reconciliation Commission of Canada* (Toronto: Lorimer, 2015), 228.

[95]The full series is shown on the Indigenous Christian Fellowship of Regina's webpage, icfregina.ca/the-creators-sacrifice, accessed March 10, 2021. Fellowship director Bert Adema's description of this commission is sobering: "[W]hile he was painting the first series ('Kisemanito Pakitinasuwin—The Creator's Sacrifice') he left town (Regina) and

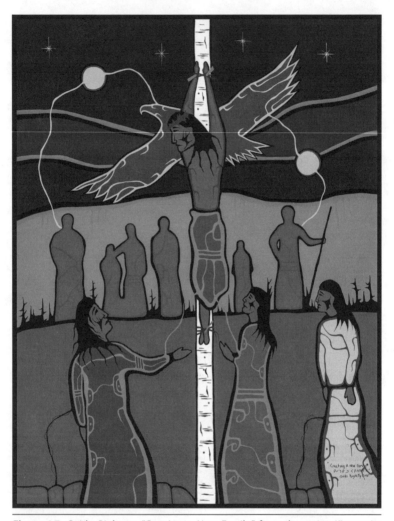

Figure 1.7. Ovide Bighetty, "Creating a New Family," from the series *Kisemanito Pakitinasuwin—The Creator's Sacrifice* (2002)

went to consult with the elders of his home community in northern Manitoba (Pukatawagan First Nation). . . . I would submit that Ovide's acceptance of the commissions and his work with the themes and content of the series are evidence of his faith in the Triune Creator despite the pain that haunted him because of the legacy of the residential

Conception Church on Manitoulin Island is crested by a Thunderbird in the dome,[96] just as there is a carved Thunderbird on the altar at Wikwemikong's Holy Cross Mission. And at the Saint Kateri Center of Chicago, where many among the First Nations that remain in Chicago worship, the cross-crested Thunderbird adorns the altar as well. The endurance of the Thunderbird in Christian context is evidence not just of the Christianizing of the Indigenous but of the indigenizing of Christianity.[97]

THE TALONS OF CHRIST

There are plenty of studies that have uncovered and foregrounded the horrors that have happened, and continue to happen, to Indigenous persons in the wake of settlement.[98] More recently, these have been supplemented by studies that finally do more to take into account the strategic embrace of Christianity by many Indigenous persons. "Present-day critics who argue that Christian missions were mechanisms of oppression and social control underestimate the intelligence and awareness of the tribes," write prominent scholars of the Moravian missions.[99] "Christianity did not eradicate old [Indigenous] beliefs," claims Colin Calloway. "Rather, it supplemented and even strengthened them, providing a new, broader spiritual basis."[100] The Indigenous choice

schools . . . and the pain in his family and community caused by Christians and Christian institutions" (personal communication).

[96]Theresa Smith suggests that while parish publications liken it to the Holy Spirit, the Thunderbird manitou is a distinct, and possibly more accurate, interpretation. T. S. Smith, "The Church of the Immaculate Conception: Inculturation and Identity Among the Anishnaabeg of Manitoulin Island," *American Indian Quarterly* 20, nos. 3-4 (1996): 525.

[97]Smith, *Island of the Anishnaabeg*, 139-40.

[98]For a recent historical treatment, see Roxanne Dunbar-Ortiz, *An Indigenous Peoples' History of the United States* (Boston: Beacon, 2014). For a more cultural approach, see Thomas King, *The Inconvenient Indian: A Curious Account of Native People in North America* (St. Paul: University of Minnesota Press, 2013).

[99]Wellenreuther and Wessel, *Moravian Mission Diaries*, 68.

[100]Colin G. Calloway, *New Worlds for All: Indians, Europeans, and the Remaking of Early America* (Baltimore: Johns Hopkins University Press, 1998), 91. Statements like this were

to accept Christianity could be "a decision to restore ancient [Native] values that had been abandoned by other Indian peoples,"[101] or even "a cry of desperation and faith proportionate to the misery produced by colonialism."[102]

This chapter has attempted to illustrate both dynamics, colonization and Indigenous Christianity, using the Native beliefs of the Underwater Panther and the Thunderbird. As an extended anthropological study of these beings puts it: "While the Thunderers are generally understood as protectors of the Anishnaabeg, the full force of their personalities appears most unmistakable when they are acting against the Underwater/Underground mantiouk [Mishipeshu]."[103] Likewise, the full force of Indigenous Christianity is best perceived when understood as a form of creative resistance. This applies even for the most seemingly "compliant" of Christian Indians.[104] Native Christianity is not a mark of inauthenticity, as it is often perceived, but a sign of revitalization in the face of overwhelming pressure, a revitalization in full flight today.[105]

"Only the Thunderers have the power and will necessary to right the imbalance that is the inevitable product of Mishebeshu's acts."[106] Likewise, perhaps only Indigenous North American Christianity can address the pervasive imbalance of Christian culture on the American continent, failing so often to honor, or even acknowledge, the land's

the first trickles of what has become of flood of literature on Christianity in Native America that informs this book.

[101]Rachel Wheeler, "Henrick Aupaumut, Christian-Mahican Prophet," in Martin and Nicholas, *Native Americans*, 231.

[102]Silverman, "To Become a Chosen People," 254.

[103]Smith, *Island of the Anishnaabeg*, 93.

[104]See Silverman, "To Become a Chosen People," 260. For how Black Elk used Christianity as a tool to resist colonialism, see Damian Costello, *Black Elk: Colonialism and Lakota Catholicism* (Maryknoll, NY: Orbis Books, 2005), 158.

[105]Wheeler, "Henrick Aupaumut, Christian-Mahican Prophet," in Martin and Nicholas, *Native Americans*, 227.

[106]Smith, *Island of the Anishnaabeg*, 122 (with an alternate spelling of Mishipeshu).

original inhabitants. Which is to say, when Chesterton announced that Christ burst into time "swift and straight as a thunderbolt," offering a "lightning made eternal as the light,"[107] he may not have had the First Nations of Turtle Island in mind. But we can.

[107]Chesterton, *Everlasting Man*, 207, 271.

RESPONSE

CAPT. DAVID IGLESIAS

MY **FRIEND AND COLLEAGUE** Matt Milliner has written movingly of Turtle Island. The nautical theme is appropriate for me since I lived for nearly seven years on an island off the Caribbean coast of Panama called Buzzard Island, or *Mulatuppu* in the Kuna language. In my response, I want to talk about art, Indigenous Americans' missions, warfare, and G. K. Chesterton.

But first, let me introduce my tribe, the Kuna nation. We have a long history of successfully resisting Western encroachment. We are one of the most independent tribes in all the Americas, and I must remind my brothers and sisters in the North (as we refer to North America) that there are other Americas that some of us have visited, and some of us are from. Time will not allow me to explain why my tribe is one of the most independent, other than to say it involves a Christian missionary woman named Anna Coope from the early 1900s, my family, the English language, an American adventurer named Richard Marsh with friends in the US Congress, and the construction of the Panama Canal, all of which played a role in this special status.

Kunas live on approximately fifty islands in an archipelago consisting of about 365 islands. This archipelago is in the Caribbean Sea along the northern coast of Panama, near the Colombian border. It's the southernmost point of the Spanish Main, for you *Pirates of the Caribbean* fans. And most of the islands are about the size of the typical American shopping mall so, if you've been to Chicagoland's

Oak Brook mall, that's about the size of the typical island in Kuna Yala. And a lot of the islands contain anywhere from a few dozen to a couple hundred people.

Kunas are studied by Western scholars like Dr. Milliner for a couple of different reasons. First, the women wear a beautifully sewn, reverse-applique blouse called a *mola*. In my opinion, they're wearable art. These are all hand-stitched in the congress hall every night. The women sit around the edge, and the men recline in the center on hammocks, conducting business in Kuna. The *molas* are stitched both for personal wear and to sell to the tourists. They depict nature, abstract designs, and even biblical themes.

You might ask, Why do Kuna women make *molas*? I ask my Northern American brothers and sisters, Why do you make art? They are beautiful interpretations of life. The Kuna women want to wear something beautiful. These are beautiful pieces of art that you can wear, mount on your walls, or even make pillows out of them.

Who are the Kuna? We call ourselves "the Golden People," which should tell you a lot about our self-image. We're a group indigenous to Panama and Colombia. Some live on the islands, some in the rain-forest, and some in the cities of Panama. English pirate Lionel Wafer wrote the first book about the Kuna in the seventeenth century. He called it *A New Voyage and Description of the Isthmus of*

Figure 1.8. Title page of Lionel Wafer, *A New Voyage and Description of the Isthmus of America,* 1704

America. He was a doctor and a pirate. Some of my friends would say those are the same thing. Wafer was injured, spent four months with my tribe in 1695, and wrote a book about my tribe that talked about body painting and nose rings and included a short Kuna dictionary. Wafer left the practice of medicine to become a buccaneer. He wanted to sack Panama City, which had a lot of stolen Inca gold. But he was injured, and my tribe nursed him back to health. So here we have a trained medical doctor, who had to be nursed by the local people, intent on sacking a rich Spanish city. Truth is indeed stranger than fiction.

Western scholars have also studied Kuna governance because every night there is a highly participatory meeting, and every facet of island life is covered, including disputes, including how to price the sale of coconuts—anything that can be mediated. Consider this to be a combination of Congress and small-claims court rolled into one. And my father used to spend hours every night talking to the chiefs.

The Kunas are the Golden People, they're the artistic people, but I think the best name that I've read is what a professor of anthropology at MIT called them, which was "the people who would not kneel." That is a topic that Dr. Milliner writes powerfully about. In the North, the tribes were forced to kneel. In the case of my tribe, we were not forced to kneel. On Columbus's fourth journey to the New World, he mentions meeting a group of people, which I believe to be the Kuna, in April of 1502. That was a very early European contact. But despite five hundred years of contact, the Kuna survived guns, germs, steel, warfare, piracy, and encroachment—and have survived on their own terms.

According to James Howe (the MIT anthropologist) and my family's own oral history, my family was active in tribal politics.[1] Though

[1] James Howe, *A People Who Would Not Kneel: Panama, the United States, and the San Blas Kuna* (Washington: Smithsonian Institute, 1998).

Dr. Milliner avoids politics, I have to talk about it because it is inescapable in this story. About a hundred years ago, my oldest uncle, Claudio, received his education from a Jesuit, Padre Jesus; went to Costa Rica; came back; and became what scholars call "a radical modernist." He believed that the Kuna should embrace Western culture and turn their backs on customs such as wearing nose rings and wearing the *mola*, to become Westernized.

My Uncle Claudio was on the wrong side of history, I'm sad to say. He was pro-Panamanian and antitradition, and those views did not sit well with tribal leadership. My uncle was killed by traditional tribal members. This collision between Western and Indigenous people led to a violent and successful revolution in 1925, which led to an autonomous status of the Kuna and a grudging respect by the civil authorities in Panama City.

My next family member who became educated was my Uncle Lonnie, who went to the United States, received his college education, married a woman from Michigan, and came back as a Christian missionary to his own people. Have any of you heard K. P. Yohannan, the founder and president of Gospel for Asia, talk about Native missionaries? My family was doing that eighty years ago. So this is not a new idea. He knew the language, he knew the culture, and he was the oldest survivor of eleven children.

I want to warn you, I'm going to address politics again. Uncle Lonnie also became a member of the Panamanian legislature, where he helped draft legislation to protect Kuna independence and territorial integrity. My family was doing Native missionary work in the 1930s, when the common model at the time was Western missionaries among Native people. That model was impossible on the islands because my tribe banned foreigners spending the night on the islands, especially men, for obvious reasons. An exception was made for my American aunt and my American mother. The New Testament was

translated by my family, hymns were translated by another Kuna couple, and a people who had not kneeled to earthly powers learned to kneel to the God of Israel. It was this type of independence that is typically Kuna.

Let me give you a more modern example. We all remember when President Carter entered into a treaty and gave the Panama Canal back to Panama. It had to be approved by the people of Panama. And it overwhelmingly passed, except for one region: Kuna Yala. Kuna Yala wanted it to stay in American control. Why? Because the Kunas worked on American military bases. They sent money home. They trusted the United States in a way that they did not trust Panama City. So when you think about that, your mind kind of bends, because of the history of the American government in the North. And at least, as regards my tribe, it was a completely different experience.

But my Uncle Lonnie experienced personally the transformative effects of the gospel and of Western education. He convinced his parents to send the youngest sibling, my father, Claudio, to America for education. A lot of times when we talk about immigration to the United States, we speak of coming to the land of opportunity. But if you talked to my father when he was alive, he would say, "I didn't want to go. I was happy living on the islands, going to the jungle, fishing. But I *had* to receive an education so I was forced to do that." After going through Ellis Island—which was still open in 1936—he ended up at a Baptist-run orphanage in Muskogee, Oklahoma, where he grew up with Native Americans from the North. He became the second Kuna to receive a college education; he married my mother, Margaret Geiger from Minnesota (Wheaton class of 1945); and they went back to the islands as missionaries for fifteen years.

My mother was a Wycliffe Bible translator to the Masateco tribe of southern Mexico. So missionaries, Indigenous politics, the military, all collide in my family history. But they decided to come to America to

allow my sisters and me to receive an American education. We moved to Oklahoma and then New Mexico, where my parents led Native American churches in Gallup, Santa Fe, and Albuquerque. We became friends with a large number of tribes, including Delawares and Osages, and tribes you've never heard of because they were all sent to Oklahoma. I learned how to say *God* in Kiowa. I learned to sing the Creek hallelujah. We were immersed in North American tribal culture. My father was greeted with open arms, even though his ancestry was from Central and South America. It didn't matter.

We went to pow-wows to visit and show our support to church members. What I remember about pow-wows was the drumming. It goes right through the core of your being. It's an overwhelming experience, regardless of your own ancestry. For somebody of an Indigenous ancestry, it is an overwhelming experience. I still see the color, the sound, the chants, the counterchants, the swirling, and it is an overwhelming experience. The hair on the back of my neck is standing up now just thinking about the drums and the chanting. I hadn't seen so many Indigenous people since leaving the islands.

And then I came to Wheaton in 1976, and I became a unicorn. There's no Indigenous equivalent of a unicorn. It's a great Western concept. I was the only overtly Indigenous person here, but I did find a tribe. That tribe was Wheaton football. I had the long hair, which was culturally appropriate, for both my tribal culture and my athletic culture. And then I made lifelong friends. It was a wonderful experience.

But then I ended up going back to New Mexico. I went back to the familiar world of Hispanic, Native, and Anglo, and I could not have foreseen a return to the tribal world until I became a United States Attorney, with jurisdiction to enforce federal law on *tribal* land. Uncle Sam loves Native peoples, but he doesn't trust them to have their own criminal justice system so the Justice Department enforces ten major crimes. I saw the beauty of Native life in both

North and South America, but I also saw the danger, the crime. And God gave me just the perfect background to meet tribal leaders and prosecute criminals and help make Indian Country a little bit safer. Indian Country is actually the term of art used in the federal court system.

But it wasn't until I came back to Wheaton five years ago that I was able to take my daughters back to where I was raised: Buzzard Island, *Mulatuppu*. Then I also had a chance to take a study program to South America, and I met two out of the three political leaders of my tribe. My students met them and asked them a lot of interesting questions.

Then I got to go back—thank you, Wheaton College—in 2016 and again in 2019. I took my football tribe to meet my real tribe, where we rebuilt a church that was created in 1930 and fell apart. My life came full circle: San Blas islands, Wheaton College football.

Figure 1.9. Kuna woman painting on the nose of a Wheaton College football player

Where does art come into this picture? Art is more than just beauty. It's a testament that a people live. The Kuna see art as a living, breathing phenomenon that they can use on a blouse, a nose ring, a woodcarving. If you remember one thing about my comments, please make it this: We survived. We persisted. We live. And if you're ever in Panama, you'll see Kuna women in full regalia, wearing scarves, and this is a beautiful testimony to their persistence.

I'll close by quoting Chesterton, who said, "Art, like morality, consists of drawing the line somewhere."[2] So where is the line to be drawn? On the nose. The Kunas love long noses. Anyone with long noses would be welcome on the islands. During one of our visits, a Kuna woman painted a black line down the nose of a Wheaton football player, who wanted to have that done. For me, the drawing of this line signifies the confluence of Indigenous resistance, art, warfare, and missions. We all draw the line somewhere.

[2]G.K. Chesterton, "Drawing the Line Somewhere: May 5, 1928" in *Collected Works*, vol. 34, *The Illustrated London News, 1926–1928* (San Francisco: Ignatius Press, 1991), 518.

2

THE COST OF CHICAGO

The land shall not be sold in perpetuity, for the land is mine; with me you are but aliens and tenants.

LEVITICUS 25:23

We spat at them rights and riches, out of a gun.

G. K. CHESTERTON

Despite his critique of the Viking's nihilistic love of death, [Chesterton's] Alfred regards heathen beauty and dignity as indispensable for Christian existence. Yet he also knows that such prehistoric virtues will not suffice unto themselves.

RALPH C. WOOD

G. K. CHESTERTON WAS not only the Apostle of Common Sense, as he is often called, but the Apostle of Contentment—tutoring us to love our own land, nations, homes, food, friends, and families. By such counsel he does not intend us to turn a blind eye to injustice, as might a lesser localist. "It is not strange that our workers should often think about rising above their position, since they have so continually to think about sinking below it."[1] By counseling the love

[1]G. K. Chesterton, "The Contented Man," in *Selected Essays* (Mumbai: Wilco, 2005), 6. Politically, Chesterton was neither of the left nor right as we might understand those

of lowly things, Chesterton was instead criticizing the restless modern striving for more. By *contentment* Chesterton has in mind the French meaning of the term, of simply "being pleased."

> It may be true that a particular man, in his relation to his master or his neighbour, to his country or his enemies, will do well to be fiercely unsatisfied or thirsting for an angry justice. But it is not true, no sane person can call it true, that man as a whole in his general attitude towards the world, in his posture towards death or green fields, towards the weather or the baby, will be wise to cultivate dissatisfaction.[2]

Such contentment is "an active virtue . . . not only affirmative, but creative. . . . It is the power of getting out of any situation all that there is in it. It is arduous and it is rare."[3] And such contentment can bring into admirable focus the places where we live: "The young genius says, 'I have lived in my dreary and squalid village before I found success in Paris or Vienna.' The sound philosopher will answer, 'You have never lived in your village, or you would not call it dreary and squalid.'"[4]

Chesterton's point was driven home for me one evening in Oxford, which I was enjoying with students on a study-abroad excursion. After our mandatory C. S. Lewis tour of the city, my family and I made our way with two students to The Eagle and Child, which once hosted the Inklings, who, of course, knew their G. K. Chesterton well. We opened the door to see a crowd of Americans like ourselves

terms today. Monopoly was "neither private nor enterprising" and capitalism was a result of England's oligarchical past that lacked "a widely scattered ownership." Socialists put capital into "the hands of even fewer people [i.e. politicians]" and communism reformed "the pickpocket by forbidding pockets." Ian Ker, *G. K. Chesterton: A Biography* (Oxford: Oxford University Press, 2011), 559. Chesterton was what he called a "distributist," expressing that "a man felt happier, more dignified, and more like the image of God, when the hat he is wearing is his own hat [not leased or shared in rotation to express comradery]" (556-57).

[2]Chesterton, "Contented Man," 7.
[3]Chesterton, "Contented Man," 7-8.
[4]Chesterton, "Contented Man," 8.

seeking the same experience staring back at us, and we retired to a café next door for a cheaper and less crowded meal. At that meal we concluded the obvious—that the Oxford of the Inklings was not our Oxford. After all, one block away at the Ashmolean Museum we had just seen a prized Native American artifact, prominently on display since 2017. Powhatan's mantle (c. 1600–1638) had been given to the English by the man who was Pocahontas's father (see fig. 2.1). We had also passed the Pitt Rivers Museum, which, I was soon to learn at a NAIITS conference, still retains the family treasures of a Christian Haida woman who wants them back.[5] Looking back on that rainy evening in Oxford, it was as if these famous Christian intellectuals of Europe, so many of them inspired by Chesterton, were telling us to go home and examine our own history instead. If Chesterton advises us to attend to our own homes and histories, grappling with Indigenous North American culture (and its suppression) is an inevitable consequence for any North Americans who wish to take him seriously. In short, Chesterton would wish us contentment at our own hearthstones, but without forgetting those whose hearthstones were taken from them.[6]

The theme of contentment is explored in Chesterton's 1912 novel *Manalive*, but perhaps best in *The Napoleon of Notting Hill*, written in 1904 but set in 1984.[7] Chesterton imagines a democracy drained of any meaning and run by a humorist, Auberon Quin, elected by lot—a

[5]For the ongoing conversation surrounding these collections, see Cara Krmpotich and Laura Peers, *This Is Our Life: Haida Material Heritage and Changing Museum Practice* (Vancouver: University of British Columbia Press, 2014). I thank the 2018 NAIITS conference in Nova Scotia, "White Supremacy, Racial Conflict, and Indigeneity: Towards Right Relationship," for making this conversation possible.

[6]See, for example, Susan E. Grey, "Native Americans and Midwestern History," in *Finding a New Midwestern History*, ed. Jon K. Lauck, Gleaves Whitney, and Joseph Hogan (Lincoln: University of Nebraska Press, 2018), 55-72.

[7]George Orwell may indeed have been nodding to Chesterton when he titled his 1948 novel *Nineteen Eighty-Four*. See Luke Seaber, *G. K. Chesterton's Literary Influence on George Orwell: A Surprising Irony* (Lewiston, NY: Mellen, 2012).

Figure 2.1. Algonkian artist, Powhatan's mantle (before 1638) on display at Oxford's Ashmolean Museum

"man whose soul has been emptied of all pleasures but folly."[8] Quin revives medieval banners for the sport of it, but local loyalist Adam Wayne, a resident of the London neighborhood of Notting Hill, takes the joke with deadly resolve. An Indigenous American connection here might seem far-fetched, but it is Chesterton himself that makes it. At the start of the novel, an Indigenous Central American character—the unseated president of Nicaragua—complains about imperialism:

> When you say you want all peoples to unite, you really mean that you want all peoples to unite to learn the tricks of your people. If the Bedouin Arab does not know how to read, some English missionary or schoolmaster must be sent to teach him to read, but no one ever says, "This schoolmaster does not know how to ride a camel; let us pay a Bedouin to teach him."[9]

[8]G. K. Chesterton, *The Napoleon of Notting Hill* (1906; repr., Caracas, Venezuela: Arroyo and Morgado, 2018), 36. Readers of the novel will grasp the fittingness of this Venezuelan reprint!
[9]Chesterton, *Napoleon of Notting Hill*, 28.

Later in the novel, when the young Adam Wayne defends his territory valiantly, we can see why two astute critics recently suggested that *The Napoleon of Notting Hill* is a "a novel for the era of Standing Rock."[10]

Adam takes King Quin's Charter of Cities seriously, just as the Potawatomi took the Treaty of Chicago seriously, and therefore sued for the land that was not ceded in that treaty—namely, a strip of Chicago Fire debris that is now prime city real estate.[11] In *The Napoleon of Notting Hill*, Adam Wayne is offered a staggering sum to enable a highway to be built through his neighborhood, but the money is refused. The would-be purchasers complain that Wayne "pleads the inviolate sanctity of Notting Hill and calls it the Holy Mountain."[12] And in the same way, the American government—after the Supreme Court acknowledged that the Black Hills were indeed stolen—has attempted to settle with the Lakota for seizing them.[13] Like Adam Wayne, they will not take the money. In short, when we read Chesterton's first novel as if it were a Western, many things fall into place.

I aim in this chapter to tell the story of my own home, Chicagoland, with this broad Native history in mind. The fact that Chicago has been

[10]Brianna Rennix and Nathan J. Robinson, "What's with Nationalism?" *Current Affairs*, December 30, 2018, www.currentaffairs.org/2018/12/whats-with-nationalism. The authors are critical of Chesterton's novel as well, arguing it could also be interpreted in defense of an aggressive American nationalism. Indeed it could be, which is why I am interpreting it in defense of Indigenous concerns instead.

[11]John N. Low, *Imprints: The Pokagon Band of Potawatomi Indians and the City of Chicago* (East Lansing: Michigan State University Press, 2016), 95-138.

[12]Chesterton, *Napoleon of Notting Hill*, 100.

[13]The Fort Laramie Treaty of 1869 ensured that the Black Hills would be "set apart for the absolute and undisturbed use and occupation of the Indians." Still, reports of gold by Custer led to an influx of miners that could not be controlled. Eventually this led to an American military attempt to eject the Sioux, resulting in the Battle of Little Bighorn in 1876. In 1980, eight out of nine members of the Supreme Court determined that it would be hard to find a more "ripe and rank case of dishonorable dealing" than the seizure of the Black Hills. As of this writing, the compensation offered has not been accepted. Jeffrey Ostler, *The Lakotas and the Black Hills: The Struggle for Sacred Ground* (New York: Viking, 2010), 164. At the same time, "though Lakota tradition firmly associates that people with the Black Hills, all evidence suggests that that people originated much farther east, until they were driven by tribes armed with new European firearms." Philip Jenkins, *Dream Catchers: How Mainstream America Discovered Native Spirituality* (Oxford: Oxford University Press, 2004), 252.

called "the cockpit of the continent" ensures that this will be of more than local interest,[14] and I hope that this exercise can inspire similar regional examinations elsewhere. In this broad retelling of Chicago and its surrounding area, I won't contribute to the debate about whether a new star should be added to the four stars of the Chicago flag. And I will go beyond the laudable suggestion that "we rededicate the first star in the city's flag to honor the era when Chicago was a part of the Indian Country of the western Great Lakes."[15] Instead, I will redefine the stars altogether, likening this area's Indigenous persons, without romanticizing them, to the defenders of Notting Hill. Instead of Fort Dearborn, the Great Fire of 1871, the World's Columbian Exposition of 1893, and the Century of Progress Exposition of 1933 (the four current stars), I will be choosing four different events to commemorate this area's everlasting people: the area's original mounds, Indian removal, Simon Pokagon's speech at the World's Columbian Exposition, and an evocative, virtually unknown sculpture of Christ (see fig. 2.2).

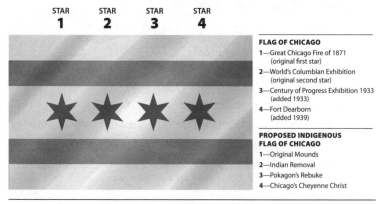

Figure 2.2. Flag of Chicago and proposed Indigenous flag of Chicago

[14]Ann Durkin Keating, *Rising Up from Indian Country: The Battle of Fort Dearborn and the Birth of Chicago* (Chicago: University of Chicago Press, 2012), 5.
[15]Keating, *Rising Up*, 246. Admittedly, while my proposal is an imaginative experiment, Keating's has a chance of succeeding, and should.

THE FIRST STAR: MOUNDS

As much as proper Chicagoans (and Chesterton) might look down upon the suburbs,[16] it is the suburbs that can best approximate the early views that surrounded Fort Dearborn, the fort with which the modern city of Chicago began. Moving twenty-five or so miles to the west of Chicago, the winding West Branch of the DuPage River looks very much like the winding Chicago River on the Fort Dearborn site two centuries ago (see fig. 2.3). And while the mounds within the city of Chicago have disappeared, ancient burial mounds can still be found on the banks of the DuPage.

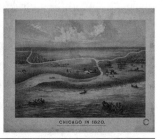

Figure 2.3. View of Winfield Mounds / Chicago Lithographic Co., Chicago in 1820 (c. 1867)

Estimates of the total mounds on this continent approach one million—most of which, like the original prairie itself, have been destroyed.[17] Like the Great Pyramids of Egypt, which some North American mounds predate,[18] and like burial mounds of Chinese emperors, these monuments are, or in this case were, testimony to collective humanity's insistence that death is not the end. "Your dead shall

[16]Unlimited suburban sprawl, for Chesterton, destroyed "at once the dignity of a town and the freedom of a countryside." G. K. Chesterton, *The New Jerusalem*, cited in Ian Ker, *G. K. Chesterton: A Biography* (Oxford: Oxford University Press, 2011), 418.

[17]Gregory L. Little, *The Illustrated Encyclopedia of Native American Mounds and Earthworks* (Memphis, TN: Eagle Wing Books, 2009), 2.

[18]Watson Brake in Louisiana dates to 3500 BC while traditionally the oldest pyramid, Djoser, dates to nearly a thousand years after that (c. 2600 BC).

live, their corpses shall rise," writes the prophet Isaiah. "The earth will give birth to those long dead" (Is 26:19). And that is what makes her, the earth, pregnant now—gravid with bodies awaiting the resurrection. The fourth-century theologians Macrina and Gregory of Nyssa, whose teachings are especially compatible with Indigenous approaches,[19] lived at the same time that these mounds were built. "Those outside our philosophy," Macrina told Gregory, "by various assumptions in different ways have partly attained to the doctrine of the resurrection."[20] Had settlers seen the mounds that way, perhaps fewer of them would have been ransacked and destroyed.

Following vandalism in 1927 and University of Chicago excavations in the 1930s, which discovered human remains that disintegrated on contact, Wheaton College enacted a salvage operation at the Winfield Mounds in 1975 and 1976, attempting to protect and catalog what was left of the site. The latest thesis on the area mounds by Peter Geraci more firmly dates the mounds to the Middle Woodland Period, AD 250–1000,[21] and evokes the cultural and spiritual importance of the area sites and springs as well.[22] Geraci gestures toward something

[19]Cheryl Bear, *Introduction to First Nations Ministry* (Cleveland, TN: Cherohala Press, 2013), 94.

[20]Gregory of Nyssa, *The Soul and the Resurrection*, trans. Catharine P. Roth (Crestwood, NY: St. Vladimir's Seminary Press, 2002), 89.

[21]As the latest researcher to study the area, Geraci approximates occupation around AD 250–500 and another around AD 700–900, when true arrowheads appear on the scene (personal communication). Brian and Joyce Ostberg at BeHistoric have produced five excellent deeply researched videos on the Winfield Mounds, including interviews with researchers. Begin with "The Winfield Mounds Prehistoric Site—Introduction," BeHistoric, accessed March 12, 2021, www.youtube.com/watch?v=Hi9A_Zy7Fog&t=329s.

[22]Peter John Geraci, "The Prehistoric Economics of the Kautz Site: A Late Archaic and Woodland Site in Northeastern Illinois" (master's thesis, University of Wisconsin-Milwaukee, 2016), *Theses and Dissertations*, 1141. "Springs have a spiritual significance in many Native American belief systems; they often figure prominently in creation myths as a source of life and/or interface between earth and the underworld such as the Winnebago myth of Blue-bear" (Geraci, "Prehistoric Economics," 200). Though Geraci focuses on the Kautz site, the Winfield Mounds 3 km (approx. 1.9 miles) south are "directly associated" with the Kautz site (Geraci, "Prehistoric Economics," 237).

above the archaeologist's pay grade, evoking sacred space. But rather than pursuing these connections, the mounds are named after "Old Fuss and Feathers," General Winfield Scott (1786–1866). Scott's military record is admittedly impressive.[23] But he also supervised the Trail of Tears. "Poor creatures!" he tells us of the Cherokee. "They had obstinately refused to prepare for the removal."[24] Scott's strangely upbeat account of that infamous journey, related in the third person so as to be able to confer praise upon himself, makes the Trail of Tears sound more like the Trail of Cheers. "He has reason to believe that, on the whole, their condition has been improved by transportation."[25]

The Winfield Mounds, or to use their official archaeological designation, Du-33,[26] have been associated with the northern edges of the Hopewell Ceremonial Complex (200 BC–AD 300) and the Havana Hopewell of the Illinois River basin within that.[27] But the site is also connected to the western edges of the spectacular Late Woodland Effigy Mounds tradition as well (AD 700–1100).[28] The Hopewell Complex was a trade network that connected massive swaths of North America east of the Rockies.[29] The objects found at Du-33 and other

[23]Timothy D. Johnson, *Winfield Scott: The Quest for Military Glory* (Lawrence: University Press of Kansas, 1998).

[24]Winfield Scott, *Memoirs of Lieut.-General Winfield Scott, LL.D.* (New York: Sheldon, 1864), 326.

[25]Scott, *Memoirs*, 329. Timothy Johnson points out that "although he accepted the responsibility of fulfilling his government's policy, he nevertheless felt sorrow for the Cherokees." Johnson, *Winfield Scott*, 133.

[26]The "Du" refers to their being in DuPage County.

[27]Douglas Kullen, "The Archeology of Winfield Mounds and Village, DuPage County, Illinois," *Wisconsin Archeologist* 70, no. 3 (1989): 343-44. Robert A. Birmingham and Amy L. Rosebrough, *Indian Mounds of Wisconsin*, 2nd ed. (Madison: University of Wisconsin Press, 2017), 84-85.

[28]Kullen, "Archeology of Winfield Mounds," 344-45. Based on this connection, Kullen dates the mounds "from sometime between A.D. 300 and 1642," with the later village at the same site to "sometime between A.D. 800 to 1100."

[29]A lavishly illustrated account of Hopewell (and other ancient cultures) is on offer in Bradley T. Lepper, ed., *Ohio Archaeology: An Illustrated Chronicle of Ohio's Ancient American Indian Cultures* (Wilmington, OH: Orange Frazer Press, 2005).

sites nearby are not terribly impressive. But other Hopewell mound burial sites include richly elaborate pottery, sculpture, statuary, animal pipes, grizzly-bear teeth, shells, and obsidian—a continental collage.[30] Refuting those who dismissed such mortuary practices as primitive, Chesterton wrote, "I believe they put food or weapons on the dead for the same reason that we put flowers, because it is an exceedingly natural and obvious thing to do."[31] Simply put, the Newark Earthworks in present-day Ohio, a famous Hopewell site contemporary to the Du-33 mounds, is "the largest and most precise complex of geometric earthworks in the world."[32] But perhaps an even greater marvel is that, although these mounds are as sophisticated as Stonehenge and as enormous as the Nazca geoglyphs in Peru, few area residents know about them.[33] The theme that characterizes these earthworks, and the sculptures and offerings associated with them, is again resurrection: "The rebirth and renewal of the world and all its living things."[34]

As corn moved north and became a staple of what is now the Chicago-land area,[35] mounds became more, we might say, playful in the Late Woodland period. Possibly activated by lost liturgies, these later effigy mounds, often in the shapes of animals and birds, were "built to symbolize and ritually maintain balance and harmony with the natural world within the contexts of ceremonies of renewal and rebirth."[36] One site on the Mississippi River boasted 894 such mounds.[37] Extending well

[30]Birmingham and Rosebrough, *Indian Mounds of Wisconsin*, 93-94.

[31]G. K. Chesterton, *A Tonic for Malaise: Selected Essays*, ed. Madeline Johnson (Hillsdale, MI: Hillsdale College Lyceum, 2016), 69.

[32]Richard D. Shiels, "The Newark Earthworks Past and Present," in *The Newark Earthworks: Enduring Monuments, Contested Meanings*, ed. Lindsay Jones and Richard D. Shiels (Charlottesville: University of Virginia Press, 2016), 23.

[33]Lindsay Jones, "I Had No Idea! Competing Claims to Distinction at the Newark Earthworks," in Jones and Shiels, *Newark Earthworks*, 1.

[34]Birmingham and Rosebrough, *Indian Mounds of Wisconsin*, 87.

[35]Birmingham and Rosebrough, *Indian Mounds of Wisconsin*, 103.

[36]Birmingham and Rosebrough, *Indian Mounds of Wisconsin*, 125.

[37]Birmingham and Rosebrough, *Indian Mounds of Wisconsin*, 122.

beyond the famous Effigy Mounds site on the Mississippi, Late Wood-
land animorphic mounds were documented in the early twentieth cen-
tury in Aurora, Illinois, along the Fox River. One group of mounds
depicted birds flying to the south;[38] perhaps they were Thunderbirds. A
lizard mound was documented on Chicago's North Side (destroyed to
make way for the Brown Line of the El train), bringing what was per-
haps the Mishipeshu into the conversation as well (see fig. 2.4).[39] Chica-
goans would do well to think of such mounds when they watch pitchers
hurl balls from the mound at Wrigley Field, not far from the lost lizard
mound. The throwing motion used by those pitchers was the same em-
ployed by ancient hunters, who affixed atlatls to their spears for addi-
tional thrust.[40] Those atlatls, forged at the time of Moses and
David (1500–1000 BC), are easily as impressive as Brâncuși's abstract
bird in flight (AD 1919–1920) that stands proudly in the Modern Wing
of the Art Institute of Chicago today (see fig. 2.5). Which is to say, In-
digenous artists in what is now the Midwest beat modernists to the
punch by roughly three thousand years.[41]

The marvels of Indian abstraction, whether in the form of ancient
birdstones or medieval animal mounds, gives Midwesterners much to
celebrate. After the Effigy Mounds culture, however, came the men-
acing grids of settlement. I refer not to the modern electric-powered
street grids of Illinois, but to the similar grids of Cahokia, a city

[38]J. F. Snyder, "Prehistoric Illinois: Certain Indian Mounds Technically Considered," *Jour-
nal of the Illinois State Historical Society (1908–1984)* 1, no. 4 (1909): 33-34.
[39]"According to archaeologist Kurt Sampson, the Lakeview 'lizard' resembles many 'water
panther' effigy mounds in Wisconsin." Jesse Dukes, "Map Quest: Searching for Chicago's
'Lizard Mound,'" WBEZ 91.5 Chicago, April 15, 2018, https://interactive.wbez.org
/curiouscity/lakeview-effigy-mound/. The mound would have been about where the
Wellington stop is today.
[40]The bow and arrow replaced spear throwing for hunting and fighting in the region
around AD 500. Birmingham and Rosebrough, *Indian Mounds of Wisconsin*, 102.
[41]For an exploration of more recent abstraction in Indigenous art, see Philip J. Deloria,
Becoming Mary Sully: Toward an American Indian Abstract (Seattle: University of Wash-
ington Press, 2019).

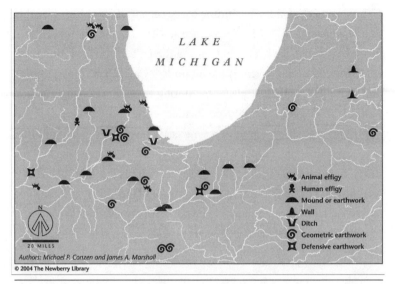

Figure 2.4. Michael P. Conzen and James A. Marshall, Ancient Indian Earthworks in the Chicago Region

Figure 2.5. Birdstone, Archaic Illinois and Indiana, 1500/1000 BC

planned in line with the axes of the sun and the moon. Though closer to present-day St. Louis, Cahokia can be referenced in connection to the Chicagoland area because the "militaristic imaginary"[42] of this empire expanded at the expense of others.[43] The corn kingdom of

[42]Birmingham and Rosebrough, *Indian Mounds of Wisconsin*, 165.

[43]One of the great Mississippian outposts was Aztalan in present-day Wisconsin. Reasons for this expansion may have been to "conquer potential enemies, to demonstrate the

Cahokia emerged at the beginning of the second millennium, possibly as a response to an AD 1054 supernova.[44] The swelling of this culture, moreover, may have been what caused the Late Woodland Indians to cease the creation of animorphic mounds.[45] Cahokia was magnificent, and merciless, at least if you were among those ritually sacrificed at mound 72. These were public performances of women being clubbed or strangled to death—four at a time at first, then seven. On another occasion, nineteen people were ritually murdered, then twenty-four, thirty-nine, and fifty-three at a time, in theatrical, public displays.[46] And finally, after exploiting both people and land, elitist Cahokia collapsed on its own before any European settler arrived on the scene.[47] As one comprehensive study puts it:

> [Such] findings call into question some long-held beliefs—for instance, that ecologically sensitive, peaceful, mystical, and egalitarian peoples freely roamed the North American continent, never overpopulating or overexploiting their environments; or that these people were not subject to such base human emotions as avarice, greed, and covetousness and thus could not have built cities or allowed power to be concentrated in the hands of elites.[48]

power and status of individual rulers and their lineages, and even to spread religious beliefs." Birmingham and Rosebrough, *Indian Mounds of Wisconsin*, 165.

[44]Timothy R. Pauketat, *Cahokia: Ancient America's Great City on the Mississippi* (New York: Viking Penguin, 2009), 23.

[45]Pauketat, *Cahokia*, 86. There may be possible visual evidence for Cahokia's expansion in the Gottschall Rockshelter imagery as well. This is not to simplistically infer that Cahokia's colonizing violence is to be contrasted to its peaceful northern neighbors. At the Turkey River site, one of the earliest Late Woodland effigy mound locations, there is considerable evidence for violent death. Birmingham and Rosebrough, *Indian Mounds of Wisconsin*, 83.

[46]Pauketat, *Cahokia*, 80. "Possibly they were captives, taken from the hometowns. . . . They might also have been considered slaves, . . . or they might have been local farm girls who understood their part in a community-wide celebratory drama, as symbolic wives of the Morning Star or personification of goddesses." Pauketat, *Cahokia*, 113.

[47]"The reasons for the demise of Cahokia may have been varied and included overexploitation of local resources, internal political friction, warfare, loss of ideological power, and widely fluctuating climatic swings." Birmingham and Rosebrough, *Indian Mounds of Wisconsin*, 184.

[48]Pauketat, *Cahokia*, 3.

And so, the first thing to say when retelling the history of Chicagoland is, yes, the mounds were symbols of hope, evoking Chesterton's benevolent view of pagan cultures awaiting Christianity—*and*, yes, they became monuments to human sacrifice that may have exploited and ritually murdered the more playful mound building culture to the north, evoking Chesterton's Carthage, which "fell because she was faithful to her own philosophy and had followed out to its logical conclusion her own vision of the universe. Moloch had eaten his children" (see fig. 2.6).[49] And yet, even here Chesterton can help us look with sympathy, contrasting Cahokia with modern versions of devaluing human life. Pagan sacrifices, he argued, were "infinitely more decent and dignified. . . . The pagan altar at least treated a man's life as something valuable, while the lethal chamber treats a man's life as something valueless."[50]

Even so, to conclude a discussion of the mounds by ending with Cahokia would leave out the revival of the mound tradition today. In his visits to the Eternal City, Chesterton insisted that a theology of perpetual resurrection, "pagan" culture positively reborn, is "the real clue about Rome,"[51] and it may be the real clue about Chicagoland as well. Thanks to Michael Heizer's *Effigy Tumuli* at Buffalo Rock State Park on the Illinois River,[52] or the contemporary mound work of Indigenous

[49]G. K. Chesterton, *The Everlasting Man* (1925; repr., San Francisco: Ignatius Press, 1993), 149.

[50]G. K. Chesterton, *As I Was Saying: A Book of Essays*, cited in Ker, *G. K. Chesterton*, 721. Or as Philip Jenkins remarks, "Such acts [of ritual Indigenous violence at sites like Cahokia] did not discredit their culture or their religions, any more than the sporadic outbursts of religious violence in contemporary Europe should be taken as necessary characteristics of Christianity." Jenkins, *Dream Catchers*, 221.

[51]G. K. Chesterton, *Resurrection of Rome* (New York: Dodd, Mean & Company, 1930), 462. "The first fact to be seized about [the Renaissance] is that it was emphatically a Christian movement. . . . We all understand the sense in which it is called Pagan, for it was certainly in that sense a resurrection of Paganism. But only the Paganism was Pagan; not the resurrection" (355). Perhaps a similar claim can be made about aspects of the Turtle Island Renaissance underway in North America today.

[52]Michael Heizer, "Effigy Tumuli," Double Negative, http://doublenegative.tarasen.net/effigy-tumuli, accessed April 16, 2021. I thank the Chicagoland artists David Wallace Haskins and Joel Sheesley for this reference.

Figure 2.6. Herb Roe, artist's conception of Mound 72 sacrifice ceremony at Cahokia

artist Santiago X in Chicago,[53] or through the Midwestern school buildings built in the shapes of turtles and Thunderbirds further afield,[54] Midwestern mounds are no longer simply monuments of the past, but testify to the resurrection of Indigenous area culture today.

THE SECOND STAR: INDIAN REMOVAL

If the Chicago flag's first star, the settlement of Fort Dearborn, can be reimagined as the ancient mounds that are resurfacing today, then the Great Chicago Fire of 1871—the city's second star—can be replaced, for

[53] These include "Serpent Twin" in Schiller park and "Coil Mound" in Horner Park. Darcel Rockett, "Coiled Snake Earthworks Planned for Horner Park," *Chicago Tribune*, March 7, 2021, 5.

[54] At the Oneida Nation elementary school in Wisconsin, Indigenous language instruction takes place in the very heart of the turtle. There are currently plans for a Thunderbird-shaped school at the Forest County Potawatomi reservation in Wisconsin, and one such structure already exists at the Fond du Lac College in Cloquet, Minnesota. Joy Monice Malnar and Frank Vodvarka, *New Architecture on Indigenous Lands* (Minneapolis: University of Minnesota Press, 2013), 85.

the purposes of this exercise at least, with a far more serious tragedy, that of Indian removal. In the late eighteenth century, Native presence in the Great Lakes region around what is now Chicagoland comprised "networks of family, trade, tribe, and visions of the future."[55] Resources, not real estate, are the keys to understanding these complex networks.[56] The Effigy Moundbuilding societies had long dispersed. Among other nations, the Ho-Chunks (long known as Winnebago) today claim a connection to the mound cultures (specifically the Oneota) and were to the north of what is now Chicagoland.[57] To the west along the Rock River were the Sauk, who had moved into the area following the decline of the Illinois Confederacy encountered by Father Jacques Marquette.[58] To the south were the Kickapoo. Other nations near the area included the Miami, and to an extent the Shawnee and Delaware. But what would become Chicagoland was primarily Anishinaabe, Potawatomi more specifically, who controlled "eighteen million acres in a wide band running from Detroit across Lake Michigan to Milwaukee."[59] Yet, the 1696 Jesuit Mission of the Guardian Angel to the Miami, once within what is now Chicago proper, is a reminder that many Native Americans laid claim to the area.[60]

The Potawatomi had migrated to the Great Lakes from the Saint Lawrence River area. Tribal tradition says this migration was due to a

[55]Keating, *Rising Up*, 7.

[56]Keating, *Rising Up*, 7.

[57]Paul Radin, *The Winnebago Tribe* (1923; repr., Lincoln: University of Nebraska Press, 1990). For a list of other tribes with associations to the Effigy Mound culture, see "Effigy Moundbuilders," National Park Service, accessed March 12, 2021, www.nps.gov/efmo /learn/historyculture/effigy-moundbuilders.htm.

[58]Keating, *Rising Up*, 15. A possible glimpse at Illini material culture can be seen at the Minneapolis Institute of Art, a shirt made from animal hide from c. 1720–1750. Another hide with an abstract Thunderbird design is at the Quai Branly Museum in Paris.

[59]Keating, *Rising Up*, 14.

[60]Bradley J. Birzer, "Miamis," *Encyclopedia of Chicago*, accessed March 12, 2021, www .encyclopedia.chicagohistory.org/pages/825.html. I thank Michael Zimmerman Jr. (Potawatomi) for this reference.

vision of food upon water (wild rice), which is not inconsistent with the traditional historical explanation: that they moved westward due to the expanding Haudenosaunee, or Iroquois Confederacy, who part-nered with the Dutch and British in the fur trade.[61] All in all, the esti-mated population of Indians in the western Great Lakes area was about 30,000, a figure doubled "across the Great Lakes more broadly."[62] By interposing his ancestors over a Chicagoland map, Indigenous artist Chris Pappan reminds us of these original residents of various Indigenous nations. The figures are distorted like funhouse mirrors, a skillful depiction of skewed settler vision (see fig. 2.7).

The tragedy of removal comes into proper focus only when the real possibility of shared inhabitation is grasped. Following a series of ugly frontier conflicts culminating in the 1794 Battle of Fallen Timbers (to be explored more fully in the next chapter), a covenant was struck between the American government and the Indians of what is now the Midwest. The Treaty of Greenville, resulting from negotiations that took place from June to August of 1795, "stands as perhaps the final instance of extensive and meaningful use of wampum diplomacy on the part of both Native and American negotiations."[63] Another scholar calls Greenville "perhaps the most decisive treaty ever made between the United States and Indigenous people in North America."[64] General "Mad" Anthony Wayne— nicknamed Mad not just for his youthful hotheadedness but also for his "growing obsession with military discipline"—presided.[65] The Shawnee chief Blue Jacket and Miami chief Little Turtle were among

[61]Keating, *Rising Up*, 8, 12.
[62]Keating, *Rising Up*, 15-16.
[63]Daniel F. Harrison, "Change amid Continuity, Innovation Within Tradition: Wampum Diplomacy at the Treaty of Greenville, 1795," *Ethnohistory* 64, no. 2 (2017): 196.
[64]William Hogeland, *Autumn of the Black Snake: The Creation of the U.S. Army and the Inva-sion That Opened the West* (New York: Farrar, Straus & Giroux, 2017), 373.
[65]Hogeland, *Autumn of the Black Snake*, 262.

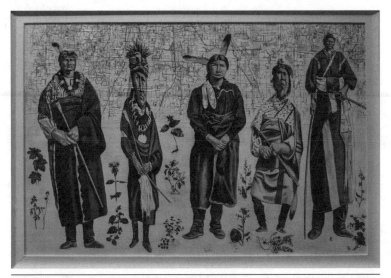

Figure 2.7. Chris Pappan (b. 1971, Osage/Kaw/Cheyenne River Lakota Sioux), *Fox River Delegation* (2008)

the leaders representing the Indians. But unlike the British and George Washington, who referred to Native people as children, General Wayne, who presided over the council, insisted on referring to them as brothers.[66] "The Great Spirit is the true and only owner of this soil," claimed the Wyandot chief Tarhe, "and he has given us an equal right to it."[67] The treaty was signed by twenty-three Potawatomi, who generally brokered a positive arrangement: they gave up some small tracts of land, including six square miles at the mouth of the Chicago river (the site of Fort Dearborn), in exchange for annuities.[68] The Delaware who signed the treaty, having been betrayed

[66]Hogeland, *Autumn of the Black Snake*, 197. By contrast, on the manuscript of one speech to the Indians, Washington crossed out the word *brothers* to replace it with *children*. Colin G. Calloway, *The Indian World of George Washington* (Oxford: Oxford University Press, 2018), 459.

[67]Hogeland, *Autumn of the Black Snake*, 198. Happily, a 1915 monument to Tarhe, "distinguished Wyandot Chief and loyal American," stands along Ohio's Sandusky River.

[68]Keating, *Rising Up*, 40.

by the British, were even prepared to leave their enmity of the United States behind.[69]

Even if the conditions were not ideal,[70] the Treaty of Greenville marked the "twilight of true wampum diplomacy,"[71] which is to say, it was the last treaty negotiation in which Native people and settlers trusted one another enough to respect Indigenous oral tradition and diplomatic culture.[72] All in all, twenty-three belts were exchanged over a series of days.[73] These wampum, made of tiny tubular beads cut from Atlantic mollusks, signified "open and honest communication."[74] Another, evoking a tomahawk removed from Wayne's head, was a "ritual renunciation of war."[75] One of the wampum that sealed this treaty is still on view at Fort Meigs in Ohio. The triangles likely represent the fifteen fires of the United States (fifteen states at the time), and the bands the ten nations of the Northwestern Indian Confederacy (see fig. 2.8).[76]

The treaty assumed a clear boundary line between White settlers and Native Americans that quickly dissolved. A younger generation

[69]John P. Bowes, *Land Too Good for Indians: Northern Indian Removal* (Norman: University of Oklahoma Press, 2016), 87.

[70]Richard White, *The Middle Ground: Indians, Empires, and the Republics in the Great Lakes Region, 1650–1815* (Cambridge: Cambridge University Press, 1991), 472. White points out the complexities that arose from inability to determine who could represent what territory. "On the surface, Wayne negotiated with the Indian confederation, . . . but in reality he negotiated with quarrelling and embittered groups of villagers" (472).

[71]Harrison, "Change amid Continuity," 193. While the presentation of wampum beads is documented up to 1841, "there are no recorded instances after 1795 where treaty negotiations were conducted as they were at Greenville" (Harrison, "Change amid Continuity," 211).

[72]Harrison, "Change amid Continuity," 199. Wampum protocol was not just Iroquoian but Abenaki as well, lending more credence to the notion that such a tradition could represent many Indian nations. I thank Mike Zimmerman Jr. for this clarification.

[73]Harrison, "Change amid Continuity," 204.

[74]Harrison, "Change amid Continuity," 197.

[75]Harrison, "Change amid Continuity," 198.

[76]Harrison, "Change amid Continuity," 207. The nations of the Western Confederacy at this time were the Wyandot, Delaware/Lenape, Shawnee, Odawa, Ojibwe, Potawatomi, Miami, Eel River, Wea, and Kickapoo (Harrison, "Change amid Continuity," 196).

Figure 2.8. Greenville Treaty Wampum Belt (1795) on display at Fort Meigs, Ohio

of Potawatomi warriors who were not promised annuities found such negotiations repulsive.[77] Still, recent Indigenous voices have suggested that treaties agreed upon at this ceremonial scale, at least in spirit, can still be in effect, even if later sales and arrangements nullified some details. As Suzan Harjo (Cheyenne and Hodulgee Muscogee) puts it:

> Treaties intertwine nations at the time of their making and throughout their histories. . . . A decision to dissolve a nation-to-nation treaty relationship would be immense, larger than the original one that forged the agreement. None of the United States' treaties with Native Nations has ever been abrogated, even though most have been stretched to the breaking point, ignored, or all but forgotten.[78]

Before the mollusks were dry from the Treaty of Greenville, the stretching began. From 1803 to 1809, Thomas Jefferson worked with William Henry Harrison, then governor of the Indiana Territory, to negotiate no less than fifteen additional treaties. Absent any of the wampum ceremony, their express aim was to gain "as large a share of the most valuable land for cultivation as circumstances will admit."[79] Harrison did not hesitate to "whet the wheels of diplomacy" with whiskey kegs when negotiations stalled.[80] Settler encroachment combined with lack of enforcement, spiked by Indigenous resentment

[77]Harrison, "Change amid Continuity," 40-41.

[78]Suzan Shown Harjo, ed., *Nation to Nation: Treaties Between the United States and American Indian Nations* (Washington, DC: Smithsonian Books, 2014), 1.

[79]Keating, *Rising Up*, 53-54.

[80]James Joseph Buss, *Winning the West with Words: Language and Conquest in the Lower Great Lakes* (Norman: University of Oklahoma Press, 2011), 33. It did not help that Jefferson's ideal of the male farmer conflicted with the region's Indigenous notions of gender, where agriculture was the expert domain of women. Keating, *Rising Up*, 43.

stoked by the British, increased tensions dramatically.[81] As Chesterton once remarked, "The Republic of the young men's battles grew stale and stank of old men's bribes."[82]

The confederacy of the betrayed organized under the charismatic leadership of Tecumseh and his younger brother, the prophet Tenskwatawa, who preached racial purity to the point of mandating the separation of families of mixed race.[83] While Tecumseh was gathering forces, Tenskwatawa attacked William Henry Harrison's troops, and Tecumseh's confederacy was defeated at the Battle of Tippecanoe in 1811.[84] The next year came the attack, by a small force of Potawatomi, on Fort Dearborn. The possibilities of shared inhabitation imagined by the Treaty of Greenville were dissolving as settlers overwhelmed the agreed-upon lines.

When an ambitious Sauk warrior named Black Hawk who had fought alongside Tecumseh challenged the new arrangement, he was defeated in what became known as the Black Hawk War of 1832. This conflict marked the beginning of the US policy of "strip[ping] tribes of their land bases [and] their culture, economic, and political independence as well."[85] Black Hawk was quite willing to return the favor, even to his fellow Indians, desiring the "annihilation, if possible, of all their [the Cherokee] race" who had killed his father.[86] Even so, after

[81]Harrison, "Change amid Continuity," 211.

[82]G. K. Chesterton, *The Queen of Seven Swords* (London: Sheed & Ward, 1946), 20.

[83]"Tenskwatawa's dictates struck at the heart of long-standing relationships between Indians and white traders." Keating, *Rising Up*, 80.

[84]Phil Christman observes, "In a sense, Tenskwatawa *did* win. The concept of '*The* Indian' owes a lot to him; by helping to create a kind of pan-Indian political project, he made possible inter-tribal cooperation that has underwritten Native resistance and survival ever since." Phil Christman, *Midwest Futures* (Cleveland: Belt, 2020), 46-47.

[85]Patrick J. Jung, *The Black Hawk War of 1832* (Norman: University of Oklahoma Press, 2007), 185.

[86]Black Hawk, *Life of Black Hawk*, ed. J. Gerald Kennedy (New York: Penguin Books, 2008), 16. By modern standards, Black Hawk's views on race, as with Tenskwatawa's, were less than enlightened. His considered solution to those of African descent was to sell separate

some initial victories, Black Hawk was overcome. The Sauk were cut down on the Mississippi River after Black Hawk—leading a band that included women and children—attempted to surrender twice.[87] Even Sauk babies were deliberately shot.[88] Black Hawk survived the struggle thanks to a young Sauk boy who, tired of fighting, received the pipe of peace on his behalf.[89] Black Hawk was imprisoned near the epicenter of the Late Woodland Effigy Mound culture, not far from Prairie du Chien where so much of what is now Chicagoland was ceded just a few years before.[90]

Faced with the enormity of European influx in his subsequent visits to Baltimore and Philadelphia, where he was received like a celebrity, Black Hawk agreed to peace. But he also wrote in his autobiography that he was "very much afraid, that in a few years, they will begin to drive and abuse our people, as they have formerly done. I may not live to *see* it, but I feel certain that the day is not distant."[91] As the autobiography was published, the 1833 Treaty of Chicago was sealed; in it the remaining Native people of Chicagoland brokered the best arrangements they could for themselves under the circumstances, a "bloodless conquest of monumental proportions."[92] The Pokagon band of Potawatomi managed to remain by purchasing land in Michigan. But

Black women and men to different American regions, "and it will not be long before the country is clear of the *black skins*" (Black Hawk, *Life of Black Hawk*, 97).

[87] Jung, *Black Hawk War of 1832*, 183.

[88] Jung, *Black Hawk War of 1832*, 174.

[89] Jung, *Black Hawk War of 1832*, 182.

[90] Large portions of what is now Chicagoland were ceded at the Second Treaty of Prairie du Chien in 1829 by the Ojibwe, Ottawa, and Potawatomi of Illinois (Sections 148 and 149). Charles C. Royce, *Indian Land Cessions in the United States* (Newberry Library, Ayer 301. A2 1896-97, pt. 2, pl. 125). These maps are available under "Treaties Past" at the Newberry Library's excellent Indians of the Midwest site, https://publications.newberry.org/indians -midwest. Accessed April 16, 2021.

[91] Black Hawk, *Life of Black*, 198.

[92] John N. Low and Paula Holley, "Treaty of Chicago—September, 1833," in *Native Chicago*, ed. Terry Straus, 2nd ed. (n.p.: Albatross Press, 2002), 107. The authors add, "the Natives were not hapless victims of the colonization juggernaut."

when another Potawatomi band led by Chief Menomini (also spelled Menominee) in Indiana attempted a similar purchase, they were tricked into congregating in their chapel, which enabled their capture.[93] A week later, 850 of them were escorted west under American military guard. This Trail of Death was followed by additional removals, or flights to Canada.[94]

While Northerners tend to consider ourselves free from the troubles lately faced by Southern monument culture in the United States, it needs be remembered that the Midwest currently remembers the events just related with columns of triumph.[95] One in Indianapolis, the Indiana Soldiers and Sailors Monument (dedicated in 1902), proclaims Harrison the "conqueror of the Indian Confederacy." Another, in Illinois, commemorating a site of the Black Hawk War where a young Abraham Lincoln buried some scalped soldiers, reads: "The presence of soldier, statesman, martyr, Abraham Lincoln assisting in the burial of these honored dead has made this spot more sacred" (erected in 1901).[96] I do not dispute the facts that these columns commemorate, or the dignity of the lives there lost. But should we follow the trail to where America dumped the Christian Potawatomi, who simply aimed to live by the terms of the Treaty of Greenville, we find not columns of triumph, but crosses, on which the names of all those who were brought there to die are lovingly spelled out. Which is to say, if the blood of the martyrs is what makes places holy, the Midwest has holiness to spare. (See figs. 2.9.1–2.9.3 for all the monuments mentioned here.)

[93]James A. Clifton, *The Prairie People: Continuity and Change in Potawatomi Indian Culture, 1665–1965*, rev. ed. (Iowa City: University of Iowa Press, 1998), 298. Shirley Willard and Susan Campbell, *Potawatomi Trail of Death: 1838 Removal from Indiana to Kansas* (Rochester, IN: Fulton County Historical Society, 2003), 148.

[94]Clifton, *Prairie People*, 299-311.

[95]W. C. Madden, *Indianapolis*, Then and Now Series (Charleston, SC: Arcadia, 2003), 83.

[96]Lorenzo A. Fiorentino, *Illinois Military Monuments* (Charleston, SC: Arcadia, 2019), 22.

Figure 2.9.1. Indiana State Soldiers and Sailors Monument, Indianapolis, Indiana

Figure 2.9.2. Stillman's Run Battle Site, Stillman Valley, Illinois

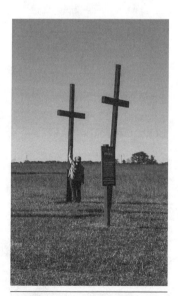

Figure 2.9.3. Potawatomi gravesite at the terminus of the Trail of Death, St. Philippine Duchesne Memorial Park, Kansas

Speaking of holy places, while on a visit to Rome, Chesterton mar-
veled at the Egyptian obelisk in the Piazza del Popolo. Once dedicated
to the Egyptian sun god by Ramses II and then, under Augustus, to the
sun god of the Romans, it is now surmounted by a Christian cross. "This
stone, once dedicated to two sun gods," Chesterton remarked, "now
stands in a light that is brighter than twenty suns."[97] Unlike in Rome,
Midwestern columns and crosses are separated by thousands of miles
because of forced evictions.[98] Perhaps it is the job of the twenty-first-
century Christian Midwesterner to, without forgetting the suffering of
settlers, imagine our monuments with Indigenous crosses on top.

THIRD STAR: POKAGON'S REBUKE

In the transcriptions of Tecumseh's speeches to William Henry Har-
rison in 1810, Tecumseh appeals to the violated Treaty of Greenville[99]
and, furthermore, appears to do so on Christian grounds:

> How can we have confidence in the white people when Jesus Christ came
> upon the earth you kill'd and nail'd him on a cross, you thought he was
> dead but you were mistaken. . . . Everything I have told you is the truth.
> The great spirit has inspired me and I speak nothing but the truth to you.[100]

Whatever we make of such rhetoric—and taking it at face value should not
be ruled out—a similar and equally forceful Christian address by a dif-
ferent Indian, Simon Pokagon, is the event I am advancing for Chicago's

[97]G. K. Chesterton, *The Resurrection of Rome* (New York: Dodd, Mead, 1930), 124-25.

[98]Fortunately, however, there is a 37-foot obelisk, dedicated in 1872, marking the site of
the 1782 Gnaddenhutten Massacre, and Lorado Taft's 48-foot-tall The Eternal Indian
(1911, restored 2020) stands over the Rock River in Illinois.

[99]William Henry Harrison, *Messages and Letters of William Henry Harrison* (Indianapolis:
Indiana Historical Commission, 1922), 464.

[100]Harrison, *Messages*, 467. Earlier volumes of Chicago history did highlight this passage.
See Lloyd Lewis, *Chicago: History of Its Reputation* (New York: Harcourt, Brace, 1929),
12-13. That such a speech survives in the records is remarkable considering "we only have
Euroamerican transcriptions of his speeches." Rachel Buff, "Tecumseh and Tenskwatawa:
Myth, Historiography and Popular Memory," *Historical Reflections* 21, no. 2 (1995): 280-81.

third star. The World's Columbian Exposition of 1893 itself, celebrating—one year late—the four hundredth anniversary of Columbus's arrival in the New World, is currently commemorated on the Chicago flag, and Pokagon's speech happened within that celebration. Simon Pokagon was the son of Chief Leopold Pokagon, making him among the Potawatomi who had brokered an arrangement to remain in the area.[101] Pokagon chose not to protest this celebration that lionized European culture, but—like Wells and Douglass[102]—secured an opportunity to speak within it.[103] Yet Pokagon's speech, defiantly printed on birch bark, is itself a protest against the lack of Native inclusion in the opening ceremonies of the fair.[104] (See fig. 2.10 for samples of *The Red Man's Rebuke*.) One surprised listener to this address complained that Pokagon was the "only man yet discovered who has seen the World's Fair and doesn't approve of it."[105]

Figure 2.10. Simon Pokagon, *The Red Man's Rebuke* (1893)

[101]I am grateful that Casey Church, related to the Pokagons, wrote the preface to this book.

[102]Ida B. Wells, et al., *The Reason Why the Colored American Is Not in the World's Columbian Exposition*, Library of Congress, www.loc.gov/item/mfd.25023/, accessed April 19, 2021.

[103]Low and Holley, "Treaty of Chicago," 106.

[104]Jonathan Berliner, "Written in the Birch Bark: The Linguistic-Material Worldmaking of Simon Pokagon," *PMLA* 125, no. 1 (2010): 73-91. "Once we begin to see Pokagon's writing materials not simply as kitsch but as a directed, progressivist kind of mass-cultural production, the potential import of his work comes into sharper focus" (80). And it does when we view it as Christian prophecy as well!

[105]Cited in Melissa Rinehart, "To Hell with the Wigs! Native American Representation and Resistance at the World's Columbian Exposition," *American Indian Quarterly* 36, no. 4 (2012): 423.

Some parts of Pokagon's speech are frequently cited, such as the following remark:[106]

> And while . . . your hearts in admiration rejoice over the beauty and grandeur of this young republic and you say, "behold the wonders wrought by our children in this foreign land," do not forget that this success has been at the sacrifice of our homes and a once happy race.[107]

But there is good reason Pokagon's speech is rarely quoted in its entirety. Pokagon goes out of his way to celebrate the Christianity that he had made his own: "To be just, we must acknowledge there were some good men with these strangers, who gave their lives for ours, and in great kindness taught us the revealed will of the Great Spirit through his Son Jesus, the mediator between God and man." And then he wields that very faith, as did Tecumseh, as a sword against his colonizers:

> But while we were taught to love the Lord our God with all our heart, mind, and strength, and our neighbor as ourselves, and our children were taught to lisp, "Our Father who art in heaven, hallowed be thy name," bad men of the same race, whom we thought of the same belief, shocked our faith in the revealed will of the Father, as they came among us with bitter oaths upon their lips, something we had never heard before, and cups of "fire-water" in their hands, something we had never seen before.[108]

If Chesterton reminds us that Christ "never restrained his anger,"[109] it was a reminder that Pokagon did not need. As his speech continues, Pokagon appeals to God's judgment—the day when the great drum

[106]John N. Low, foreword, in *Mapping Chicagou/Chicago: A Living Atlas*, Settler Colonial City Project (Chicago: Chicago Architecture Biennial, 2019), 6.

[107]Simon Pokagon, *The Red Man's Rebuke* (Hartford, MI: Engle, 1893), 10, https://library.si.edu/digital-library/book/redmanquotsrebu00poka, accessed March 13, 2021.

[108]Pokagon, *Red Man's Rebuke*, 5.

[109]G. K. Chesterton, *Orthodoxy* (1908; repr., New York: Image, 1959), 170.

will beat. And God opens his mouth to settlers and says: "I gave my only Son, who declared unto you my will . . ." Yet,

> I also find you guilty of following the trail of Christian missionaries into the wilderness among the natives, and when they had set up my altars, and the great work of redemption had just begun, and some in faith believed, you then and there most wickedly set up the idol . . . [of taverns]. . . . But now I say un to you, Stand back! You shall not tread upon the heels of my people, nor tyrannize over them any more.[110]

Pokagon has been accused of being, in his novels at least, an assimilationist.[111] But those who heard his speech, which concludes with Christ warning that he will delegate the Indians to "cast you out of Paradise, and hurl you headlong through its outer gates into the endless abyss beneath," might have concluded otherwise.[112] A famous 1894 novel, with Christ overturning tables on the frontispiece, was entitled, *If Christ Came to Chicago*.[113] In the year prior to that publication, through his servant Simon Pokagon, perhaps he did.

There are considerable parallels between Pokagon's critique of mainstream America as represented by the World's Columbian Exposition and Chesterton's critique of America published early in the next century. Both writers decry America's, particularly Chicago's, gun culture. In Pokagon's speech, the Great Spirit thunders: "Neither shall you with gatling-gun or otherwise disturb or break up their [Native] prayer meetings in camp any more."[114] Pokagon is likely referring to the 1890 Massacre at Wounded Knee that had happened three years

[110]Pokagon, *Red Man's Rebuke*, 15-16.

[111]Charles R. Larson, *American Indian Fiction* (Albuquerque: University of New Mexico Press, 1979), 44.

[112]Larson, *American Indian Fiction*, 16.

[113]W. T. Stead, *If Christ Came to Chicago! A Plea for the Union of All Who Love in the Service of All Who Suffer* (Chicago: Laird & Lee, 1894).

[114]Pokagon, *Red Man's Rebuke*, 16.

previously. For Chesterton, the machine gun was a tool long used by governments "against barbarians so brutal and ignorant as not to surrender their own mines or oil fields to the foreign millionaires who govern most of the governments."[115] But Chicago in particular offered the unwelcome development of "the organized use of machine guns by the ordinary criminal classes."[116] Admittedly Chesterton is more lenient toward alcohol than Pokagon, who sees alcoholism as something of a serpent, perhaps evoking the Mishipeshu.[117] But whether they are for or against alcohol, what unites them is the matter of justice. For Pokagon, the use of alcohol was to hinder Indians, and for Chesterton, its hypocritical prohibition hindered the poor. "[I]n modern America . . . the wealthy are all at this moment sipping their cocktails, and discussing how much harder labourers can be made to work if only they can be kept from festivity. . . . So long as you do not believe in justice, and so long as you are rich and really confident of remaining so, you can have Prohibition and be as drunk as you choose."[118]

Finally, both Pokagon and Chesterton were unimpressed by Chicago's high-rise architecture which was just then emerging. Both authors explicitly oppose the modern myth of the skyscraper.[119] "All our fathers once loved to gaze upon," complains Pokagon in his speech, "was destroyed, defaced, and marred, except the sun, moon and starry skies above, which the Great Spirit in his wisdom hung beyond their reach."[120] Pokagon foretells environmental degradation that few today would dispute. In a similar way, Chesterton is

[115]Chesterton, *Sidelights*, Collected Works 21 (San Francisco: Ignatius Press, 1990), 531.

[116]Chesterton, *Sidelights*, 531.

[117]Pokagon, *Red Man's Rebuke*, 6.

[118]Chesterton, *What I Saw in America*, Collected Works 21 (San Francisco: Ignatius Press, 1990), 146.

[119]The term, for Chesterton, was a "very fine example of the American lie." Chesterton, *Sidelights*, 531.

[120]Pokagon, *Red Man's Rebuke*, 4.

less than awed by new buildings which "illustrates that huge in-
human anomaly of modern men being cut off from the very earth."[121]
"Men first discovered that they could build skyscrapers," he com-
plains, "at the same moment as they discovered there was no such
thing as the sky," capturing modernity's arrogance in a phrase.[122] In
light of the Christian critique of skyscrapers from both authors, I
wonder if Pokagon or Chesterton would have been surprised to
learn that two Ghost Dancers who had survived the Massacre at
Wounded Knee, Short Bull and Kicking Bear, had been imprisoned
within one of Chicago's imposing high rises, namely, the tower at
Fort Sheridan[123] (see fig. 2.11). This was the same Short Bull who
would later relate to a Jesuit priest that in the dance circle he had
seen "the Son of God," who had told him to "under your clothes,
always paint your bodies."[124]

FOURTH STAR: CHICAGO'S CHEYENNE CHRIST

Chicago awarded itself another star at the 1933 Century of Progress
International Exposition, also known as the Chicago World's Fair,
whose unofficial motto was "Science Finds, Industry Applies, Man
Conforms."[125] It was just this progressivism that Chesterton set out to
counter when he wrote of the "dangerously optimist" view of history

[121]Chesterton, *Sidelights*, 571.

[122]Chesterton, *Sidelights*, 570. He commends more modest American homes instead: "It is
a slander on America to call it a land of skyscrapers. . . . An enormous number of
[Americans] live in little wooden houses . . . and they are immeasurably happier and
better than anybody in the very biggest hotel; and perhaps happiest of all in the fact that
nobody has ever heard of them" (571).

[123]Louis S. Warren, *God's Red Son: The Ghost Dance Religion and the Making of Modern
America* (New York: Basic Books, 2017), 379. In 1891 it was the tallest building in greater
Chicago, "a monument to the military solution many sought for dealing with immi-
grants and Indians alike" (380). Fort Sheridan is now an apartment complex.

[124]Warren, *God's Red Son*, 384.

[125]Ron Grossman, "Century of Progress: The Science and the Sleaze," *Chicago Tribune*,
May 26, 2013, www.chicagotribune.com/news/ct-per-flash-century-progress-0526
-20130526-story.html.

Figure 2.11. Fort Sheridan Water Tower and barracks where Ghost Dancers were imprisoned, Fort Sheridan, Illinois

that is "the first cry of Imperialism."[126] But as the march of progress rolled on, some lives in Chicago took a different shape, even testifying, at least on a small scale, to the harmony between Indigenous and White inhabitants imagined at the Treaty of Greenville.

[126]Ker, *G. K. Chesterton*, 333.

Peter Powell was five years old when the 1933 fair was celebrated. Not too long thereafter he began studying the history and the ceremonies of the Plains Indians.[127] In fact, studying Indian culture, he told me, is what caused him to want to become an Anglican priest. But just as Powell set out to serve among the Navajo beyond Chicago, he realized that Indigenous America was coming to him. The 1950s saw the mass urbanization of the American Indian, with Chicago serving as the movement's defining city.[128] Powell, therefore, founded St. Augustine's Center for American Indians instead, which has been "instrumental in advancing the [Indigenous] self-determination movement."[129] He organized emergency relief for Indians uprooted by dislocation. The city's incoming American Indians "increasingly acknowledged Powell as a friend who held a deep respect for them and their culture."[130] (See Father Powell in fig. 2.12.)

Powell chose Augustine because this saint, who himself faced a flood of refugees in his own city of Hippo, knew what so many Christians have forgotten: "What is now called the Christian religion existed of old and was never absent from the beginning of the human race until Christ came in the flesh. Then true religion which already existed began to be called Christian."[131] Or as Powell himself put it at the beginning of his first massive study of the Cheyenne people:

> Christ came as the Perfector, the Fulfiller, of all the world's cultures and traditions. The Church holds that the finest in the pre-Christian

[127]Peter J. Powell, *Sweet Medicine: The Continuing Role of the Sacred Arrows, the Sun Dance, and the Sacred Buffalo Hat in Northern Cheyenne History* (Norman: University of Oklahoma Press, 1969), 1:xxi.

[128]Grant P. Arnt, "Relocation's Imagined Landscape and the Rise of Chicago's Native American Community," in Straus, *Native Chicago*, 159.

[129]John J. Laukaitis, *Community Self-Determination: American Indian Education in Chicago, 1952–2006* (Albany: SUNY Press, 2015), 35.

[130]Laukaitis, *Community Self-Determination*, 36.

[131]Augustine, *The Retractions*, trans. Mary Inez Bogan, Fathers of the Church 60 (Baltimore: Catholic University of America Press, 1968), 52.

Figure 2.12. Albert Lightening, Cree holy man, and Father Peter Powell converse in Chicago in 1970

religions reflected the eternal truth and beauty of God. Thus, these religions were, in their way, preparations for God's revelation of Himself in human flesh as Jesus Christ.[132]

If this sounds suspect to some, it did not to the presiding elder of Indigenous studies, Vine Deloria Jr., who early on gave Powell and his book *Sweet Medicine* a glowing imprimatur in *God Is Red*, a book that is otherwise excoriating of Christianity.[133] As an emerging activist, Powell criticized the Bureau of Indian Affairs and criticized the Chicago school system for teaching a false history that ignored the dignity and courage of American Indians.[134] From the storefront post of the St. Augustine Center, Powell said daily Mass, organized relief efforts, and ably fundraised, even partnering with Mayor Richard J. Daley for urban Indian

[132]Powell, *Sweet Medicine*, 1:xxiii.

[133]Vine Deloria Jr., *God Is Red: A Native View of Religion*, 30th anniv. ed. (Golden, CO: Fulcrum, 2003), 34. For another Indigenous testimony, see n. 139 below.

[134]Deloria, *God Is Red*, 37.

aid.[135] Soon the center grew into a North Side brownstone home, all while effectively partnering with the complementary work of the American Indian Center of Chicago. Powell was careful to keep spiritual interests separated from publicly funded relief.[136] Above all, Powell did not maintain control. Instead, "letting go was a form of activism."[137] His entire board of directors consisted of American Indians, and in 1971 he resigned as director to make way for an Indigenous person, Matthew Pilcher (Ho-Chunk), to take his place. But Powell continued his role as spiritual director of the program while maintaining his scholarly work.[138]

What remains of St. Augustine's Center for American Indians can be seen in Father Powell's modest North Side home, itself a gallery of Indigenous art from the entire continent that once gathered at the center to worship. But even while Powell is responsible for the Indigenous collections at the Art Institute of Chicago and elsewhere, the art gathered in his living room is not for display but for prayer. There are carvings from the Northwest coastal artist Lelooska,[139] paintings of Native Marys and Indigenous Magi, even icons painted in the Byzantine style. But the centerpiece is a large brown wooden crucifix of the Cheyenne Christ, in use by the center since its Chicago storefront beginning. The American Colonel Mackenzie's soldiers had destroyed the "Northern Cheyenne wealth and material beauty,"[140] so Powell commissioned its re-creation. He hired a Southern Cheyenne sculptor,

[135]Deloria, *God Is Red*, 38.
[136]Deloria, *God Is Red*, 40-41.
[137]Deloria, *God Is Red*, 44.
[138]James Mooney, *In Sun's Likeness and Power: Cheyenne Account of Shield and Tipi Heraldry*, ed. Peter J. Powell, 2 vols. (Lincoln: University of Nebraska Press, 2013).
[139]In his interviews, Lelooska said, "Father Powell is a man of God. If there really are any running around, he has got my vote. . . . So far as I know, Father Powell is the only non-Cheyenne by blood who can be present when the Medicine Arrows are renewed or when Is'siwon is revealed. He holds the great name High Forehead." Chris Friday, *Lelooska: The Life of a Northwest Coast Artist* (Seattle: University of Washington Press, 2003), 194.
[140]Powell, *Sweet Medicine*, 1:xx.

Richard "Dick" West, to create a Christ that conveyed both the suffering and the beauty of his people.[141]

Now in his nineties, Powell remains an Anglican priest and an honorary Cheyenne chief. Of course, he sees no conflict in these vocations. On my visit to meet him, he accommodated my request to see the Cheyenne Christ. He held it as if it were a child and laid it upon his living room altar, where he still performs daily Mass. Father Powell almost seemed to refer to the sculpture *as* Christ, testifying to the effect of the countless prayers offered by all those from across the continent who gathered to worship before it for more than fifty years. Chesterton might have been describing this sculpture when he wrote,

> The desire of all nations, the dreams of all religions, the imaginative craving that in some way something heroic might save the sufferings that are human—that indeed existed everywhere and that was the need which the Gospel was sent to supply.[142]

Christ's elongated body conforms to the gentle bend of the cottonwood. His eyes are softly closed as he absorbs his afflictions with hard-won grace: the wounds inflicted on him by the feather-clad priests of Cahokia; by Old Fuss and Feathers himself, General Winfield Scott; by Chicago's gun culture and the amnesiac arrogance of its towers; and by the forgetfulness of all who—still benefiting from the remarkably efficient American policy of conquest and removal—live obliviously in Chicagoland today.

Standing before the sculpture with Father Powell, I felt something of what Adam Wayne did when he said the Notting Hill neighborhood of London was the "heart of the universe,"[143] just as Black Elk could

[141]Laukaitis, *Community Self-Determination*, 38.
[142]Chesterton, *Resurrection of Rome*, 359.
[143]Chesterton, *Napoleon of Notting Hill*, 81.

say "anywhere is the center of the world."[144] Father Powell, though, was less sanguine, having absorbed some of the sculpture's radiant sadness. After all, in dynamics that parallel the western frontier,[145] so much of Chicago's Indigenous population has been gentrified away from North Side Chicago neighborhoods, which are as upscale today as is London's Notting Hill.[146] "The world as a whole," Powell gently informed me as I departed, gesturing to the Cheyenne Christ, "is not ready to receive this power."

[144]John G. Neihardt, *Black Elk Speaks: The Complete Edition* (Lincoln: Bison Books/ University of Nebraska Press, 2014), 26.

[145]Neil Smith, "New City, New Frontier: The Lower East Side as Wild, Wild West," in *Variations on a Theme Park: The New American City and the End of Public Space*, ed. Michael Sorkin (New York: Noonday Press, 1992), 89; and Neil Smith, *The New Urban Frontier: Gentrification and the Revanchist City* (New York: Routledge, 1996). I thank Noah Toly for these references.

[146]As the Diné (Navajo) scholar Glen Coulthard puts it, "The dispossession that originally displaced Indigenous peoples for their traditional territories . . . is now serving to displace Indigenous populations from the urban spaces they have increasingly come to call home." Glen Sean Coulthard, *Red Skin, White Masks: Rejecting the Colonial Politics of Recognition* (Minneapolis: University of Minnesota Press, 2014), 175.

RESPONSE

DAVID HOOKER

I AM GOING TO DO MY BEST to limit myself to ways in which my
artistic practice, specifically explorations in pottery and sculpture,
relate to two key themes in Dr. Milliner's essay: finding ways to fully
connect to our specific place—which includes recognizing the signifi-
cance of its history—and resisting the complacency of forgetting. In
the case of the Winfield Mounds, the two themes are interrelated.

Before I start with the mounds, I want to talk about pottery. For me,
pretty much everything starts with pottery. Roughly thirty-five miles
from the place I grew up in North Carolina is the home of one of the
oldest living ceramic traditions on the continent, in the Catawba
Indian Nation.[1] Here the pottery tradition has continued *unbroken*
for a staggering four thousand years, although the thread of that tra-
dition has nearly broken twice during the twentieth century.[2] The
knowledge of how to dig the clay, prepare it, work the forms, and fire
it properly has been passed down from generation to generation all
that time. This often happens in families like the Robbins family. The
clay that is at the heart of the tradition doesn't come from a store;
rather, it is dug from the ground by hand. The Catawba are insistent
on that point. They will only use the clay from the traditional field that
was used by their ancestors. It has been mined from the same place for

[1] Thomas John Blumer, *Catawba Indian Pottery: The Survival of a Folk Tradition* (Tuscaloosa
and London: The University of Alabama Press, 2003).
[2] Accessed April 19, 2021, www.catawbaindian.net/the-nation/catawba-pottery.php.

at least two thousand years. Try to wrap your mind around those numbers: a four-thousand-year-old *living* tradition getting its clay from the same land for two thousand years. It is beyond my imagining. The Catawba and the work they put into making pottery redefine my understanding of what it means to be connected to a place.

When we think of pottery, or see pottery in museums, we often think about the forms, or the surface decorations, the imagery, and how they tell us something about the culture. Very few of us think about the material, the clay itself, and how it is part of the story. It is in fact the beginning of the story. For the Catawba, it is a way of declaring their connection to their ancestors and to their land.

Figure 2.13. Moon jar

We have largely lost that understanding in our industrialized world, in which clays are mined, refined, and mixed together to make them more standardized, but it is still possible to dig your own clay, discover its special characteristics, and allow those characteristics to be a part of your work. That is something I did when I lived in the Carolinas, but

Figure 2.14. Wood-fired cups

I hadn't done here in Illinois until fairly recently. It was time spent in an artist residency in China that inspired me to look for sources of local clay here when I returned. You can see the results in these pots.

While the clay body is still a commercial product, the glazes are made in large part from locally dug clays. In this way the work becomes much more significantly about place. The moon jar (fig. 2.13) is glazed in a way that is specifically about Wheaton; the cups (fig. 2.14) are glazed in a way that is specifically about HoneyRock camp.

I think of Native American mounds in the same way I think of the pottery. Each one is a unique expression of a culture because each one connects to a place. The Winfield Mounds are unique not because of anything they may or may not have had in them; the Winfield Mounds are unique because they are in Winfield, made from Winfield soil. My wife, Elaine, and I have visited many different Native American mounds during our marriage, a practice that started when we lived in Ohio while I finished graduate school. Mounds can be found all over the country; we have visited them in South Carolina and Florida as well as at several sites in the Midwest. Sometimes the mounds are part of large national parks. Sometimes they are only spots on a map with an overgrown, forgotten trail one has to navigate to get there. The contrast is sometimes striking. I actually enjoy seeing them both ways. The sites to me are sacred—acknowledged or not, protected or not. They speak of a people's connection to land, to place, to earth. I connect to them through that same material: earth. There is sacredness in the ordinary.

I was excited to discover there were mounds in Winfield, the town where we have lived since moving to the area. Even as I celebrate the mounds, I have to acknowledge the more troubling history that is also part of their story. They were excavated, I would say desecrated, and laid open until somewhat restored, sans artifacts, decades later. I know of nothing that can be done about that. But they have been given the name of the town, which takes its name from General Winfield Scott, who oversaw the Trail of Tears, and that is a travesty. The name of the mounds could, and should, be changed.

This reminds me of a work of art by the German artist Anselm Kiefer, *Eisen-Steig*, which roughly translates as "Iron Rail." In much of his work, Kiefer has confronted Germany with its own past, not allowing it to forget the atrocities that took place under the Third Reich. In this way he serves much the same role as many Old Testament prophets. This is important and difficult work. At a time when Germany was rebuilding and wanting to leave the past behind, his work was a reminder that there is no moving forward without acknowledging the past. Complacency is not an option. In the 1980s Kiefer painted massive historic-scale landscapes. They are indistinct, often somewhat abstracted, but they all have a kind of postapocalyptic feel that evokes bombed-out buildings, strewn rubble, or desolate fields. In this work, railroad tracks slice the land in half, leading to . . . where, exactly? Is this a train leading out of this bleak landscape, or into it? A train leading to a new beginning, or to Auschwitz?

While I do not pretend to try to make artwork that speaks *to* or *for* my generation, I felt in Kiefer an opportunity to make work that might help me connect to my own place and its history. One of these works is *The Service Project*, which explores my connection to the Winfield Mounds. For this work I filmed a series of performances, one for each season of the year, in which I served tennis balls slowly and methodically at Winfield Mounds Forest Preserve for an extended period of time (usually one to two hours). I chose tennis for a number of reasons. I played tennis competitively in my teens and still enjoy playing tennis today. Tennis has consistently been a part of my life. It is a generational sport in my family: handed down from my father to me and my brothers and to some of our children. There is also a ritualistic action in playing tennis, especially in practicing, which consists of hitting the ball over and over again to build muscle memory. In the service motion, that ritual action is subtly emphasized: there is a moment just after the ball toss when my arms are raised in a gesture reminiscent of

an orant pose, a gesture of prayer. But I also recognize tennis is a sport, like my ritual, that is fraught with tension: it is an "elitist" sport, played mostly by the upper classes. As such, it is a sport that calls into question the distribution and use of economic and environmental resources. By hitting serves at the mounds, I hoped to find a way to personally connect with the space; to feel it viscerally, make it part of my muscle memory; and to call attention to the mounds—but also to acknowledge the tension related to their history through my ritualistic action.

Like Dr. Milliner, I, too, want to encourage us to connect to the history of this place. We need to recognize it as place, not space, as defined by Walter Brueggemann.

> A sense of place is to be sharply distinguished from a sense of space. . . .
> "Space" means an arena of freedom without coercion or accountability,
> free of pressures and void of authority . . . characterized by a kind of
> neutrality or emptiness waiting to be filled by our choosing. . . . But
> "place" is a very different matter. Place is space that has historical
> meanings, where some things have happened that are now remem-
> bered and that provide continuity and identity across generations. . . .
> Place is indeed a protest against the unpromising pursuit of space. It is
> a declaration that our humanness cannot be found in escape, de-
> tachment, absence of commitment, and undefined freedom.[3]

We are not free from place; places give us identity but also require commitment. Wheaton is generally pretty good about acknowledging its history. I daresay most of us are aware of and celebrate the fact that Wheaton College was once an active part of the Underground Railroad. We have the bones of a mastodon that was discovered in Glen Ellyn on display in the Meyer Science Center. The DuPage County Historical Museum is mere blocks from here in downtown Wheaton. The Winfield Mounds, or what is left of them, remain part of a protected

[3]Walter Brueggemann, *The Land: Place as Gift, Promise, and Challenge in Biblical Faith*, 2nd ed. (Minneapolis: Fortress, 2002), 4.

forest preserve. These are spaces we have set apart in which to celebrate our past.

But by setting these spaces apart, we are also able to set them aside. We are not so comfortable allowing the history of this place to ask something of us. We do not always let our sense of history affect our daily lives. It is easy to become complacent about the past, or to give in to the tyranny of the now, or to place all our hope on the future. But I think a right orientation to the past should permeate our understanding of the present and help shape our future. This, I believe, is part of what it means to seek the wisdom of God. As Christians, we are tasked with participating in the New Creation, but we need to remember that the new creation springs out of the old. Christ does not wipe out the past; he redeems it.

And so I would like to leave you with some questions to ponder:

- What might it look like to connect with this place, Wheaton, Illinois, this land, this earth, in ways that count the cost and infuse it into our everyday lives?

- In what ways can we both love our neighbor and welcome the stranger better?

- What might our public buildings, commercial real estate, places of worship, homes, and lawns look like if we adapted our vision to the land instead of adapting the land to our vision?

3

MOTHER OF THE MIDWEST

The White Buffalo Maiden may be interpreted as the prefiguring of that Virgin who bore in her womb the eternal Son of God.

Fr. Peter Powell

But the woman was given the two wings of the great eagle, so that she could fly from the serpent into the wilderness, to her place where she is nourished for a time, and times, and half a time. . . . Then the dragon was angry with the woman, and went off to make war on the rest of her children, those who keep the commandments of God and hold the testimony of Jesus.

Revelation 12:14, 17

It is remarkable that in so many great wars it has been the defeated who have won.

G. K. Chesterton

THE QUEEN OF SEVEN SWORDS

Having examined G. K. Chesterton's apologetic work and his first novel, in this chapter I turn to Chesterton's poetry—a slim volume so neglected that it does not appear in collected poetry of G. K. Chesterton or even warrant a mention in Ian Ker's magisterial biography.[1] Chesterton's

[1]G. K. Chesterton, *The Queen of Seven Swords* (London: Sheed & Ward, 1946).

poem on the Virgin Mary, *The Queen of Seven Swords*, is one overlooked place to see his own limitations being overcome. I consider it a duty to resurrect this poem because another of Chesterton's Marian poems *has* been resurrected. Following the September 11, 2001, attacks, the American Chesterton Society produced a lavish republication of Chesterton's *Lepanto*, celebrating the 1571 victory of the Holy League over the Ottoman Empire.[2] I do not begrudge Europe this victory, nor do I wish the Ottomans had vanquished the Christian fleet. Still, anyone aware of the way Lepanto has been visualized in Christian history (baby Jesus holding the severed head of a Muslim, for example[3]) would do well to be cautious.[4] *Lepanto*, to put it mildly, does not showcase Chesterton's most enduring insights. Buddhist architecture is described as "temples where yellow gods shut up their eyes in scorn."[5] Protestantism is merely "tangled things and texts and arching eyes."[6] And Islam (to which

[2]G. K. Chesterton, *Lepanto, with Explanatory Notes and Commentary*, ed. Dale Alquist (San Francisco: Ignatius, 2003).
[3]See the Cologne rosary confraternity pamphlets in Rita George-Tvrtković, *Christians, Muslims, and Mary: A History* (Mahwah, NJ: Paulist Press, 2018), 79.
[4]Ralph C. Wood exemplifies such caution in *Chesterton: The Nightmare Goodness of God* (Waco, TX: Baylor University Press, 2011), 69-98.
[5]Chesterton, *Lepanto*, 27. Tom Villis claims Chesterton presages Edward Said's critique of Orientalism: "We have the cry for Imperialism in all our clubs at the very time when we have Orientalism in all our drawing rooms." Tom Villis, "G. K. Chesterton and Islam," *Modern Intellectual History* 4 (2019): 47-69. Even so, although some of Chesterton's approaches to Buddhism and Hinduism can be insightful, Bede Griffiths and William Johnston are to be preferred when engaging either faith. Both are careful to make the same distinguishing moves of Chesterton but have a much wider and deeper appreciation for these traditions. See Bede Griffiths, *The Cosmic Revelation: The Hindu Way to God* (Springfield, IL: Templegate, 1983); and William Johnston, *Christian Zen* (New York: Harper & Row, 1971). Griffith's reflections on the Christian combination of myth and history in the concluding chapter of *Cosmic Revelation* are distinctly Chestertonian. All of Johnston's books are careful in making a clear distinction between Christianity and Buddhism, but without the wholesale dismissal of Buddhism indulged in by Chesterton.
[6]Chesterton, *Lepanto*, 27. Protestantism, for Chesterton, contained the defensible and indefensible, but what was most difficult for Chesterton to forgive was "Christian mutiny during a Moslem invasion." G. K. Chesterton, *The Resurrection of Rome* (New York: Dodd, Mead, 1930), 111.

Chesterton connects Protestantism[7]) is, in this poem at least, simply demonic.[8] One can see, reading *Lepanto*, why Charles Williams would complain that in Chesterton's poetry "everything is spoken of in terms of war. . . . [One] must be either a hero or a coward."[9]

But if *Lepanto*, published when Chesterton was in his cocksure thirties (1911), shows him at his most truculent, *The Queen of Seven Swords* (1926) shows him in his wiser fifties. The Virgin, of course, is still prominent in this poem. If the poet Edmund Spenser replaced England's famed pilgrimage site, Our Lady of Walsingham, with the veneration of Queen Elizabeth I, Chesterton attempts the reverse, restoring Mary to her place of English honor. In this poem, Mary ("She grows young as the world grows cold") and God ("Ancient of Days, grown little for your mirth") are youthful and cast against a modern world that has grown old.[10] The traditional seven swords of Mary's sorrows are recast as European blades: James of Spain, Anthony of Italy, Patrick of Ireland, and so on: a rather standard list. But then

[7]In Protestant Iconoclasm, "the ecstasy of the deserts returned, and [this] bleak northern island was filled with the fury of the Iconoclasts." G. K. Chesterton, *A Short History of England*, ed. James V. Schall, rev. ed., Collected Works 20 (San Francisco: Ignatius, 2002), 466.

[8]Chesterton, *Lepanto*, 27. Chesterton can do better than this: "We learnt enormously from what the Saracen did. Secondly, we learnt enormously from what the Saracen did not do." Chesterton, *Short History of England*, 468. And "[Islam] has no rant of merely racial superiority; there is a brotherhood of men, if it be a brotherhood of Moslems," cited in Julia Stapleton, *Christianity, Patriotism, and Nationhood* (Lanham, MD: Lexington Books, 2009), 187. Chesterton's disagreement with Islam is chiefly over the paradox of the Trinity: "the doctrine that 'bewilders the intellect utterly quiets the heart.'" Ian Ker, *G. K. Chesterton: A Biography* (Oxford: Oxford University Press, 2011), 225. Tom Villis argues that Chesterton's "views of Islam are at times orientalist and at other times critical of imperialism and elitism. . . . One of the positive things which [Chesterton] saw in Islam was its antiracism." Villis, "G. K. Chesterton and Islam," 55.

[9]Charles Williams, *Poetry at Present* (Oxford: Oxford University Press, 1930), 98-99. Cited in Wood, *Chesterton*, 70. Ralph Wood identifies the same problem, and offsets *Lepanto* with Chesterton's "The Truce of Christmas" (1915). The welcome pacific turn in Chesterton's poetry identified by Wood was completed, I would suggest, in *The Queen of Seven Swords*.

[10]Chesterton, *The Queen of Seven Swords*, 20, 9.

Chesterton includes Africa. "Turn thou the mercy of thy midnight face. This also is in thy spectrum; this dark ray."[11] Chesterton seems well aware, as we all should be, that in the color range of Christianity, the summit is not white but apophatic darkness. If we want a multicultural G. K. Chesterton (and some do not), it would be hard to do better than this: "In all thy thousand images we salute thee. . . . Hewn out of multi-coloured rocks and risen Stained with the stored-up sunsets in all tones."[12] And rather than raising their swords, each of the nations (unlike in his *Lepanto* poem) sets them down.[13] Here is an answer to Charles Williams's valid complaint that in Chesterton's poetry "there are drawn swords from the first page to the last."[14] Which is to say, *The Queen of Seven Swords* offers more evidence for Ralph Wood's contention that Chesterton "came at the end to surrender his nostalgic hope for a restored Christendom."[15]

But although all humanity is cast as clay red in this poem ("out of the Red Mountains / Of which man was made"[16]), there is no Native American chapter in *The Queen of Seven Swords*. I intend therefore in this essay simply to add one—not by trying my hand at rhythmic verse but through an image: by offering a Virgin Mary of the Midwest, perhaps one serviceable for all of North America, who I believe summarizes what we need to know about the settler dynamics of this land that Chesterton visited so superficially. If such a focus troubles Protestant readers, so be it. Considerable anti-Indian rhetoric on this continent was bound up with anti-Catholicism, which Protestants took for granted, and we need to yield some ground.[17] This Virgin is the

[11]Chesterton, *The Queen of Seven Swords*, 35.
[12]Chesterton, *The Queen of Seven Swords*, 35.
[13]Chesterton, *The Queen of Seven Swords*, 53.
[14]Williams, *Poetry at Present*, 98-99. Cited in Wood, *Chesterton*, 70.
[15]Wood, *Chesterton*, 152.
[16]Chesterton, *The Queen of Seven Swords*, 3.
[17]For a brilliant Protestant embrace of Mary as Mother of God, see Amy L. Peeler, *Mother of God* (Grand Rapids, MI: Eerdmans, 2021).

opposite of such arrogance, and yet, not being tethered to an especially divisive doctrine, she makes room for Protestants and Orthodox Christians as well.[18] I do not advance her to replace other American dedications, specifically Our Lady of Guadalupe[19] or the Mary of the Immaculate Conception,[20] both of which (especially the former, of course) have extensive connection with Indigenous persons. But the Virgin I have in mind has the advantage of expressly bringing the stories of the First and Second Nations together. Neither triumphantly Catholic nor Orthodox (let alone Protestant), she atones for acrid divisions among Christians that have bedeviled this continent, especially its Indigenous populations. Above all, she is very different from Our Lady of Lepanto—not Our Lady of Victory but Our Lady of Defeat. She encapsulates Chesterton's "first law of practical courage" (neglected while he was writing *Lepanto*): "To be in the weakest camp is to be in the strongest school."[21]

[18]I refer to the doctrine of Mary being conceived without original sin (the Immaculate Conception), mandated for Catholics since its promulgation in 1854 but not a required belief for either Orthodox or Protestant Christians.

[19]John Paul II, who canonized Juan Diego, went so far as to claim he "represents all the natives who welcomed the Gospel of Jesus." D. A. Brading, *Mexican Phoenix: Our Lady of Guadalupe: Image and Tradition Across Five Centuries* (Cambridge: Cambridge University Press, 2002), 340. As if to prove the point, an Indigenous North American, Dennis Wawia, a deacon at the Anishinabe Spiritual Centre, had a vision in which "he realized that he was being told to bring about devotion to Our Lady of Guadalupe." Christopher Vecsey, *The Paths of Kateri's Kin* (South Bend, IN: University of Notre Dame Press, 1997), 238. See also Mark Clatterbuck, ed., *Crow Jesus: Personal Stories of Native Religious Belonging* (Norman: University of Oklahoma Press, 2017), 168.

[20]Marquette's successful mission in what is now Illinois was dedicated to the Immaculate Conception, and his devotion to Mary pervades his journals. Jacques Marquette, *Father Marquette's Journal*, 4th ed. (Lansing: Michigan Historical Center, 2003), 58. For a contemporary Marian poetic work that recalls Marquette's naming the Mississippi after this doctrine, see James Matthew Wilson, *The River of the Immaculate Conception* (Belmont, NC: Wiseblood Books, 2019). Father De Smet's standard of the "Virgin Mary surrounded by stars" sounds like the iconography of the Immaculate Conception. She was "a reassuring and popular image among the Hunkpapas, who related to her as someone similar to White Buffalo Woman." Edward J. Rielly, *Legends of American Indian Resistance* (Santa Barbara, CA: Greenwood, 2011), 115.

[21]G. K. Chesterton, *Heretics* (1905; repr., Nashville: Sam Torode Book Arts, 2014), 34.

Telling this story requires something of a leap in both time and region, taking us to the Mediterranean island of Cyprus during the Crusades, an epoch that Chesterton admired.[22] Chesterton's sympathetic take on the Crusades is not without insight, anticipating some of the recent retellings of this medieval episode.[23] But, at its worst, it devolves into the "at least it's an ethos" defense, only anticipating *The Big Lebowski*: "[The crusader's] perspective is rude and crazy, but it is perspective."[24] Chesterton is especially fond of the English crusading King Richard the Lionheart (1157–1199). In deference to such fondness, I aim here to briefly tell the story of an image that King Richard inadvertently helped create.[25] If, for Chesterton, "chivalry might be called the Baptism of Feudalism,"[26] then this particular icon reminds us that chivalry needed to undergo a baptism as well. The story involves French and English colonization of an Indigenous population, which applies to North America also. It is also a story of catastrophic defeat followed by much more impressive military conquest, a pattern that describes the United States in the Ohio Country as well.

[22]Chesterton, "The Age of the Crusades," in *Short History of England*, 468.

[23]As Crusades historian Jonathan Riley-Smith puts it, "Before we become too certain of our rectitude and complacent about how far our society has advanced, we should remember that secular ideological violence . . . has manifested itself recently in wars waged in the names of imperialism, nationalism, Marxism, fascism, anticolonialism, humanitarianism, and even liberal democracy." Jonathan Riley-Smith, *The Crusades, Christianity, and Islam* (New York: Columbia University Press, 2008), 80.

[24]Chesterton, *Short History of England*, 468. "[Chivalry] was an attempt to bring the justice and even the logic of the Catholic creed into a military system which already existed; to turn its discipline into an initiation and its inequalities into a hierarchy" (468). Chesterton sees the chivalric exaltation of women as a response to the crusader's perception of the devaluation of women in Islam (469).

[25]For the story of this remarkable icon told at much greater length, see my *Mother of the Lamb* (Minneapolis: Fortress, 2022).

[26]Chesterton, *Short History of England*, 469.

The Conscience of the Crusades[27]

In the medieval case, the defeat came at the hands of Guy de Lusignan (c. 1150–1194), a French knight who found himself wearing the crown of the Kingdom of Jerusalem. Jerusalem had been won by the First Crusade in 1099, and western knights had managed to hold onto the city for nearly a century. But Jerusalem, under Guy's leadership, would not stay conquered for long. Though launched with fervor by great saints like Bernard of Clairvaux, the Second Crusade (1147–1150) was unable to secure the crusader states. Amid the resulting insecurity, Guy de Lusignan—to prove his worthiness—required a victory. The rulers of Jerusalem before Guy had enough respect for Sultan Saladin's (1137–1193) army that they did not dare provoke him in open battle. But egged on by the head of the Knights Templar, who was itching for a fight, Guy de Lusignan shifted tactics.[28] Marching his army to just beyond the Sea of Galilee in the height of summer, he attempted to take Saladin head on. Saladin watched in confidence, blocked the road to the water, and waited. As the sun peaked on July 4, 1187, he destroyed the crusader army, even permitting his accompanying Sufi warriors to personally behead numerous Knights Templar.[29] The best punishment for Guy de Lusignan, however, was to keep him alive.

The loss of Jerusalem was the necessary impetus to launch what became known as the Third Crusade (1189–1192). The kings of France and England—Philip Augustus and Richard the Lionheart—both responded, choosing to go on crusade personally. Cyprus at this time was an Orthodox island, and had been for some time. Like the Lakota in the Black Hills, the Orthodox had not been on the island forever, but they had made it their own. The king of England conquered the

[27] After I shared the story of this icon with Dick Ohman, he replied that the image functions as "the conscience of the Crusades." I thank him for this formulation.

[28] Thomas Asbridge, *The Crusades: The Authoritative History of the War for the Holy Land* (New York: HarperCollins, 2011), 327.

[29] Asbridge, *Crusades*, 353.

island in 1191, deposed the Byzantine ruler, and, to make money to fund his crusading venture, sold the island to the Knights Templar.[30] Unable to subjugate the Orthodox population, the knights slaughtered them on Easter morning of 1192 and gave the island back to Richard. Richard then sold it again to the French, specifically to Guy de Lusignan. And so Guy, who was responsible for losing Jerusalem, was given Cyprus as his consolation prize. That is why, to this day, this Mediterranean Orthodox island is filled with French Gothic architecture.

And this is where our image enters the story. The Orthodox islanders were not about to take up the Gothic style. They of course had a rich artistic tradition of their own (a style that never impressed Chesterton), and the conquering English and French were not about to extinguish it. In fact, that most accomplished Orthodox artist on the island, a man named Theodore Apsevdis, fled into the mountains and began to paint.[31] He was commissioned by a deposed Orthodox governor on the island to repaint a church in this time of crisis. But a confident Virgin Mary that filled the churches before Cyprus was conquered would have been inappropriate for a land that was undergoing so much suffering. And so, instead, Theodore painted a freshly mourning Virgin Mary.[32] One form of Christianity may have conquered another in the quest for the Holy Land, but this Virgin reminds us that there were Christians on both sides of the Crusades, the Orthodox Christians being collateral damage on the way to fight Islam.[33] Instead of angels confidently bearing scepters, Theodore's

[30]Peter W. Edbury, *The Kingdom of Cyprus and the Crusades, 1191–1374* (Cambridge: Cambridge University Press, 1991), 5-10.

[31]For a recent assessment of this artist and his fresco program at Lagoudera, see Athanasios Papageorgiou, Charalambos Bakirtzis, and Christodoulos Hadjichristodoulou, *The Church of Panagia tou Arakos* (Nicosia, Cyprus: Foundation Anastasios G. Leventis, 2018).

[32]Sophocles Sophocleous, *Panagia Arakiotissa: Lagoudera, Cyprus* (Nicosia, Cyprus: Centre of Cultural Heritage, 1998).

[33]George Demacopoulos, *Colonizing Christianity: Greek and Latin Religious Identity in the Era of the Fourth Crusade* (New York: Fordham University Press, 2019).

angels bear the cross, spear, and sponge, a reminder that the Christ child is going to die. Hence, this is not one more Virgin of Victory but the Virgin of the Passion, the first known instance of the type in the history of art (see fig. 3.1). Mary had often been depicted as a conquering general in Byzantine history, but, on Cyprus, Byzantium was no more. So she returned to her more original role.

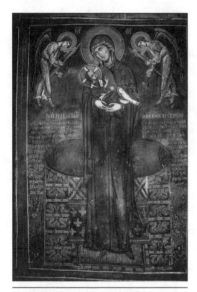

Figure 3.1. Theodore Apsevdis, "The Virgin of the Passion" at Lagoudera, Cyprus (1192); a later version of the same icon will be titled "Our Lady of Perpetual Help"

To say that this Virgin caught on would be an understatement. From this point forward, the Byzantine Empire—shattered by the sack of Constantinople in the Fourth Crusade—would undergo its slow process of dying, and the Virgin of the Passion became something of an emblem of this defeat. But at the same time, she testified to something more interesting than political collapse. Wherever she appeared, whether on the shrinking Balkan frontier, or in Crete just as Constantinople was overcome by the Ottomans, she testified that Orthodox Christianity was more pervasive and enduring than Byzantine political boundaries. This Mary expanded in inverse proportion to Byzantine political collapse.[34]

[34]For an overview of the image's expansion, see Matthew J. Milliner, "Emblems of the End: Byzantium's Dark Angels," in *Faith and Community Around the Mediterranean: In Honor of Peter R. L. Brown*, ed. Petre Guran and David A. Michelson = Études Byzantines et post-byzantines n.s. 1 (8) (Heidelberg: Herlo Verlag; Bucharest: Académie roumaine, 2019 [2020]).

Birth of an Army

I am convinced the experience of Orthodox Christians under the Crusades merges with the experience of Indigenous people under American and Canadian national expansion—with the same Virgin Mary functioning as an emblem of Native American "survivance" under defeat.[35] Indeed, the dynamic that gave rise to the first Virgin of the Passion in the Middle Ages may be directly woven into the DNA of the American army itself. I am referring to the recent historical work that illuminates the Indigenous side of America's Revolutionary period.[36] In contrast to the kind of American history I grew up with, these authors unfurl the full extent of George Washington's Native American world.[37] And central to Washington's Indian world is the defeat of the first American army in the Northwest Territory.

Washington, of course, had a vision for the Northwest (now the Midwest) of the United States, and Indians stood in the way. The Ohio Company of Associates had a vision as well. This group of New Englanders, many of whom were veterans of the Revolutionary War, had raised money by selling stock to speculators and purchased a million and a half acres from Congress. Hence, private and public interest were intertwined in what was then known as the Northwest. It was to be an orderly settlement north of the Ohio that would replicate New England towns and raise money for the new republic. David McCullough rightly celebrates the way the Northwest Territory outlawed slavery thanks to the effort of Rev. Mannaseh

[35]Gerald Vizenor, ed., *Survivance: Narratives of Native Presence* (Lincoln: University of Nebraska Press, 2008).

[36]Colin G. Calloway, *The Victory with No Name: The Native American Defeat of the First American Army* (Oxford: Oxford University Press, 2015); and William Hogeland, *Autumn of the Black Snake: The Creation of the U.S. Army and the Invasion That Opened the West* (New York: Farrar, Straus & Giroux, 2017).

[37]Colin G. Calloway, *The Indian World of George Washington* (Oxford: Oxford University Press, 2018).

Cutler (1742–1823).[38] But the outlawing of slavery does not automatically render an acquisition lawful. Mercy to the Indians and peace was, of course, desirable, but no one was willing to budge on the bottom line—the new United States was to have this land.

Washington ordered Arthur St. Clair, governor of the Northwest Territory, to avoid war if possible but to "punish [the Indians] with severity" if they persisted in hostility.[39] The Indians persisted, not surprisingly, because their land was being invaded. They formed into a Northwestern Confederacy led by the Miami chief Little Turtle and Shawnee chief Blue Jacket to defend their home. Initially, Secretary of War Henry Knox sent Brigadier General Josiah Harmar into the territory in 1790; Harmar was roundly defeated.[40] Washington resolved that a stronger force would teach this confederacy a lesson. Thomas Jefferson, not normally bellicose in regard to Indian matters, told Washington, "I hope we shall give the Indians a thorough drubbing" in the summer of 1791.[41]

It was the first congressionally approved military expedition of the new republic.[42] It was, in other words, America's first war. Washington had given the Indians a choice of "civilization or death."[43] And the colonel to issue this thorough drubbing—our equivalent to Guy de Lusignan—was Arthur St. Clair, the territory governor himself. Everything about the campaign was doomed. The supply chains fell through. The army was so difficult to raise that one thousand "reluctant citizens" of Kentucky were drafted.[44] Under orders from George Washington, St. Clair sought to establish a fort but was so sick that he sometimes

[38]David McCullough, *The Pioneers: The Heroic Story of the Settlers Who Brought the American Ideal West* (New York: Simon & Schuster, 2019), 29-30.
[39]Calloway, *Indian World of George Washington*, 378. McCullough relates St. Clair's defeat in chap. 4.
[40]Calloway, *Indian World of George Washington*, 385.
[41]Calloway, *Victory with No Name*, 72.
[42]Calloway, *Indian World of George Washington*, 386.
[43]Calloway, *Indian World of George Washington*, 386-87.
[44]Calloway, *Indian World of George Washington*, 388.

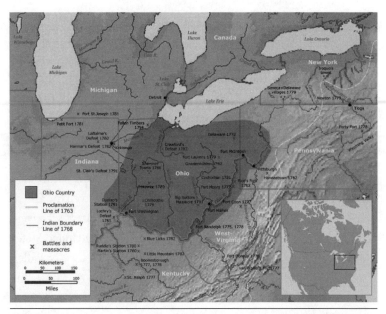

Figure 3.2. Ohio Country with battles and massacres between 1775 and 1794

needed to be carried on a litter. Still, the new republic needed a victory as surely as did Guy, and the plans pressed on. On October 28, 1791, the well-prepared Indian warriors departed. They assembled in crescent formation and triumphed, achieving the "high-water mark in resistance to white expansion."[45] The result of this confrontation was what remains to this day the largest proportional defeat of an American army: 630 soldiers were killed, 37 of which were officers, and 252 were wounded. St. Clair's defeat resulted in the nation's first congressional investigation. And Washington's reticence to disclose documents related to this particular defeat laid the foundation for what we now know as executive privilege. Finally, just as Guy de Lusignan, after his defeat, was essentially exonerated and given the consolation prize of Cyprus, St. Clair was exonerated of responsibility as well.[46]

[45]Hogeland, *Autumn of the Black Snake*, 374.
[46]Calloway, *Indian World of George Washington*, 393.

As was the case in the Mediterranean, this massive defeat led to a new display of force. It caused the American army to dispatch its own Richard the Lionheart, whom we know as General "Mad" Anthony Wayne (1745–1796). The defeat motivated the new nation to build the army that Washington had long desired, driven by the need "to efface the Stain, which the last defeat has cast upon the American Arms."[47] Wayne raised a disciplined, professional army and erected Fort Recovery on the very spot of St. Clair's defeat. Fortunately for him, the confederacy had lost many of its warriors. When Wayne confronted them at the Battle of Fallen Timbers in 1794, they perceived the army's new capacity and retreated to Fort Miami. There the British, who were willing to arm the Indians but not to risk war with the United States, did not let them in. According to Calloway, the victory at Fallen Timbers saved Washington's reputation, and "for the first time, the young nation had demonstrated the ability to enforce its will by force of arms."[48] Such were the preconditions for the Treaty of Greenville discussed in the last chapter, where Blue Jacket, Little Turtle, and General Wayne negotiated. The two forces showed great respect for one another's power, not dissimilar to the way Saladin and Richard the Lionheart engaged in mutual flattery after their military confrontations in the Levant. Such honor lent gravity and even honor to the proceedings at the Treaty of Greenville. With both St. Clair's defeat and the Battle of Fallen Timbers in mind, we might summon Chesterton's poem again:

The world is a wind that passes
And valour is in vain
And the tallest trees are broken
As the bravest men are slain.[49]

[47]Calloway, *Indian World of George Washington*, 433-34.
[48]Calloway, *Indian World of George Washington*, 438-39.
[49]Chesterton, *The Queen of Seven Swords*, 25.

COMING TO AMERICA

Interestingly enough, it would not be long before the very icon that marked the Third Crusade, the Virgin of the Passion, would enter the story of American expansion. The papacy may have been the architect of the Doctrine of Discovery that facilitated the exploitation of Native Americans, but the same papacy was soon to receive a dose of its own medicine.[50] Pius IX (1792–1878), definer of papal infallibility, defended the right of the papacy to its traditional territory but was soundly defeated when the Italian democratic reforms robbed him of an area he once considered his right. It was also Pius IX who was responsible for reviving and promulgating the icon that first emerged after the crusader conquest of Cyprus in 1192, though it is unlikely that he understood the image's original connection to territorial loss. He gave it a new name, Our Lady of Perpetual Help, and commanded that it saturate the globe. His choice could not have been more fitting, but not for the reasons he intended.

Of all the places where the icon spread, the United States was of particular import. Churches dedicated to this icon permeate the area that was once the domain of the Lenape.[51] With major shrines in Brooklyn and Boston, the devotion easily spread westward. Shrines to Our Lady of Perpetual Help have been erected again near the epicenter of Wisconsin's effigy-mound territory. The current museum that stands on what is left of Fort Crawford, Wisconsin, where Black Hawk surrendered after his defeat, contains a prominent Our Lady of

[50]See "'Doctrine of Discovery' and *Terra Nullius*: A Catholic Response," Canadian Conference of Catholic Bishops, March 19, 2016, www.cccb.ca/wp-content/uploads/2017/11/catholic-response-to-doctrine-of-discovery-and-tn.pdf: "We firmly assert that there is no basis in the Church's Scriptures, tradition, or theology, for the European seizure of land already inhabited by Indigenous Peoples" (1). I thank Damian Costello for this reference.

[51]To name just a few, there are churches named after this image in Maple Shade, New Jersey; Seaside Heights, New Jersey; Levittown, Pennsylvania; Morton, Pennsylvania; and so on.

Perpetual Help icon.[52] Just a short drive from there, a curious, mosaic-encrusted garden of patriotic and religious statuary at the Dickeyville Grotto is offset by the icon of Our Lady of Perpetual Help as well. Saint Louis, in view of the mounds of Cahokia, was particularly strong in its devotion to Our Lady of Perpetual Help.[53] As this devotion spread west, the expanding Catholic cathedral of Oklahoma City naturally chose this icon as its titular image (see fig. 3.3).

To employ an overused, but in this case appropriate, word when examining American cultural topography, the Virgin of the Passion *haunts* the North American landscape, reminding settlers of those whom they displaced. Interestingly enough, the Virgin of the Passion born in Cyprus is the dedicatory icon of Our Lady of Perpetual Help Cathedral in Rapid City in the heart of the Black Hills as well (see fig. 3.3). In this case, our American equivalent of Guy de Lusignan would be the hapless George Custer, whose defeat by Native forces led to rapid punitive expeditions led by General Nelson Miles, who would stand in for Richard the Lionheart. But as with the Crusades, it is the Virgin of the Passion, it seems, who gets the last word (see fig. 3.3).

Figure 3.3. Cathedrals of Our Lady of Perpetual Help in Oklahoma City, Oklahoma, and Rapid City, South Dakota

[52]It is a prominent part of the display in remembrance of the Campion Jesuit High School for Boys, Prairie du Chien, Wisconsin.

[53]T. L. Skinner, *The Redemptorists in the West* (St. Louis: Redemptorists Fathers, 1933).

William Hogeland rightly laments that "our first war, fought by Anthony Wayne and Blue Jacket and Little Turtle, and by all of the fighters, fallen and surviving . . . remains nearly unmemorialized."[54] At Wayne's Fort Recovery, a memorial obelisk dedicated to Wayne perpetuates his legacy of "muscular, racist, American imperialism, associated with ideas about manliness."[55] The Battle of Fallen Timbers is memorialized with an impressive array of statuary, including, it must be added, places of honor given to Native Americans in addition to settlers. Still, Hogeland ends his study—not unjustifiably—with a depressing rumination on a memorial to "Global War" in Defiance, Ohio, not far from St. Clair's defeat. And yet, not even a fifteen-minute drive from the Fallen Timbers memorial in Toledo is a church conveniently dedicated to Our Lady of Perpetual Help. Perhaps then America's first war is memorialized after all—not in a way that flatters American ambitions, but in a way that reminds its residents that the land was settled at cost.

Canada can be brought into this story as well, there being a very prominent church dedicated to this icon, St. Patrick's Church, perched next to the Art Gallery of Ontario in downtown Toronto. Sometimes the image is even defiantly processed through the city's commercial glitz. Some would say that a true Indigenous perspective can only be found within the AGO itself, where Norval Morrisseau and other Indigenous artists are celebrated. And yet, Morrisseau was depicted with this very image in the 1974 documentary (whose title would have pleased Chesterton) *The Paradox of Norval Morrisseau*, reminding us of the artist's Christian Ojibwe roots (see fig. 3.4). All this is to say that we need not wait for a new icon to arise that represents the suffering of Indigenous people and reminds settlers of

[54]Hogeland, *Autumn of the Black Snake*, 386.

[55]Hogeland points out that the movie star Marion Morrison changed his name to John Wayne. Hogeland, *Autumn of the Black Snake*, 385.

the history of conquest. The advantage of this particular icon is that it saturates the globe now, and all that is needed to activate its relevance in drawing attention to Indigenous displacement is understanding its history. To borrow from the historian of the Midwest, Andrew Cayton, the Virgin of the Passion (a.k.a Our Lady of Perpetual Help) asks North Americans, Midwesterners especially, to "confront something we do not like to consider at length: the extent to which the nation's history rests on military conquest and the extent to which its history is about power as well as liberty."[56] Or as Chesterton put a similar idea:

Figure 3.4. Norval Morrisseau with Our Lady of Perpetual Help, still from the documentary *The Paradox of Norval Morrisseau* (1974)

> We took all nations captive that we might set them free. . . .
> Lo, we have freed all peoples. Oh, set us free![57]

The Congregation of the Great Spirit

It would be very easy to make a case for Our Lady of Perpetual Help as a key candidate for Our Lady of Chicago, an image that reminds Indigenous and settler alike of the city's history of conquest. I have counted no less than twelve churches in the city or around it either dedicated to this Madonna or with large shrines within them honoring her image, in addition to the one above the Saint Kateri Center

[56] Andrew L. Cayton, "The Meanings of the Wars for the Great Lakes," in *The Sixty Years' War for the Great Lakes, 1754-1814*, ed. David Curtis Skaggs and Larry L. Nelson (East Lansing: Michigan State University Press, 2001), 381.

[57] Chesterton, *The Queen of Seven Swords*, 47.

of Chicago at Saint Benedict Parish.[58] But as mentioned in the last chapter, much of the urban Native community has been gentrified out of Chicago. In Milwaukee, however, because of the peacemaking initiative of Josette Juneau (of Menominee and French descent), the city avoided a Fort Dearborn disaster.[59] The Indigenous Christian community is therefore especially vibrant, in particular at the Congregation of the Great Spirit, founded in 1989, where the Medicine Wheel dominates the choir, and statues of Mary and Jesus are lovingly bedecked in Indigenous regalia. Nearby one can visit the Milwaukee Public Museum to see disconcerting dioramas of mechanized Indian mannequins alongside Christian Indigenous artifacts stowed safely behind glass with dismissive labels.[60] But the Congregation of the Great Spirit will introduce visitors to *actual* Indigenous life, not its hollow museum memorial; and they won't even charge admission.

On the morning of my visit with students in early 2020, there were so many people in the church that our group had to disperse into the few remaining seats. Visiting Catholic seminarians from Asia gave the gathering an additional international appeal, but the Indigenous

[58]These include Our Lady of Perpetual Help in Bridgeport, Holy Family parish on Roosevelt Road (where the image is credited with rescuing the church from the Great Chicago Fire), St. Peter's in the Loop, St. John Cantius, St. Michael's in Old Town, St. Alphonsus, and our Lady of Lourdes. The Orthodox Fellowship at the University of Chicago even uses a replica of the original Virgin of the Passion at Lagoudera when it meets for worship in that campus's neo-Gothic chapel. Just outside the city proper is Our Lady of Perpetual Help in Hammond, Indiana; Our Lady of Perpetual Help in Glenview (also claiming a reported miracle); a full-scale mosaic that tells the story of the icon at the Queen of Heaven Mausoleum; and the largest, the Virgin of the Passion, now displayed to the traffic on Route 53 from St. Mary's Coptic Orthodox Church.

[59]I thank Mark Thiel for this information. See Mark G. Thiel and Christopher Vecsey, eds., *Native Footsteps: Along the Path of Saint Kateri Tekakwitha* (Milwaukee: Marquette University Press, 2012).

[60]These include a ceremonial rattle with an image of Christ on it and a staff with "Glory be to the Father, and to the Son" carved on it. "Our religions seem foolish to you [Christian missionaries]," reads the dismissive quote from Sitting Bull. Ironically, a different Sitting Bull became a Mennonite. Louis S. Warren, *God's Red Son: The Ghost Dance Religion and the Making of Modern America* (New York: Basic Books, 2017), 373. Warren adds that Sitting Bull's sons became Pentecostal ministers, a movement that coordinated well with the Ghost Dance (377).

community was unmistakably the host. I had been searching for a con-vergence on this continent, wondering if a connection could be made between the sacred heart of Jesus, whose iconography pervades the Midwest, and the sacred drumbeat of the pow-wow drum, "the heartbeat of the people."[61] The fact that Moravian Protestant missionaries used graphic images of the heart to convey their message, and that Catholic missionaries did as well, seemed to make this convergence inevitable.[62] At the Congregation of the Great Spirit I witnessed the confluence I was hoping for, and had seen only fleetingly elsewhere, at last.

During the service we smudged and sang and lamented and prayed in a sanctuary thick with the smell of cedar and sage. We participated in a rhythmically choreographed, highly energized corporate prayer in the Four Directions.[63] We were then invited up to the sanctuary for a final drum song. All of us pressed into the tiny choir, where the drum, pum-meled with startling force, enveloped us. The compressed space meant that one had no choice but to participate. An Indigenous man was holding an infant next to me, and I expected at any moment for the child to be startled awake by the pounding drum and its accompanying song of praise. But the infant continued to sleep, and I soon realized why the child was contented. During the song, I looked up and saw an image of Jesus' sacred heart above me in one stained-glass window. Across from it was a paired window displaying Mary's sacred heart. Hers, of course, was the heart that the uterine Jesus would have heard beating while

[61]Tara Browner, *Heartbeat of the People: Music and Dance of the Northern Pow-wow* (Urbana: University of Illinois Press, 2002).

[62]The evangelical iconography, with scenes of everyday life taking place within the wounds of Christ, makes the sacred-heart iconography look rather tame. Aaron Spencer Fogleman, *Jesus Is Female: Moravians and Radical Religion in Early America* (Philadelphia: University of Pennsylvania Press, 2007), plates 5-6. Heart imagery, as anyone aware of the crests of Martin Luther and John Calvin will know, is an abiding feature of Protestantism just as much of Catholicism. For Catholic iconography, see David Morgan, *The Sacred Heart of Jesus: The Visual Evolution of a Devotion* (Amsterdam: Amsterdam University Press, 2008).

[63]A helpful webpage delineating the Congregation of the Great Spirit's liturgy is available at www.greatspirit.net/beliefs, accessed April 20, 2021.

residing in her womb, explaining why the infant slept so peacefully. The beat was, to his new ears at least, a very familiar sound.

There in the womb of that choir, we too were at rest. The drum was the sacred heart of Christ's body, the church, to which there at least we all belonged. Somehow on that Milwaukee morning, in a church comprising so many ethnicities, we all—Protestant and Catholic both—were melted by the beat into one. Which is to say, the deafening cacophony of the crusades and North American conquest was overcome by a love that was even louder. Or as Chesterton put it in *The Queen of Seven Swords,*

> Knew ye not, ye that seek, wherein I have hidden all things?
> Strewn far as the last lost battle; your swords have met in
> my heart.[64]

And presiding over it all, we were not surprised to discover, was the Virgin of the Passion (see fig. 3.5).

Figure 3.5. Our Lady of Perpetual Help (a.k.a. the Virgin of the Passion) at the Congregation of the Great Spirit in Milwaukee, Wisconsin

[64]Chesterton, *The Queen of Seven Swords*, 53.

RESPONSE

AMY PEELER

IN THIS, HIS FINAL ESSAY, Dr. Milliner finds in an unlikely pairing, Chesterton's *The Queen of Seven Swords* and the Byzantine icon known as Our Lady of Perpetual Help, a way forward through a seemingly intractable problem, that of our broken history.

All of his essays have pushed us, to quote Andrew Cayton, "to confront something we do not like to consider at length: the extent to which the nation's history rests on military conquest and the extent to which its history is about power as well as liberty."[1] Dr. Milliner has reminded us of this with Indigenous people in mind, but our country has been reminded of that in this summer of 2020 from the perspective of the African slave as well. What better time for art and the church and the art of the church, in both image and poem, to teach believers how to respond to our shared history faithfully.

Milliner brings before us the older, more mature Chesterton, who brings forward multitoned nations, not to wield their swords but to lay them down at Mary's feet. He also tells us the little-known story of a very common image, Cyprus's Virgin of the Passion. Previous conquerors had become the conquered, and a mournful Mary, persecuted but not forsaken, cast down but not destroyed, gave them the vision to survive. Dr. Milliner argues that this Mary, this Queen of Heaven,

[1] Andrew L. Cayton, "The Meanings of the Wars for the Great Lakes," in David Curtis Skaggs and Larry L. Nelson, eds., *The Sixty Years' War for the Great Lakes, 1754-1814* (East Lansing: Michigan State University Press, 2001), 381.

ruling through suffering, reigning in humility, resolute for the peace born of repentance and relationship, has left her mark all over this scarred land. His winsome scholarship, compelling narrative of personal experience, and our long-term friendship prods me to believe he is correct, that this Mary can provide not an immediate answer but a way forward to the ultimate answerer.

I'd like to chart out a possible way forward from both a very personal and a more national perspective because it is my conviction that we learn the skills to respond to our corporate history by thinking about our personal history often embedded in it.[2] In other words, I'll take the liberty charted by previous respondents to Dr. Milliner and draw from my own life.

Dr. Milliner asked me to respond not only because of our shared interest in Mary but also because of my roots. I was born in an important part of the land he has studied for this project—the part that used to be called Indian Territory and is now the state of Oklahoma. And while I spent my childhood in the suburbs of Oklahoma City, largely indistinguishable from any other Midwestern suburbs,[3] I was born in a town in the southwest of Oklahoma called Anadarko, an area that remained in the early 1980s as well as now significantly populated by Native Americans.

I was born there because my father had been born there. He grew up among the children of the reservation and shared stories with me of sweet friendships but also tensions that existed between different ethnic groups. It would have been fascinating to interview him for this project, but I cannot. He passed away quite suddenly five years ago.

[2]Jemar Tisby recommends exploring one's own racial identity as an important early step in fighting racism. *How to Fight Racism: Courageous Christianity and the Journey Toward Racial Justice* (Grand Rapids, MI: Zondervan Reflective, 2021), 39-62.

[3]In preparing for this project, I was reminded that my elementary school was named for the Cherokee chief John Ross, and my middle school named for the creator of the Cherokee alphabet, Sequoyah. Even in the suburbs, this history was present.

Allow me for a moment to reflect upon this personal story. God had done mighty things in my relationship with him that are applicable to the issue at hand. My father, as is true for most, wasn't perfect so, in an act of great compassion, God taught me to have compassion on him. As an adult, I was able to acknowledge his shortfalls and the ways they had hurt me, but I also saw the larger picture of the things he struggled with and why and, through the power of the Spirit, was able to forgive him. I learned to love him honestly and freely and could say at the end that we had ended well. Although I certainly have my own failures, I am free from many of his mistakes, and yet do not stand in judgment of him. It is my conviction that this personal model can aid the corporate one.

Before that it is necessary to share one other element about myself pertinent to this conversation. I am an Anglophile. I was the teen who loved Jane Austen and as an adult found myself at key moments in my academic journey in the United Kingdom, Scotland in particular. My family and I lived there in 2018 during my sabbatical, and as ridiculous as it might sound, I had a sense of rootedness, of home, there that I've never felt anywhere else. We discovered that my ancestors were married in Dunfermline Abbey, in the very same county where we were living, so maybe there is something to be said for generational geographical memory.

But let me admit an ugly underbelly to this adoration. It has led me to disdain my own ancestral story. I have wished many times that whoever took the boat to America hadn't done so, and that I too was legitimately Scottish.

My parents were in Oklahoma not because, like so many Indigenous peoples, they were moved there but because their parents chose to move there. Previous generations were in Arkansas and Louisiana. Oklahoma offered a job, or some kind of new start, or economic promise. So if you go back several generations in my family tree to

the American South, you can discover some ugly realities of my ancestors. Those who found their way to the New World came to be identified not as Scottish but as White, not Black, not Indigenous. I must acknowledge that attitudes and actions I now abhor likely existed in my own family, and if I'm honest I've spent the last several years trying to run away from it, hating it, at times denying it, wishing it were canceled.

Dr. Milliner's work in this series has made me face the fact that there is a better way, and the image of Mary could be my guide. First, I have to acknowledge reality for what it is: nations were divided against nations, people against people, swords were drawn and used, and of course this was true in Britain as it was in America. No place or people is righteous. Mary's face shows us that we can, we must, lament this. We can scream at the top of our lungs that this was wrong, and then collapse in weeping over it.

But then we must bring our own swords to lay at her feet. We must repent. I cannot repent for what my ancestors did or did not do, but I can repent for what I have done or not done. This summer I've begun the painful and hard process of realizing I have not loved my neighbor as myself and have begun to take practical if small steps to start doing so. I've begun asking myself, *What might I do that I have not been doing to participate in the move toward full flourishing of those groups who aren't fully flourishing in part because of what my own ancestors did to theirs?*

I must also repent for the hate I harbor against my own people, the self-righteous judgment I would like to wield against them. Likely my ancestors were, as all humans are, beautifully but frustratingly complex, hurting others because they had been hurt. I say this not to excuse their actions but so that I can stand against their wrong and at the same time, by seeing their humanity, be motivated to forgive them as well.

Our society has been involved in some of these actions this summer, and praise God for it. Let's find and celebrate truth as God's truth wherever it arises. But I daresay that Christianity offers something that secular liturgies cannot quite attain, namely, a sure and steadfast hope. The mournful Mary of Cyprus, the previous conqueror who is now conquered and so has named and lamented over her people's misuse of power, she is pointing somewhere; her acknowledgment and lament are not the end of the story. She is not only pointing somewhere, she is pointing to someone—her Son, our Lord.

Allow me to draw together the threads of this story. How did I make sense of an imperfect and then suddenly absent father? He is in Christ. I know that God holds him, so I can move forward—after acknowledgement, and lament, and repentance—in hope. How do I make sense of our, my, broken ancestral history that has played on this scarred national stage? It too is in Christ. God holds it, with both justice and mercy, so I can learn to move forward. As the Potawatomi writer Kaitlin Curtice puts it, "[Y]ou may not be Native in the way that I am Native, but you belong to a people as you long for a space to know what it means to hold the realities of love, mystery, and hope."[4]

Enough hard work remains to do that it will take our lifetimes and probably those of our children and grandchildren as well, but it will ultimately work out. The kingdom will come. Relationships will be healed and restored, wounds turned to crowns, true repentance enacted, and true forgiveness offered. The great blessing and deep challenge is this: we can and must start our own renaissance now. By acknowledging and lamenting our broken history and changing our shared present, with her image before us, we will be drawn on by the sure and hopeful drumbeat of the heart of our reigning Savior.

[4]Kaitlin B. Curtice, *Native: Identity, Belonging, and Rediscovering God* (Grand Rapids, MI: Brazos Press, 2020), xiii-xiv.

CONCLUSION

RETURNING A PIPE

There is nothing more mysterious or more respected among them than the calumet. Less honor is paid to the crowns and scepters of kings than the Indians bestow on this object.

<small>FATHER JACQUES MARQUETTE (1674)</small>

It is you Telmarines who silenced the beasts and the trees and the fountains, and who killed and drove away the Dwarfs and Fauns, and are now trying to cover up even the memory of them.

<small>DOCTOR CORNELIUS IN C. S. LEWIS'S *PRINCE CASPIAN*</small>

England and the English governing class never did call on this absurd deity of race until it seemed, for an instant, that they had no other god to call on.

<small>G. K. CHESTERTON</small>

It is better to be a guest than a host.

<small>SAYING OF THE DESERT FATHERS</small>

MY WIFE AND I PACKED our toddler and infant into a Honda CRV, the same vehicle that would eventually traverse the Potawatomi Trail of Death, and made the trek west from Illinois to *Paha Sapa*, "the heart of everything that is," known by Google Maps as the

Black Hills of South Dakota. There, Wheaton College, my employer, owns a small patch of land. My goal was to teach an onsite course on Native American art so we skipped the Frank Lloyd Wright sites in Wisconsin along the way and chose to visit a sacred one instead. The red rock of Pipestone, Minnesota, has been mined by hand for centuries, even millennia. If the Black Hills are the heart of Turtle Island, Pipestone has been called her womb. I knew at this point that pipes were not for decoration, let alone recreation; they were instruments of prayer. "When you pray with this pipe, you pray for and with everything," claimed Black Elk.[1]

After examining the petroglyphs that survived at the site, I met a Dakota carver named Ray Redwing, who—after an extended conversation—sold me a hand-hewn pipe. If my ancestors were going to rename this sacred stone Catlinite from the White American painter of Indians George Catlin (1796–1872), the least I could do was support Indigenous artistry by purchasing a pipe myself. Perhaps I would reverently display it in the classroom. Or maybe even use it for prayer. About that I was unsure.[2] As we left the sacred site, the new pipe wrapped beside me, I saw a church sign that said, "Jesus is Lord of Pipestone." I do not know whether this church had in mind that Christ can be worshiped with a pipe.[3] But as a person in love with Native

[1]Black Elk, *The Sacred Pipe*, ed. Joseph Epes Brown (1953; repr., Norman: University of Oklahoma Press, 1989), 7. Philip Jenkins's caution is advisable: "*The Sacred Pipe* may be a manifestation of Western mysticism as much as of the pristine religion of the Native people of the Plains." Philip Jenkins, *Dream Catchers: How Mainstream America Discovered Native Spirituality* (Oxford: Oxford University Press, 2004), 145.

[2]Vine Deloria Jr. remarks on the "gimmick" of "Pipe Carrier" enabling non-Indians to join Indian ceremonies. Vine Deloria Jr., "More Others," in *Spirit and Reason: The Vine Deloria, Jr., Reader*, ed. Barbara Deloria, Kristen Foehner, and Sam Scinta (Golden, CO: Fulcrum, 1999), 252-53. Even so, Arval Looking Horse insists, "the Pipe is for all people, all races, as long as a person believes in it. Anyone can have a pipe and keep it within their family. But only the Sioux can have ceremonies with the Sacred Calf Pipe." Arval Looking Horse, "The Sacred Pipe in Modern Life," in *Sioux Indian Religion*, ed. Raymond J. DeMallie and Douglas R. Parks (Norman: University of Oklahoma Press, 1987), 69.

[3]They certainly might. William Stolzman's *The Pipe and Christ: A Christian-Sioux Dialogue* (1986; repr., Chamberlain, SD: St. Joseph's Indian School, 2002) is a mind-bending

American art and history who is unprepared to leave Christianity behind, I whispered to myself an amen.

On arrival at Wheaton College's campus in the Black Hills, I met my parents, who had traveled from Idaho so they could meet their infant grandchild who, incidentally, is the sole male carrier of our Milliner family name.[4] There was a joke in our family that when it comes to genealogy, don't look too deep; you might not like what you find. Such humor carried with it an intuition that there was nothing too impressive to uncover, and perhaps some embarrassment, and soon I would come to know why. A few days later I was at the Pine Ridge reservation with my students, where the American government deposited what was left of Native Americans from the area after ejecting them from the Black Hills. We passed by an empty field, and one student in our van shouted out that she had seen a Sundance Circle. We had just discussed the Sundance the previous day in class, so I wrote her comment off as overly enthusiastic. But we stopped the van anyway and learned she was right. The sacred ground was marked with a sign that read Mitákuye Oyás'iŋ ("we are all related") and offered a list of rules. The circle stood empty on the horizon, its central cottonwood tree bedecked with prayer ribbons. We kept our distance. Across the road was a similar hill with a cross upon it and a sign for an evangelical church. The cross and the cottonwood tree seemed to be in conversation as a thunderstorm approached.

We met our guide, an artist who was continuing the Plains Indian tradition of drawing on accounting ledgers. He took us to the cliff that overlooks the site of Wounded Knee Massacre, where on

chronicle of what this entails. For a responsible articulation of Christian pipe usage, see Casey Church, *Holy Smoke: The Contextual Use of Native American Ritual and Ceremony* (Cleveland, TN: Cherohala Press, 2017), 80-83.

[4]Of course, my daughter and other beloved Milliner cousins may continue the name as well, but I have in mind for the purposes of the story related here a lineage that, historically at least, extended only through name-carrying males.

December 29, 1890, the remainder of Colonel Custer's Seventh Cavalry Regiment slaughtered nearly three hundred Lakota men, women, and children, many of them associated with Ghost Dance.[5] As if on cue, a man nearby wandered close to us and ominously announced that the skin-walkers were out, by which he meant that more teenaged suicides had occurred on Pine Ridge that week. Descending to the site itself, we examined the tombs and the prayer ribbons tied to the chainlink fence. At this point in our journey we harbored no facile illusions, once aggressively promulgated by settlers, that the Ghost Dance was a "pagan" movement divorced from Christianity. One Indian agent recorded the following account:

> A young woman said when she fell [during the Dance] an eagle hovered over her and picked her up carrying her to a house, the door being open the eagle went in first and she followed, and saw Christ and shook hand [*sic*] with him three times and said He was glad to see her as she had been there before.[6]

The wooden cross over the log church built at the site of the massacre stood tall, but the church itself was covered in graffiti and boarded shut—a fitting illustration of what the American government did to the Indigenous Christian movement known as the Ghost Dance.

[5]"The Ghost Dancers harmed no one and destroyed no property—they hoped to restore their world by dancing, not fighting—but non-Indians became alarmed by reports of warriors performing a strange new dance that was supposed to result in the disappearance of whites and the return of the buffalo. . . . With midterm elections looming (including the election of a senator from South Dakota, which had become a state in 1889), President Benjamin Harrison's Republican administration likely wanted to be seen as protecting South Dakota's citizens against an Indian uprising, and mobilizing troops would also give a timely boost to the local economy." Colin G. Calloway, *First Peoples: A Documentary Survey of American Indian History*, 4th ed. (Boston: Bedford/St. Martin's, 2012), 357.

[6]Louis S. Warren, *God's Red Son: The Ghost Dance Religion and the Making of Modern America* (New York: Basic Books, 2017), 264. Such visions are similar to Black Elk's and Kicking Bear's experiences of Christ during the Ghost Dance. In these visions Christ had "the warmth and intimacy of a personal friend in heaven, much like the old spirit protectors who functioned as personal friends and guardians for individual Lakotas" (264).

Soon we were at the Pine Ridge reservation's Oglala Lakota College, where we received a tour of the museum that told the Lakota side of the story of *Paha Sapa*. The fact that we would be comfortably sleeping that night in the Black Hills, while Oglala Lakota College resided so far away from their sacred land, was beginning to dawn on us. With some horror, I impatiently asked the Oglala Lakota College representative what we should do about that disjunction. At first she answered the question without words, offering an urgent look of restrained anger mixed with exhaustion. Then she spoke. "The sacred peak of what you call the Black Hills," she told us, "is named after the Butcher of the Lakota, General Harney." Though I did not know it then, she was referring to the killing of eighty-six Brulé Lakota, including women and children, at Ash Hollow in Nebraska in 1855. We had gazed on Harney Peak a few days earlier and read the vision Black Elk had upon it.[7] We had learned how the "wounds in the palms of his hands" was aggressively edited out of Black Elk's visions.[8] The year after our visit, thanks to the efforts of Lakota Korean War veteran Basil Brave Heart, the name would be changed to Black Elk Peak.[9] But we did not know that yet, so the name Harney Peak settled in our guts like so much cement, just as it needed to. As we returned to our van, we turned on the radio only to hear a preacher sermonizing about selling all one's possessions to follow Christ (Mt 19:21).

And this, I'm afraid, is where my ancestors come into the story. Following our course in the Black Hills, and at the encouragement of the Indigenous friends I was making through NAIITS,[10] I looked into my

[7]John G. Neihardt, *Black Elk Speaks: The Complete Edition* (Lincoln: Bison Books/University of Nebraska Press, 2014), 170.

[8]Raymond J. DeMallie, ed., *The Sixth Grandfather: Black Elk's Teachings Given to John G. Neihardt* (Lincoln: Bison Books/University of Nebraska Press, 1984), 263.

[9]For an account of this renaming process, see Jon M. Sweeney, *Nicholas Black Elk: Medicine Man, Catechist, Saint* (Collegeville, MN: Liturgical Press, 2021), 101-4.

[10]The North American Institute for Indigenous Theological Studies has since expanded to Indigenous communities beyond North America, but they still go by NAIITS.

own ancestry as they advised, and I began to realize what might have been the reason for the family embarrassment surrounding our origins. Wallace Stegner, the dean of American Western writing, referred to these waves of poor immigrants as "life's discards."[11] They were the human exhaust of the industrial revolution, factory workers, coal miners, and in some cases thieves. William Milliner (1827–1891) was the latter variety, having already served (if the records are correct) months of hard labor for larceny. The Bedfordshire jail in England, where he served his sentence, was in the same region where John Bunyan once languished in prison to write *Pilgrim's Progress*.[12] But William Milliner does not appear to have had a life-altering dream. William was the sort of person in whom John Ruskin, his contemporary, hoped to awaken aesthetic sensibility nurtured by dignified creative work. John Henry Newman might have elevated William to what Newman deemed a more intellectually defensible Catholicism. But while none of these famous British authors got to my ancestor, the energetic conversion efforts of the Mormons (who Chesterton commented upon) did.[13]

I suppose William was an easy target. After the birth of his son George, his young wife, Mary Anne, had died. Perhaps she was stricken by the cholera then raging through England. Stranded in Bedfordshire with a criminal record and a toddler, the prospect of setting sail for

[11]Wallace Stegner, *The Gathering of Zion: The Story of the Mormon Trail* (1964; repr., Lincoln: Bison Books/University of Nebraska Press, 1981), 222.

[12]Chesterton's comments on Bunyan, written when Chesterton was still a Protestant, exemplify the humility that this essay is about: "If you asked Bunyan . . . whether he was sturdy, he would have answered, with tears, that he was as weak as water. And because of this he would have borne tortures." G. K. Chesterton, *Heretics* (1905; repr., Nashville: Sam Torode Book Arts, 2014), 71.

[13]Rumors swirling about Mormon kidnappings caused one Mormon elder to address the British public, leading to G. K. Chesterton's humorous comments on the subject. We could call it an early run of South Park's *Book of Mormon*. In an essay more than tinged with his anti-Jewishness, Chesterton mocks the "dull, earnest, ignorant, black-coated men with chimney-pot hats, chin bears or mutton-chop whiskers." G. K. Chesterton, *Uses of Diversity* (London: Methuen & Co. Ltd, 1920), 125.

distant Zion must have sounded appealing. So it was that William the widower (age 28) and George (age 3) set sail from Liverpool to New Orleans in 1854.[14] From there they ferried up the Mississippi for twelve days in a cholera-infested steamboat, with the poorest passengers like them crowded in the hull. Those who died were buried in sandbars along the way. After a stop in Saint Louis, they made their way up the Missouri to Westport Landing (now Kansas City, Missouri), just below the Missouri River's northward bend. There the frontier portion of the journey began through a prairie still crowded with bison and wolves. This troop's recorded encounters with Native Americans along the trail were cordial, even positive. They shared provisions and, it seems on one occasion, even a ceremonial pipe.[15] After all, wider America's suspicion of Mormons was due, initially at least, to their perceived friendliness, even alliance, with the Indians.[16]

It was also that summer that the fragile frontier arrangement shattered. For many Mormons, including my ancestors, the journey's cost was fronted by the Perpetual Emigration Fund, which was not a gift but a loan. Hence, every penny and possession, especially livestock, had to be accounted for, which more than explains the frustration of a Danish

[14]The trip was chronicled, and illustrated, in Frederick Hawkins Piercy, *Route from Liverpool to Great Salt Lake Valley* (Liverpool: Franklin D. Richards, 1855).

[15]"Diary of Thomas Ambrose Poulter," in *Saints by Sea: Latter-day Saint Immigration to America*, accessed March 15, 2021, https://saintsbysea.lib.byu.edu/mii/account/748. Whether these Mormons themselves partook is delicately withheld. Hundreds of similar journal entries testify to such conditions as well. In contrast to wider frontier "captivity narratives," Mormon journals show "very little fear of Indians recorded by men or women pioneers." Stanley B. Kimball, "The Captivity Narrative on Mormon Trails, 1846–65," *Dialogue* 18, no. 4 (1985): 82.

[16]Armand L. Mauss reports the "Gentile and government suspicions that the Mormons were cultivating alliances with the Indians against their fellow Americans," including some Mormon claims that Gentiles would be swept off the land because of the "cries of the red men, whom ye and your fathers have dispossessed." This positive Mormon disposition toward Indians later shifted in conformity to wider American policy. Armand L. Mauss, *All Abraham's Children: Changing Mormon Conceptions of Race and Lineage* (Urbana: University of Illinois Press, 2003), 55.

Mormon who lost one head of livestock on the same year of my ancestors' journey, 1854.[17] Reports conflict, but it seems a lame cow from the Mormon company that year had wandered into a Brulé Lakota camp below Fort Laramie. The cow was shot, killed, and eaten by High Forehead, one of the few Miniconjou Lakota encamped there, who was understandably frustrated at the delay in promised government provisions. The Mormons complained to the American soldiers stationed at nearby Fort Laramie, saying that they had been shot at as well.[18] They petitioned the Fort Laramie commander to apprehend High Forehead in punishment for the crime.

When negotiations stalled, Second Lieutenant John Grattan was dispatched with twenty-nine soldiers and a drunken interpreter to arrest High Forehead. Grattan, like Guy de Lusignan, seems to have been itching for a fight, and he got one. Grattan demanded that Conquering Bear, a Brulé chief without jurisdiction over the Miniconjou Lakota, turn in the offender.

Tensions mounted, and when a spooked soldier shot the chief in the back, thirty American soldiers and one civilian interpreter were killed.[19] Chaos erupted along the frontier, which is to say, the Milliners surely heard of this conflict, if they didn't witness its repercussions themselves.

[17] Both William Milliner and George Milliner appear, funded by the Perpetual Emigration Fund, on the ship manifest for the *John M. Wood* from Liverpool to New Orleans, March 12 to May 2, 1854. *Saints by Sea: Latter-day Saint Immigration to America*, accessed March 15, 2021, https://saintsbysea.lib.byu.edu/mii/voyage/200.

[18] "High Forehead had lost some relatives in the skirmish that took place in the summer of 1853 and told his companions, because his relatives were dead, he wanted to die also, but not until he had avenged himself upon the whites." High Forehead reputedly said to the Mormon after missing him, "I have missed you; you are in the hands of God Almighty; but I will kill your cow." John D. McDermott, R. Eli Paul, and Sandra J. Lowry, eds., *All Because of a Mormon Cow: Historical Accounts of the Grattan Massacre, 1854–1855* (Norman: University of Oklahoma Press, 2018), 15. The Treaty of Fort Laramie of 1851 had stipulated that property disputes should be handled by the Indian agent, not soldiers.

[19] McDermott, Paul, and Lowry, *All Because of a Mormon Cow*, 20. The tally of Indians casualties is not known. Red Cloud played a key role in overcoming the fleeing soldiers (17).

General Harney's killing of eighty-five Lakota at Ash Hollow in September of the next year, which I first learned of on my trip with students to Oglala Lakota College, was revenge for the killing of Grattan and those under his command. One attendee at the delayed military burial (with honors) of John Grattan remarked, "It was a great satisfaction to us to feel that his fall had already been avenged."[20] But of course Ash Hollow settled nothing. The Mormon cow launched a decades-long conflict known as the Sioux Wars, which would culminate in 1890 at Wounded Knee. As for William and George, they made it safely to Utah, where William worked as a cobbler and a blacksmith.

By the time George was a teenager, however, he was drawn into a spinoff conflict from the wider Sioux Wars. It was known as Utah's Black Hawk War (1865–1872) because the Ute chief, originally Antonga, was dubbed Black Hawk after the more famous conflict with the Sauk warrior Black Hawk in Illinois. Initially, contacts with Mormons and the Utah Territory's Indigenous peoples were "not only symbiotic but also peaceful and even intimate."[21] But the volume of settlers upset this arrangement. Almost as if to avenge High Forehead the cow-killer, Black Hawk grew wealthy by stealing Mormon cows and horses.[22] While the wealthiest Ute might have had thirty cows before the war, Black Hawk, with half of his army composed of many Diné (Navajo) warriors,[23] stole upwards of two thousand cows and horses from Mormons in the summer of 1865 alone.[24] And so, for the next two summers at least, George Milliner became a teenage member of

[20]McDermott, Paul, and Lowry, *All Because of a Mormon Cow*, 153.

[21]Mauss, *All Abraham's Children*, 59.

[22]John Alton Peterson, *Utah's Black Hawk War* (Salt Lake City: University of Utah Press, 1998), 195.

[23]Black Hawk's success among the Navajo was due to the fallout from the Navajo Long Walk (1863–1864) and the deplorable conditions at the Bosque Redondo reservation at Fort Sumner, New Mexico. Peterson, *Utah's Black Hawk War*, 212.

[24]Brigham Young considered Black Hawk the leader of a "predatory band of outlaws," not the chief of a tribe. Yet Black Hawk's own people named him Nu-ints, the name reserved for the Ute people themselves. Peterson's observation is astute: "Whether Black Hawk

the Nauvoo Legion, a military vanguard—illegal from an American point of view—intended to protect Mormon settlement.[25] A conflict like this cannot fit into standard Western accounts because neither the Mormons nor the Ute nor the Navajo were American at all. "The simple fact was that two honorable peoples were hopelessly trapped not only by their own cultures, goals, and interests but also by the larger political and national forces of their time."[26] The two parties, the Mormons and the Ute, even reconciled after the war.[27]

But Mormonism could be a hindrance to the American ideal of Whiteness.[28] Perhaps sensing this, George made his way out of Utah. He had married a Welsh settler named Sarah, and they had a son named Charles in 1879 (a rough contemporary of G. K. Chesterton). The family made their way to Caldwell just west of Boise, which had recently been reached by the Oregon Short Line Railroad. There George became a farmer. He was the right kind of settler, one deemed capable of properly stewarding property: that is, George Milliner was White.[29]

was champion of native rights or chief of a band of robbers depends on one's perspective; in actuality, he was probably both." Peterson, *Utah's Black Hawk War*, 199.

[25]The charter for the Nauvoo Legion had been revoked in Illinois in 1844, and a revived form of the legion defended Salt Lake City from US troops in the 1850s. Philip M. Flammer, "Nauvoo Legion," *Mormon Encyclopedia*, accessed March 15, 2021, https://eom.byu .edu/index.php/Nauvoo_Legion. The American army was stationed in the Utah Territory at the time but chose not to get involved due to Colonel Patrick Edward Connor's "jaundiced view of Mormons." Mauss, *All Abraham's Children*, 62.

[26]Peterson, *Utah's Black Hawk War*, 7. Peterson suggests one reason the Black Hawk War was not remembered was because in it "nineteenth-century Mormons failed to implement the humanitarian teachings, policies, and examples of both Joseph Smith and Brigham Young and in practice rejected a founding tenet of their faith" (Peterson, *Utah's Black Hawk War*, 9).

[27]Brigham Young even preached at Black Hawk's funeral. Mauss, *All Abraham's Children*, 62.

[28]Mainstream American critics charged that "by converting to Mormonism . . . converts essentially forfeited their whiteness, becoming almost slaves to the leaders of the church." Jason E. Pierce, "Unwelcome Saints: Whiteness, Mormons, and the Limits of Success," in *Making the White Man's West: Whiteness and the Creation of the American West* (Boulder: University of Colorado Press, 2016), 180.

[29]"It was with a sense of urgency that railroads set out to find settlers, and, without exception, the settlers they recruited were descended from old-stock Americans or Northern Europeans. When railroad promoters dreamed of settlers for their lines, they dreamed only in white. . . . 'Real' whites, usually defined as those of Northern European ancestry,

Living in the land that would soon be the state of Idaho, George and his family joined the ranks of those whom Theodore Roosevelt described as "dogged frontier farmers [who] by dint of grim tenacity overcame and displaced Indians, French, and Spaniards alike, exactly as, fourteen hundred years before Saxon and Angle had overcome and displaced Cymric and Gaelic Celts."[30] Indeed, after Utah attained statehood in 1896, Milliner's service in 1866 and 1867 in the Nauvoo Legion seems to have been retroactively categorized by the US government as generic military service "against the Indians."[31] Mormon alliances with the Indians, even perceived Mormon sympathies with the Ghost Dance, were forgiven.[32] So it was that the Mormon chapter of my family's history, to say nothing of its Welsh and Irish chapters, was gently concealed in a White, respectable fog.

In time the family upgraded to Episcopalianism. George's son Charles became an Idaho trucker. Charles's son Ernest Milliner kept up the family business by trucking tungsten through the mountains to fuel the efforts of the Second World War. My grandfather Ernest died young, and with the Milliner truck line no longer in operation, my father, John—seeing few other prospects—served in Vietnam. The late Thomas Merton called this war "an extension of our old western frontier, complete with enemies of another 'inferior' race . . . enabl[ing]

rated as the most desirable potential citizens." Jason E. Pierce, "'Our Climate and Soil Is Completely Adapted to Their Customs': Whiteness, Railroad Promotion, and the Settlement of the Great Plains," in *Making the White Man's West*, 152.

[30]Theodore Roosevelt, *The Winning of the West: The Spread of English-Speaking Peoples* (New York: Putnam's Sons, 1889), 41. This is not the entirety of Roosevelt's views of Native Americans. For his connection to activists in support of Indigenous rights, see Jenkins, *Dream Catchers*, 77.

[31]George Milliner, "Affidavit Concerning Service in Indian Wars Within the State of Utah and of Service Relating Thereto: Made Under the Provisions of Chapter 55, Laws of Utah, 1909," Utah Division of Archives and Records Service, Commissioner of Indian War Records Indian War Service Affidavits, September 15, 1867, https://images.archives.utah .gov/digital/collection/2217/id/6332/rec/28, accessed March 15, 2021.

[32]William A. Young, *Quest for Harmony: Native American Spiritual Traditions* (Indianapolis: Hackett, 2002), 292-93.

us to continue the cowboys-and-Indians game which seems to be part and parcel of our national identity."[33] If that is so, I would only add that my father, like so many others in that conflict, had little more choice in the matter than the "reluctant citizens" of the Ohio Country who were drafted to serve in St. Claire's defeat.

Upon my father's return from the war, he learned that the dynamics of settlement studied by historians was still very much in effect. He got word that Idaho acreage could still be claimed through the Desert Land Act originally passed by Congress in 1877. He made a claim, but without the money to irrigate the land, he sold it to someone who could. This modest sum enabled my father to attend graduate school. His quest for employment moved him and my mother eastward. After I and my sister were born in Indian City (Indianapolis), in view of Harrison's column of triumph, my father took a job in the city that William Penn envisioned as a place of harmony with Indigenous Americans (Philadelphia), which is what landed us on the eastern end of Turtle Island (New Jersey). There, to bring this book full circle, I was welcomed into the same faith that had once welcomed the Lenape.

Attempting to get a look at the chunk of Idaho my father had once claimed, one summer on vacation we piled the kids into the car and took a drive south of Boise. This was anything but empty land. Instead, it was a canvas, as was so much of what we call the American West. At Wee's Bar, we inspected the melon rocks strewn by the prehistoric Bonneville flood that had burst from Utah into the Snake River Valley just as, fifteen millennia later, burst the settlers.[34] The rocks were emblazoned with pictographs that researchers say are up to twelve thousand years old.[35] My son Peter, then three, was tired of traveling

[33]Thomas Merton, *Ishi Means Man* (Mahwah, NJ: Paulist Press, 1968), 34.

[34]The Great Salt Lake is what remained of the Pleistocene Lake Bonneville after this flood.

[35]An excellent survey of the latest research on such "artifaction" can be found in Ekkehart Malotki and Ellen Dissanayake, *Early Rock Art of the American West: The Geometric Enigma* (Seattle: University of Washington Press, 2018).

and was throwing a fit. I imagined what it would be like to take him, as my ancestor William had done with his three-year-old son, across an ocean and half a continent alone.

It was these discoveries that enabled me to give away, or give back, the pipe that I had purchased in Pipestone, Minnesota. Every five years the Trail of Death Association traces that scar across the Midwest, joined by various Native Americans, mostly from the Citizen Potawatomi Nation.[36] In 2018 I joined them, and about halfway through the trip a Diné (Navajo) man, Stanley Perry, joined me in my car. Over the course of a week, we traded stories, songs, and theological views. Along the way, I watched him perform ceremonies at rivers under highway overpasses, places that growing up I had considered, if I considered them at all, as depositories of trash. Stanley shared with me that while he was serving as an Eagle Dancer one summer—a position of high honor within the Sun Dance—his ceremonial pipe had been stolen. He did not know I was carrying one myself, and at the next stop, after we enjoyed lunch on a Missouri farm that hosted our band for lunch, I presented Stanley my pipe. He offered prayers and received it formally. The next day, as we stopped at a Trail of Death site along Missouri's Grand River, he presented me with an eagle feather in thanks. He prayed for me, played his flute, and sprinkled me with river water.

After the impromptu ceremony, his cousin laughed and said, "You're Indian now. That's what you wanted, right?"[37] She was joking, of course,

[36]For a moving account of an Indiana minister who walked the Trail of Death, see Keith Drury, *Walking the Trail of Death* (Marion, IN: Keith Drury, 2007). For a tenderly written account of the journey aimed at a younger audience, see Peggy King Anderson, *Two Moon Journey* (Indianapolis: Indiana Historical Society Press, 2018).

[37]"Whenever white Americans have confronted crises of identity, some of them have inevitably turned to Indians. . . . They [have] failed to produce a positive identity," complains Philip Deloria in *Playing Indian* (New Haven: Yale University Press, 1998), 156, 3. Thanks to the hospitality of the Indigenous Americans on the Trial of Death, however, I

but there is no need for that anymore because I know who I am: a descendant of the immigrant English poor who, in Utah's Black Hawk War, were once at war with the Navajo who had, five generations later, just blessed me. It was an undeserved blessing—for which another word is grace—and I'm not the only one who needs it. Truth be told, weaving my way through gutted town cores of the American Midwest to commemorate the Potawatomi Trail of Death, I learned as much about misunderstood Whites today as I did about Indigenous history.[38] But there was not a one of them who came out to meet our traveling caravan who was not blessed (see fig. C.1). Maybe one of the reasons the originally noble intentions of the evangelicals, Moravians, Jesuits, Mormons, and all manner of Christian missionaries became warped is that missionaries continually wanted to bless, not to be blessed themselves.[39]

"The whites always want something," explained the Taos Pueblo elder Mountain Lake to the famous Swiss psychiatrist C. G. Jung. "They are always uneasy and restless."[40] This prompted Jung to reflect on the history of imperialism, in which he bundled Christianity wholesale, counseling Indigenous ways of thinking, encountering our shadows, and recovering myth instead.[41] But two decades before Jung's Indigenous

no longer need to pretend membership in the "Tribe Called Wannabe." See Jenkins, *Dream Catchers*, 4-6.

[38]Father Benjamin Petit, who journeyed the Potawatomi Trail of Death to what would become his own death, recorded horror at the way the American government treated Mormons as much as the way they treated Indians. Shirley Willard and Susan Campbell, *Potawatomi Trail of Death: 1838 Removal from Indiana to Kansas* (Rochester, IN: Fulton County Historical Society, 2003), 102-3.

[39]Mauss makes it clear that early comingling of Mormons among Native peoples were one of the reasons Americans persecuted Mormons. Ultimately, however, this harmonious policy toward the "Lamanites" was expressly abandoned. Mauss, *All Abraham's Children*, 114-57.

[40]C. G. Jung, *Memories, Dreams, Reflections*, ed. Aniela Jaffé, trans. Richard Winston and Clara Winston (New York: Vintage/Random House, 1989), 247-48. Jung's trip was in 1925, just after Chesterton's first.

[41]Jung, *Memories, Dreams, Reflections*, 247-48. Jung says that Mountain Lake told him that Indigenous people, unlike the Whites, think from the heart. If so, this dovetails nicely with the great tradition of mystical prayer in the East, where the objective is for the mind to descend into the heart. Symeon the New Theologian, "The Three Methods

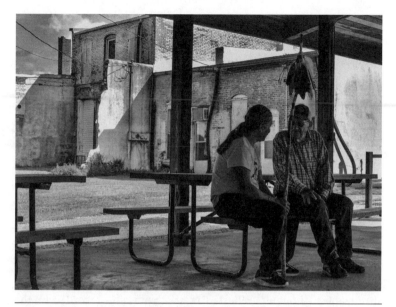

Figure C.1. Stanley Perry (Diné) blessing a Missourian on the 2018 Potawatomi Trail of Death Caravan

encounter and the psychology it helped inspire, G. K. Chesterton had made all the same moves from within the Christian faith: celebrating what he called "pagan" thinking, urging a serious recovery (not reduction) of myth, calling attention to the criminals under our own hats,[42] and tracing the invention of modern imperialism to an unholy restlessness that gratitude and contentment can heal.[43] Chesterton's program anticipated Aslan's counsel to Prince Caspian, who was embarrassed

of Prayer," in *The Philokalia*, trans. and ed. G. E. H. Palmer, Philip Sherrard, and Kallistos Ware (London: Faber & Faber, 1995), 4:67. The Centering Prayer movement is the modern revival of this method.

[42]The line is Father Brown's: Our "only hope is somehow or other to have captured one criminal, and kept him safe and sane under his own hat." G. K. Chesterton, *The Complete Father Brown Stories* (London: Wordsworth Editions, 1992), 498.

[43]Chesterton, *Heretics*, 78. I should add here that Chesterton's original take on the book of Job, where "the riddles of God are more satisfying than the solutions of man" ("The Book of Job," in *In Defense of Sanity* [San Francisco: Ignatius Press, 2011], 99), is vastly preferable to Jung's *Answer to Job*, where, according to Jungian scholar Ann Belford Ulanov,

with his less than honorable Telmarine lineage: "Be content."[44] Such counsel, moreover, only comes after Caspian's training from an "Indigenous," that is, Narnian tutor (Cornelius), and after Caspian's humiliating realization of his ancestor's colonist past. Only then does Aslan complete Caspian's genealogical exercise by extending it all the way back, to the honor and shame of Lord Adam and Lady Eve. Likewise for Chesterton, it is humility mixed with contentment that cures the colonist. Counseling such contentment is not to advise against action, of course. It is only to suggest that action proceeding from gratitude and contentment, not in pursuit of it, will have the most lasting results.[45]

With this, humbled settlers like me can scan the ostensibly secular land of North America for enchantment.[46] Returning to the Indigenous Christian vision of the Ghost Dancer with which this book began, we can see all the adventurous gradations of cosmology on offer in European thought[47] reflected in another vision recorded by the same Kiowa dancer, but with a powerful, yet wounded, Christ presiding in the lower realms (see fig. C.2).[48] He marshals the lightning,

Jung "projected his particular struggle and particular God image onto God." *The Wisdom of the Psyche* (Canada: Daimon Verlag, 2000), 125.

[44]C. S. Lewis, *Prince Caspian* (New York: HarperCollins, 1951), 218.

[45]As of this writing, after repeated efforts I have been able to make no progress toward renaming the Winfield Mounds. I have presented the difficulties of our property holdings in the Black Hills to Wheaton College's administration, who have received this counsel and are considering how to respond. Our college partnerships with the Potawatomi (thanks to Rev. Casey Church) and the Ojibwe (thanks to Rev. Michaeljohn Rezler) are off and running. Many of my classes have been recentered on Indigenous issues, and new ones have emerged as well. I look forward to what lies ahead.

[46]"Knowing of the existence of the primal faiths," observes Philip Jenkins, "has forced Christians and Jews to ask themselves about their own attitudes to the natural world, to the sacred landscape, to the environment, to the spirituality of the body." Jenkins, *Dream Catchers*, 255.

[47]See, for example, Ken Wilber, *Integral Spirituality* (Boston: Shambhala, 2006), 213. Wilber was inspired by Jean Gebser, himself more discerning of Christian uniqueness. See Jean Gebser, *The Ever-Present Origin*, trans. Noel Barstad with Algis Mickunas (Athens: Ohio University Press, 1985), esp. 90.

[48]For Kiowa drawings that show a conversion with a less positive view of the Feather (Ghost) Dance, see William C. Meadows and Kenny Harragarra, "The Kiowa Drawings

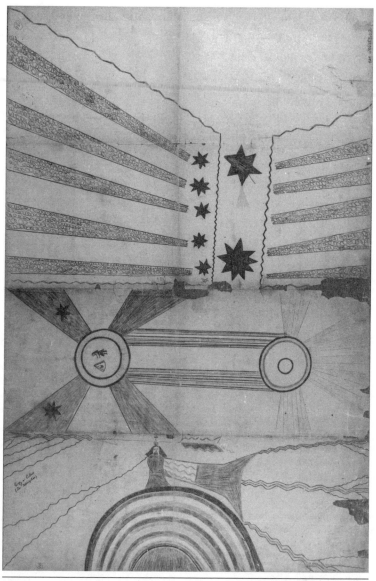

Figure C.2. Fíqí (Kiowa), Vision of Jesus collected by Smithsonian ethnologist James Mooney, c. 1890

evoking the Thunderers.[49] Fíqí's defiantly Christian vision is a wrench in the gears of colonizing New Age appropriations of Indigenous ceremony and religion. He illustrates another thinker's claim that "at the very epicenter of Christian identity—in direct challenge to the perennial road map—is the lived experience that *God does not lose energy by plunging into form.* . . . The way to God is not up but down."[50] Chesterton, in a passage that almost feels like a commentary on the Kiowa dancer's art, put it this way:

> The great psychological discovery of Paganism, which turned into Christianity . . . is merely this, that whereas it had been supposed that the fullest possible enjoyment is to be found by extending our ego to infinity, the truth is that the fullest possible enjoyment is to be found by reducing our ego to zero. . . . Humility is the thing which is for ever renewing the earth and the stars. Humility is perpetually putting us back in the primal darkness. There all light is lightning, startling and instantaneous.[51]

So inspired, we humbled guests on Turtle Island can pursue Chesterton's "mystical materialism,"[52] and there is no better partner in

of Gotebo (1847–1927): A Self-Portrait of Cultural and Religions Transition," *Plains Anthropologist* 52, no. 202 (2007): 229-44.

[49] As Mooney himself explains, "In Indian pictography the Thunderbird is figured with zigzag lines running out from its heart to represent the lightning." James Mooney, *The Ghost-Dance Religion and the Sioux Outbreak of 1890* (Chicago: University of Chicago Press, 1965), 218.

[50] Cynthia Bourgeault, *The Holy Trinity and the Law of Three* (Boulder, CO: Shambhala, 2013), 72-73. She adds: "The transcendent unity of religions notwithstanding, in Christianity, for better or worse, we are dealing with a horse of a different metaphysical color. It is not Platonism or Neoplatonism, not Traditionalism or Gnosticism, not Jungian archetypes or anthroposophy, not the perennial philosophy" (76).

[51] Chesterton, *Heretics*, 65. For an upending of those who deemed mythology primitive science worthy of Chesterton, see the brilliant chapter on James George Frazer in Timothy Larsen's *The Slain God: Anthropologists and the Christian Faith* (Oxford: Oxford University Press, 2014), 37-79.

[52] G. K. Chesterton, *A Miscellany of Men* (Norfolk, VA: IHS Press, 2004), 97. Compare Mark I. Wallace's *When God Was a Bird: Christianity, Animism, and the Re-enchantment of the World* (New York: Fordham University Press, 2018).

doing so than the millennia-old tradition that was here first. "God has not been the absentee landlord of North America," writes Steven Charleston, "but had been as active in the life of my ancestors as God was active in Israel."[53] The spiritual tradition of Native America, often expressed more through material culture and experience than through text,[54] is as worthy of engagement as the pre-Christian culture of Europe that Chesterton extolled.[55] Both are complemented, not canceled, by Christianity,[56] something that so many of North America's Christian representatives tragically missed. If for Chesterton it is Christians especially who are called to "guard even heathen things,"[57] this applies not only to Plato and Aristotle but also to North American petroglyphs and animorphic mounds.

North Americans can therefore be on the lookout not only for the fairies, gnomes, and elves defiantly celebrated by Chesterton even in industrialized Britain,[58] but for Underwater Panthers and Thunderbirds as well, which, for the purposes of this book I have equated, respectively, with the concealed mechanics of colonization and the fierce

[53]Steven Charleston, *The Four Vision Quests of Jesus* (New York: Morehouse Publishing, 2015), 56.

[54]"Students of Indian history must consider sources other than the written words, sources they are not accustomed to 'reading' . . . Native American pictographs, winter counts or calendars on buffalo robes. . . . One of the obstacles faced by historians of Native America is dispelling the myth that Indians were 'a people without history' because they produced no written records." Calloway, *First Peoples*, 6, 8.

[55]"Plato offers us ways of conceptually understanding spiritual experience. . . . By contrast, the American Indian religious traditions in general are not explained in conceptual but in experiential terms." Arthur Versluis, *The Elements of Native American Traditions* (Shaftesbury, UK: Element, 1993), 83.

[56]"Unlike Wovoka or Black Elk, Jesus became his vision. . . . This kind of vision quest is far beyond what Native American tradition understood. 'This is my body,' he told them. 'This is my blood.'" Charleston, *Four Vision Quests of Jesus*, 72.

[57]G. K. Chesterton, *The Ballad of the White Horse*, cited in Alison Milbank, *Chesterton and Tolkien as Theologians: The Fantasy of the Real* (London: T&T Clark, 2009), xi.

[58]"It is the English who are odd because they don't see fairies." Chesterton, *Heretics*, 75. See also, "Through all the noises of a town / I hear the heart of fairyland." G. K. Chesterton, "Modern Elfland," in *Collected Poetry*, part 1, ed. Aidan Mackey, Collected Works 10 (San Francisco: Ignatius Press, 1994), 234.

light of Christ. Indeed, I have often wondered why, in the mounds, beadwork, and petroglyphs that surround the Great Lakes region, the two creatures, the menacing Mishipeshu and the thrilling Thunderbirds, are depicted so proximate to one another (see fig. C.3).[59] Perhaps this is the reason: "Unless we do conscious work on it, the shadow is almost always projected."[60] Or as Chesterton's Father Brown put it, "No man's really any good till he knows how bad he is, or might be . . . till he's got rid of all the dirty self-deception of talking about low types and deficient skulls."[61] In other words, until the crimes are acknowledged, whether Chesterton's *Crimes of England* or the crimes of America and Canada, the magic stays concealed.[62] Only then can we

[59]"The symbolic oppositions within [the Illinois] landscape may have signified the never-ending struggle between the Thunderers of the Upper World and the Horned Serpent of the Under World. The Horned Serpents and the Thunderers, although opposites, are linked together through water symbolism." Mark J. Wagner, Mary R. McCorvie, and Charles A. Swedlund, "Mississippian Cosmology and Rock-Art at the Millstone Bluff Site, Illinois," in *The Rock-Art of Eastern North America*, ed. Carol Diaz-Granados and James R. Duncan (Tuscaloosa: University of Alabama Press, 2004), 63. Dennis Merritt reports that at Wisconsin's Lizard Mound site, "members of the tribe . . . [ritually] formed the body of an eagle, incorporating the two elongated panther mounds as wings." Dennis L. Merritt, *The Dairy Farmer's Guide to the Universe: Jung, Hermes, and Ecopsychology*, vol. 1, *Jung and Ecopsychology* (Carmel, CA: Fisher King Press, 2012), 104.
[60]Robert A. Johnson, *Owning Your Own Shadow: Understanding the Dark Side of the Psyche* (San Francisco: HarperCollins, 1991), 31. In so suggesting, I am not simply taking these "in the Jungian sense, a self and shadow pair," which Smith cautions against. Theresa S. Smith, *The Island of the Anishnaabeg* (Lincoln: University of Nebraska Press, 1995), 132. Like the Indigenous traditions, Jungianism benefits from Christianization as well. "C. G. Jung in particular repeatedly intimated that totality must include evil as well as good. This is a dangerous and misleading thought for, in spite of the necessity for evil, *evil has a negative power of its own which is directly opposed to the life-giving power of totality.* We must distinguish between chaotic or undifferentiated parts of our personality, which may seem to us to be devilish but which must be included if we are to be whole, and absolute or ultimate evil—a very different thing which cannot be integrated into wholeness since it is antiwholeness." John A. Sanford, *The Kingdom Within: The Inner Meaning of Jesus' Sayings*, rev. ed. (New York: HarperCollins, 1987), 137.
[61]Chesterton, *Complete Father Brown Stories*, 498.
[62]"Water spirits were menacing, but they could also confer great blessing." Robert A. Birmingham and Amy L. Rosebrough, *Indian Mounds of Wisconsin*, 2nd ed. (Madison: University of Wisconsin Press, 2017), 135.

guests on Turtle Island say of this land what Chesterton said so happily of his:

This is the town of thine own home
And thou has looked on it at last.[63]

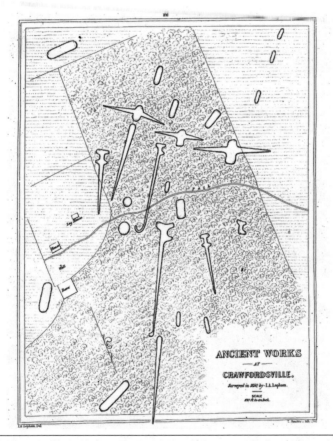

Figure C.3. Increase Lapham, The Dewey Mound Group near Big Bend, Wisconsin, 1855

[63]Chesterton, "Modern Elfland," 234. For a fruitful reflection on this poem, including an exploration of the way Chesterton pursues the Arthurian myth of England the Grail Legend, see J. Cameron Moore, "'All Men Live by Tales': Chesterton's Arthurian Poems," in *The Inklings and King Arthur: J. R. R. Tolkien, Charles Williams, C. S. Lewis, and Owen Barfield on the Matter of Britain*, ed. Sørina Higgins (Berkeley, CA: Apocryphile Press, 2017), 205-18.

CONTRIBUTORS

Matthew J. Milliner (PhD, Princeton University) is associate professor of art history at Wheaton College. His work has appeared in several publications, including the *New York Times* and *First Things*. He was awarded a Commonwealth Fellowship at the Institute for Advanced Studies in Culture at the University of Virginia to complete his forthcoming book, *Mother of the Lamb*.

David J. P. Hooker (MFA, Kent State University) is an artist and professor at Wheaton College. His works have been exhibited both nationally and internationally, and he has twice been part of the Dunhuang Ceramic Residency in Lanzhou, China. You can see his work at www.davidjphooker.com.

David Iglesias (JD, University of New Mexico School of Law) is Jean and E. Floyd Kvamme Associate Professor of Politics and Law and the director of the Wheaton Center for Faith, Politics, and Economics. He is also a Kuna Nation tribal member, a retired US Navy JAG Captain, and a former US Attorney and White House Fellow.

Amy Peeler (PhD, Princeton Theological Seminary) is associate professor of New Testament at Wheaton College and associate rector at St. Mark's Episcopal Church in Geneva, Illinois. She is the author of *"You Are My Son": The Family of God in the Epistle to the Hebrews*. Her work focuses on the book of Hebrews and the theology of gender.

FIGURES CREDITS

Figure I.1. Fíqí (Kiowa), Vision of Jesus between crosses blessing the Feather (Ghost) Dance collected by Smithsonian ethnologist James Mooney, c. 1890 / National Anthropological Archives, Smithsonian Institution

Figure 1.1. Lenape (Delaware) "Penn" wampum belt (c. 1682) / Photo by author

Figure 1.2. Site of the 1782 Gnadenhutten Massacre / Photo by author

Figure 1.3. Modern evocation of the original Piasa pictograph seen by Jacques Marquette, Alton, Illinois / Photo by author

Figure 1.4. George Winter, Portrait of Miss en nah go gwah (Potawatomi), c. 1837 / Tippecanoe Historical Society

Figure 1.5. Hodag statue in present-day Rhinelander, Wisconsin / Photo by Gourami Watcher / Wikimedia Commons

Figure 1.6. Ojibwe Methodist minister Peter Jones in Scotland, 1845 / Hill & Adamson / J. Paul Getty Museum

Figure 1.7. Ovide Bighetty, "Creating a New Family," from the series *Kisemanito Pakitinasuwin—The Creator's Sacrifice* (2002) / Indigenous Christian Fellowship of Regina

Figure 1.8. Title page of Lionel Wafer, *A New Voyage and Description of the Isthmus of America*, 2nd ed. (London: James Knapton, 1704) / Photo by Capt. Iglesias

Figure 1.9. Kuna woman painting on the nose of a Wheaton College football player, 2019 / Photo by Capt. Iglesias

Figure 2.1. Algonkian artist, Powhatan's mantle (before 1638) on display at Oxford's Ashmolean Museum / Photo by author

Figure 2.2. Flag of Chicago and proposed Indigenous flag of Chicago

Figure 2.3. View of Winfield Mounds / Google Earth; Chicago Lithographic Co., Chicago in 1820 (c. 1867) / Library of Congress

Figure 2.4. Michael P. Conzen and James A. Marshall, Ancient Indian Earthworks in the Chicago Region / Encyclopedia of Chicago

NAME INDEX

Apsevdis, Theodore, 109-10
Auden, W. H., 13-14
Augustine, 91
Bighetty, Ovide, 47-49
Black Elk, 128, 131
Black Hawk, 80-81
Brainerd, David and John, 24, 26-27
Brueggemann, Walter, 100
Cayton, Andrew, 122
Charleston, Steven, 9-10, 23, 145
Chesterton, G. K., ix, xiii, xv, 1, 13, 15-16, 18-21, 23, 30-34, 43-44, 60-62, 73, 90, 102-7, 122, 127, 132, 141
 "The Age of the Crusades," *A Short History of England*, 107
 As I Was Saying: A Book of Essays, 73
 Autobiography of G. K. Chesterton, 43-44
 Ballad of the White Horse, 145
 Complete Father Brown Stories, 141, 145
 "The Contented Man," *Selected Essays*, 60-61
 Everlasting Man, xiii, 3-5, 16, 21, 32-33, 35-36, 42, 73
 Heretics, 106, 141-45
 "Lepanto," 103-4
 Miscellany of Men, 144
 "Modern Elfland," 147
 Napoleon of Notting Hill, 62-64, 94
 New Jerusalem, 9, 66
 Orthodoxy, xiv, 2, 59, 86
 Queen of Seven Swords, The, 80, 102, 105, 114, 118
 Resurrection of Rome, 20-21, 73, 84, 94
 Sidelights on New London and Newer York, 89

St. Thomas Aquinas, 1-2
 Tonic for Malaise: Selected Essays, 69
 Uses of Diversity, 132
 What I Saw in America, 10, 88
Chief Joseph, 15
Church, Casey, ix-xii, 6, 101, 129
Curtice, Kaitlin, 126
Custer, George Armstrong, 64, 116, 130
Debassige, Blake, 8
Deloria, Vine, Jr., 16, 21-22, 70, 92, 128
Douglass, Frederick, 85
Flaget, Benedict Joseph, 39-40
Geraci, Peter John, 67-68
Grattan, John, 134-35
Gregory of Nyssa, 67
Harjo, Suzan Shown, 79
Harrison, William Henry, 30, 79, 82, 84
Heizer, Michael, 73
High Forehead, 134
Hooker, David, 96-100
Iglesias, David, 55-58
Jackson, Andrew, 40
Jefferson, Thomas, 112
Jenkins, Philip, 13, 15, 17-18, 22, 41, 64, 140, 142
Jones, Peter (Sacred Feathers, Kahkewaquonaby), 44-45
Jung, C. G., 140-41, 146
Ker, Ian, 9, 20, 102
Kiefer, Anselm, 99
Le Jeune, Father Paul, 23
Lelooska, 93
Lewis, C. S., 127, 142
Lewis-Williams, David, 33

Lincoln, Abraham, 82
Lusignan, Guy de, 108-9, 113, 116, 134
Marquette, Father Jacques, 36-38, 106, 127
Merton, Thomas, 137-38
Milliner, George, 132-37
Milliner, Matthew, 138-41
Morrisseau, Norval, xiii, 1, 6, 35, 45-46, 117-18
Mountain Lake, 140
Neumann, Erich, 42
Pappan, Chris, 76-77
Peeler, Amy, 123-26
Penn, William, 26
Perry, Stanley (Diné), 139, 141
Pius IX (pope), 115
Pokagon, Simon, 84-88
Powell, Peter, 91-95, 102
Rahner, Hugo, 17-18
Roosevelt, Theodore, 137
Santiago X, 74
Scott, General Winfield, 68, 98

Sitting Bull, 119
Smith, Theresa, 6, 17, 35, 49-50
St. Clair, Arthur, 112-14
Tecumseh, 80, 84
Tekakwitha, Kateri, 1
Tenskwatawa, 80
Tinker, George, 6
Twiss, Richard, 19
Virgin Mary, 103-6, 109-11, 115, 122, 125-26
Wafer, Lionel, 53-54
Washington, George, 77, 111-14
Wayne, General "Mad" Anthony, 76-77, 114, 117
West, Richard "Dick," 93-94
Williams, Charles, 104
Winter, George, 40-41
Wood, Ralph C., 10, 60, 103-4
Young, Brigham, 135-36
Zeisberger, David, 24-25
Žižek, Slavoj, 3

SUBJECT INDEX

Anishinaabe, ix, xi, 3, 7, 42, 50, 75
Anishinabe Spiritual Centre, 8
Battle of Fallen Timbers, 76, 113-14, 117
The Black Hawk War of 1832, 80-81
Black Hills, 128-31
Cahokia, 70-72
Catawba Indian Nation, 96-97
cave paintings, 31-32
Cherokee, 80
Cheyenne, 93-94
Cheyenne Christ, 89, 93-94
Chicago, 64-65, 73, 81, 89, 118-19
Choctaw, 9
Christian thought, culture, spirituality, 12-13, 41-42, 46, 49-51, 144-45
Columbian Exposition of 1893, 84
Congregation of the Great Spirit (Milwaukee), 119-21
contentment, 60-62
Crusades, 107-10
Cyprus, 108-9
Delaware (Lenni Lenape), 24-31, 40-41, 75, 77, 115
Eckankar (New Age), 45-46
evangelicalism, 24-25
First Nations, 47-49
forgiveness, 124-26
Fort Dearborn, 65-66, 73, 77, 80
Fort Sheridan, 89-90
Frenchifying, 38-39
Ghost Dance (Feather Dance), 12, 130, 142
Gnadenhutten Massacre, 26-27, 40-41
Ho-Chunks (Winnebago), 75
Hodag, 34, 42-43

Hopewell, 68-69
Huron, xii
iconography, 106, 114-20
Illinois, 38
Indian Removal Act, 40
Indigenous art, 70
Indigenous Christian Fellowship of Regina, 47-48
Indigenous Peoples history, thought, culture, spirituality, ix-xi, xv, 8-13, 24-25, 35-36, 38, 44, 49-51, 76-82, 86-88, 111-14, 118-19, 129-30, 144-45
Iroquois (Haudenosaunee), 24, 76
Jesuits, 38-39
Kickapoo, 75
Kiowa, 11
Kuna Yala, 52-56
Lakota, 64, 108, 131, 134
Manitoulin Island (Spirit Island), 5-6, 49
Massacre at Wounded Knee, 88, 130
Miami, 75-76, 112
Mishipeshu (Underwater Panther), x, xiii, 16-17, 34-38, 42-43, 50, 70, 88, 145-46
missions, 11, 24-26
Mississippi, 8
Mohican, 41
molas, 53
Moravian Indians, *see* Delaware
Mormonism, 132-37, 140
mounds, 64-74, 98
Mount Athos, 2, 5
Native Americans, *see* Indigenous Peoples
Native rock art, xi, xiii-xiv, 16-17, 32-34
Navajo, 135-36, 139-40

Odawa, 7
Ojibwe, xiii, 7-8, 35, 44-46
Orthodox Christianity, 108-11
Ottawa, 40-41
Our Lady of Perpetual Help, 114-18, 121
Pequot, 11
Pine Ridge reservation, 129-31
pipes, 128
Pipestone, Minnesota, 128
place (sense of), 96, 100-101
Pokagon, xi, 81-82, 85
Potawatomi, ix, xi, xiv, 7, 41, 64, 75, 77-79, 81-82, 85, 136
pottery, 96-97
Protestant and Catholic conflict, 14-15, 105-6
racism, 43-44
Saint Kateri Center of Chicago, 49, 118-19
Sauk, 75, 81
Seneca, 40
Shawnee, 40, 75-76, 112

spirits, 31
St. Augustine's Center for American Indians, 91-93
Sundance Circle, 129
sweat lodge, 6-7
Thunderbird (Animiki), xiii, 16-17, 43-50, 142, 144-46
Timucuan, 14
The Trail of Death, xiv, 82-83, 139-40
The Trail of Tears, 68
Treaty of Greenville, 76-79, 84, 90
Turtle Island, ix, 21, 24, 138, 144, 147
Utah's Black Hawk War, 135-36
Ute, 135-36
wampum, 78-79
Western thought and culture, x, 41-42
Wiikwemkoong, 6, 49
Wiindigo, 36
Winfield Mounds, 66-68, 98-100, 142
Wyandot, 41, 77

The Marion E. Wade Center

ounded in 1965, the Marion E. Wade Center of Wheaton College, Illinois, houses a major research collection of writings and related materials by and about seven British authors: Owen Barfield, G. K. Chesterton, C. S. Lewis, George MacDonald, Dorothy L. Sayers, J. R. R. Tolkien, and Charles Williams. The Wade Center collects, preserves, and makes these resources available to researchers and visitors through its reading room, museum displays, educational programming, and publications. All of these endeavors are a tribute to the importance of the literary, historical, and Christian heritage of these writers. Together, these seven authors form a school of thought, as they valued and promoted the life of the mind and the imagination. Through service to those who use its resources and by making known the words of its seven authors, the Wade Center strives to continue their legacy.

THE HANSEN LECTURESHIP SERIES

The Ken and Jean Hansen Lectureship is an annual lecture series named in honor of former Wheaton College trustee Ken Hansen and his wife, Jean, and endowed in their memory by Walter and Darlene Hansen. The series features three lectures per academic year by a Wheaton College faculty member on one or more of the Wade Center authors with responses by fellow faculty members.

Kenneth and Jean (née Hermann) Hansen are remembered for their welcoming home, deep appreciation for the imagination and the writings of the Wade authors, a commitment to serving others, and their strong Christian faith. After graduation from Wheaton College, Ken began working with Marion Wade in his residential cleaning business (later renamed ServiceMaster) in 1947. After Marion's death in 1973, Ken Hansen was instrumental in establishing the Marion E. Wade Collection at Wheaton College in honor of his friend and business colleague.